OXFORD STUDIES IN THE HISTORY OF ART AND ARCHITECTURE

General Editors

ANTHONY BLUNT FRANCIS HASKELL

CHARLES MITCHELL

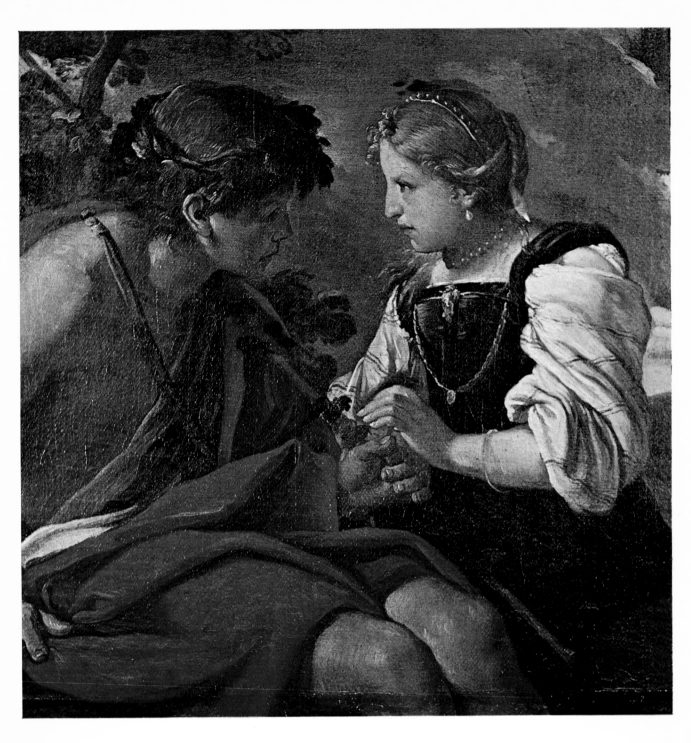

P. F. Mola, *Bacchus and Ariadne* (Detail), (Cat. 67 and Pl. 125)

Pier Francesco Mola

RICHARD COCKE

CLARENDON PRESS · OXFORD

1972

Oxford University Press, Ely House, London W.1

GLASGOW NEW YORK TORONTO MELBOURNE WELLINGTON
CAPE TOWN IBADAN NAIROBI DAR ES SALAAM LUSAKA ADDIS ABABA
DELHI BOMBAY CALCUTTA MADRAS KARACHI LAHORE DACCA
KUALA LUMPUR SINGAPORE HONG KONG TOKYO

PRINTED IN GREAT BRITAIN BY ROBERT MACLEHOSE AND CO. LTD
THE UNIVERSITY PRESS, GLASGOW

Preface

IN this study, which arises out of my London thesis, I hope to provide a reliable corpus of paintings and drawings by Pier Francesco Mola. The limits of the documentation make the suggested chronology speculative, and further research will clarify the gaps in our knowledge about his development. A complete catalogue of the drawings, although desirable, seemed premature, since many drawings in the major collections have been mislabelled, and there is much material in private collections to which I have not had access. Of one omission I am fully conscious; I failed to obtain photographs of any of the drawings in the Real Accademia de San Fernando, Madrid, which Dr. Ann Sutherland Harris had brought to my attention.

In the course of this work I have incurred many debts, but I would like to acknowledge especially the help I received from H. Adhémar, A. Busiri-Vici, I. Faldi, J. Gere, F. and L. Haskell, K. Hartmann, J. Pope-Hennessy, A. M. Jaffé, G. Incisa della Rocchetta, M. Kitson, R. W. Lee, M. Levey, D. Mahon, A. Martindale, U. Middeldorf, J. Montague, B. Nicolson, A. Percy, E. Schaar, E. Schleier, J. Shearman, Mr. and Mrs. R. Suida-Manning, M. Waddingham. Dr. A. Sutherland Harris encouraged my research from the outset, and I have benefited from Professor E. K. Waterhouse's many pertinent comments on my thesis.

Grants from the Central Research Fund of the University of London made it possible to travel at the outset of my research, and a grant from the General Board of the Faculties at Cambridge enabled me to travel to America at Easter 1969. The final draft of the manuscript was completed by December 1968, although it does include some minor changes made in the light of my trip to America. I am grateful to the Clarendon Press for their many helpful suggestions.

I am particularly indebted to Professor Sir Anthony Blunt, who first suggested Mola as a topic for research, and from whose critical and encouraging attitude to earlier drafts of my thesis I have benefited greatly. My mother supported my research at the Courtauld Institute, but my greatest debt is to my wife whose enthusiasm for the paintings encouraged me to finish this book.

Acknowledgements

Permission to reproduce photographs is gratefully acknowledged as follows:
By gracious permission of Her Majesty the Queen, 7, 43. By Courtesy of A. Hendriks, Arnhem, 105; Kupferstichkabinett, Staatliche Museen, Berlin-Dahlem, 52, 76, 83, 116; Staatliche Museen, Berlin, 31; E. K. Waterhouse, Barber Institute, Birmingham, 106, 107, 109; Herzog Anton Ulrich-Museum, Brunswick, 86, 126; Hessisches Landesmuseum, Darmstadt, 122, 133; R. Rémy, Dijon, 68, 69, 79; Kunstmuseum, Düsseldorf, 29, 63, 67, 87; National Galleries of Scotland, Edinburgh, and owner, 36; Gabinetto dei Disegni, Uffizi, Florence, 10; Städelsches Kunstinstitut, Frankfurt, 134, 135, 146; V. Bloch, The Hague, 18; Teyler Museum, Haarlem, 34, 39, 46, 84, 104, 108; Hermitage, Leningrad, 113, 114, 132; British Museum, London, 11, 12, 65, 72, 117; Christie, Manson and Wood, London, 54; Courtauld Institute of Art, London and owners, 6, 16, 25, 28, 51, 61, 71; D. Mahon, London, 19, 23, 98, 140; Mansell Collection, London, 88, 94, 99, 127; National Gallery, London, 24, 129; W. B. Pollard, London, and owner, Frontispiece; J. Rowlands, London, 75; Sotheby and Co., London, 20, 26, 27, 124; Warburg Institute, London, 22, 62, 81, 82; Camponagara, Lyon, 143, 144; P. Pedroli, Mendrisio, 1, 2, 3, 4; Musée Atger, Montpellier, 66; Musée Fabre, Montpellier, 80; Staatliche Sammlungen, Munich, 111, 130; Museo Nazionale di Capodimonte, Naples, 15, 118; R. Michenet, Nevers, 121; R. Krautheimer, New York, 42, 44; Department of Drawings, Metropolitan Museum, New York, and owner, 48; R. Suida-Manning, New York, 32; J. McCrindle, New York, 30; Allen Memorial Art Museum, Oberlin, 21; Department of Western Art, Ashmolean Museum, Oxford, 17, 112; École des Beaux-Arts, Paris, 47; Cabinet des Dessins, Musée du Louvre, 8, 9, 14, 41, 49, 50, 64, 77, 78, 115; Musée du Louvre, Paris, 33, 45, 110, 123; P. Rosenberg, Paris, 119, 120; Art Museum, Princeton, 102, 103; A. Busiri-Vici, Rome, 90; Chauffourier, Rome, 93; Gabinetto Fotografico Nazionale, Rome, 35, 55, 56, 60, 73, 74, 85, 91, 92, 100, 101, 136, 137, 138, 139, 141, 142; Gabinetto dei Disegni, Palazzo del Farnesina, Rome, 57, 58, 59; Soprintendenza ai Monumenti di Lazio, Rome, 40; Ringling Museum of Art, Sarasota, 37, 38; M. H. de Young Memorial Museum, San Francisco, 131; Art Museum, Seattle, 145; Nationalmuseum, Stockholm, 53, 70, 95, 128; Art Gallery, Toronto, 89; Gallerie degli Accademia, Venice, 96, 97; Fondazione G. Cini, Venice, 5; Kunsthistorisches Museum, Vienna, 13.

Contents

List of Plates

LIST OF PLATES

I

The Life

THE conflicting evidence about the life of Pier Francesco Mola has led to confusion over the dating of his works. His two early biographers, G. B. Passeri[1] and L. Pascoli, differ in their accounts of Mola's early trips out of Rome: Passeri[2] mentions two journeys, the first of which was to Venice, while Pascoli[3] mentions only one, which started in Bologna and went on to Venice.

About Mola's birth and background the facts are fairly clear; but the evidence concerning his training and early career is ambiguous. It can be best dealt with when, after a discussion of the established facts of his career, we return to consider the biographies of Pascoli and Passeri.

Pier Francesco Mola was born in the small village of Coldrerio, near Lugano in the Canton of Ticino, on the 9 February 1612.[4] His father was Giovanni Battista Mola, and his mother's name was Isabetta. The other members of the family, according to Passeri, were two older sisters and a younger brother. Giovanni Battista Mola[5] was an architect, and many stone-masons and architects of distinction came from the Canton of Ticino,[6] among them Francesco Borromini, Carlo Maderno and Carlo Fontana.

We know a little about Giovanni Battista Mola's work as an architect. The main sources are the manuscript *Life* by Nicola Pio[7] in the Vatican Library, dated 1724, and Mola's own guide book to Rome written in

[1] The system of references used is an abbreviated one which gives the author, date and page reference. The titles of books and articles as well as of the journals in which they are to be found, are given in full in the Bibliography. The edition of Passeri is that of J. Hess, 1934.

[2] Passeri-Hess, 1934, pp. 367–8. [3] Pascoli, 1730, p. 123.

[4] Voss, 1910, p. 177 publishes the entry in the Parrocchiale of Coldrerio: 'A di 9 Febraro an.o sudo (1612) p.me sud.o fu batezato pietro franc.o fig.o legitimo di Gio. batta molla Isabetta madre Compar il S.r franc.o vergo Comer Sig.a Luccia pozzi.'

[5] Passeri-Hess, 1934, p. 367. [6] cf. Donati, 1942, p. 21 ff.

[7] Manuscript Vat. (Capponigno no. 257.)

1663.[1] The major extant work which can be attributed to him is the Ospedale di S. Giovanni,[2] in Rome, which according to his guide book[3] he designed with his brother Giacomo.[4]

Pier Francesco Mola had been brought to Rome by his father together with the rest of the family by 1616,[5] when he was only four. The family lived near the Palazzo Mattei di Giove, and continued to live at the same address until Pier Francesco's death in 1666.

Miss Sutherland[6] has established the dates of Mola's two journeys out of Rome as 1633–40, and 1641–7. The Stati d'anime for the parish of San Nicola ai Cesarini show that Mola was not in his father's house at Easter of the following years, 1634, 1635, 1639, 1640 and 1642–6. The lists for the years 1636–8 are missing or unreliable, but we know from the inscription on a drawing by Mola in Montpellier[7] that he was in Lucca in 1637. He was in Rome at Easter in 1641,[8] but by August 1641[9] he was in Coldrerio where he was working on the frescoes for the Confraternity of the Madonna del Carmelo, the last recorded payment for which is on the 28 April 1642. There is no further trace of Mola in any published documents until his return to his father's house in Rome by Easter 1647,[10] but his presence in Rome is recorded regularly at Easter from then until his death in 1666.

Mola appears to have been in Venice in 1644. According to Boschini,[11] Cardinal Alessandro Bichi admired there some now lost frescoes by Veronese so much that he had them copied by Pier Francesco and Battista Mola. Alessandro Bichi, who had been created a Cardinal on the 28 November 1633,[12] arrived in Venice on the 22 December 1643 and negotiated a peace settlement between the Republic of Venice and the Pope

[1] ed. K. Noehles, 1967. All further references to this edition are given as Mola-Noehles, 1967.

[2] Published by Donati, 1942, pl. 307–12. [3] Mola-Noehles, 1967, p. 78.

[4] The most recent survey of Mola's career as an architect is given by Noehles in Mola-Noehles, 1967, pp. 20–32.

[5] The presence of G. B. Mola as early as this was first noted in a document published by Bertolotti, 1881, p. 14. The presence of the rest of the family was established by Sutherland, 1964, p. 364.

[6] Sutherland, 1964, pp. 364–7.

[7] The drawing, 864-2-228, is inscribed 'Pietro Testa lo feci io Pietro franco Mola in Lucca l'anno 1637'. It can be dated to the end of the year since in September of that year Testa, who was planning to go to Lucca with Cardinal Franciotti, was still in prison (see Bottari, 1822, Vol. I, pp. 358–61).

[8] Sutherland, 1964, p. 364.

[9] The correct transcription of these payments, which were first published by Voss, 1910, is given by Brentani, 1938, Vol II, p. 142, see Cat. 7.

[10] Sutherland, 1964, p. 364. [11] Boschini, 1660, p. 194, see under Cat. L.1.

[12] Cardella, Vol. VI, 1792, p. 302 and p. 306.

THE LIFE

on the 1 May 1644.[1] Bichi, who died in Rome in 1657, had previously had a distinguished diplomatic career as the Papal Nuncio to the French Court.[2]

In a letter of the 30 October 1658,[3] probably to his friend Bonini in Rome,[4] Albani refers to Mola's period of study with him: 'Come me parete facessero fare a Monte Cavallo quasi come una concorenza, e ne furono anco premiati 4 quali il Sig. diro Carlucci e Sig. Piero Fran.co Mola che quello el quale si tratteve circa dui anni nella mia stanza diro con profito avanzandosi (come intendo) assai nel coloria come mi vien detto, che gliene venne il premio'. This apprenticeship with Albani, which is not dated, probably occurred, as we shall see below, after the visit to Venice in 1644.

Although there is no documentary proof that Mola visited Venice before 1644 we know that he was out of Rome during the years 1633–40, and the style of the Coldrerio frescoes of 1641–2, (Cat. 7), reveals his knowledge of Titian's *St. Mark Enthroned with Saints Sebastian, Roch, Cosmas and Damian* now in S. Maria della Salute, Venice.

Passeri tells us that Mola returned from Venice to Rome painting in a style that he describes as Bassanesque, and that he then went to Milan on family business, and that it was after this that he settled with Albani in Bologna.[5] This fits in with the documents which show that Mola returned to Rome at Easter 1641, and that later that year he worked on the fresco cycle in his native village of Coldrerio.[6] The painting of *The Image of St. Dominic Carried to Soriano*, Pl. 36, in SS. Domenico e Sisto, which we know to have been finished by 1648, confirms Passeri's story that the contact with Albani came after the Coldrerio frescoes for it clearly shows the impact of Bolognese painting.[7]

These facts, which corroborate Passeri's account of Mola's early years, suggest that Mola visited Venice before 1641 and again in 1644, and date his stay with Albani 1645–7; this reveals Pascoli's inaccuracy, for he mentions only one trip to the North, where we know that there were two, and says that the artist moved first to Bologna and then on to Venice to

[1] Cicogna, Vol. IV, 1834, p. 576 and p. 273 – this was first noted by Branca, 1965.

[2] cf. Pastor, Vol. XXVIII, 1938, pp. 322 ff.

[3] Now in the collection of Frits Lugt, Paris. I am grateful to Dr. J. Montague for bringing this letter to my attention, and to Mr. Carlos Van Hasselt for providing me with a photograph.

[4] Malvasia, Vol. II, 1841, p. 183 notes that in his old age Albani wrote 72 letters to Bonini in Rome, and these at one time were in Malvasia's collection.

[5] Passeri-Hess, 1934, p. 368. [6] cf. further p. 45. [7] For a detailed stylistic analysis cf. p. 19.

meet Guercino.[1] The style of the dated paintings suggest that Mola was in Venice before Bologna, and certainly Mola would never have gone to Venice to meet Guercino, for Guercino was never in Venice.[2] We can accept as true what Pascoli says at the most general level, that Mola was in both Venice and Bologna, but we must be very cautious of the details with which he embroidered his story.

During the period 1647–66 there are a number of additional documents concerning him. *The Image of St. Dominic Carried to Soriano*, Cat. 56, commissioned as an altarpiece for SS. Domenico e Sisto by the Costaguti, is recorded as having been put in position by 1648. From the evidence of Niccolo Sega in the Valmontone trial, with which we will deal more fully below, we learn that Pier Francesco Mola decorated the Villa of the Pamphili at Nettuno with frescoes in 1652–3. The architect in charge of the building had been Pier Francesco's father,[3] but the building has been altered beyond recognition, and all traces of the frescoes have now completely vanished.

The redecoration of S. Marco, Rome was undertaken by Niccolò Sagredo, the Venetian Ambassador to the Holy See in Rome from 1651–6,[4] and there is a record of a payment to Mola for his *St. Michael Confounding Lucifer*, Cat. 59, on 21 December 1655, but this is not the final payment for the picture. Earlier in the same year, on the 13 June, Mola entered the Accademia di San Luca.[5] There is a portrait of Giovanni Battista in the Accademia,[6] so he too must have been a member.

From the 13 September 1656 Mola was working on his fresco for Alexander VII in the Quirinal Palace for which he received the final payment on 27 July 1657. Pietro da Cortona,[7] although not taking an active role, was the *entrepreneur* in this ambitious decorative scheme which employed many of the best artists in Rome. In 1657, or perhaps 1658, Mola painted a large standard for the Pamphili, which is now lost, but which depicted the Virgin in either an *Assumption* or an *Immaculate Conception*.[8]

From the 16 July until the 20 December 1658 Mola was working for the

[1] Pascoli, 1730, p. 123.
[2] As Hess in Passeri, 1934, p. 354 notes, Guercino moved to Bologna from Cento on 6 September 1642.
[3] Mola-Nòehles, 1967, p. 214.
[4] For Sagredo see Hess in Passeri, 1934, p. 369, note 1.
[5] Archivio dell'Accademia di San Luca, Vol. 43, 1634–74 *ad vocem*.
[6] Published by Donati, 1942, pl. 313; according to Pio it can be attributed to A. Masucci.
[7] The most recent and fullest discussion of the scheme is that by Wibiral, 1960, pp. 123–65.
[8] See under Cat. L.3.

Pamphili in their Palace at Valmontone.[1] He did not, however, complete his frescoes, but brought a court case against Prince Don Camillo Pamphili. This case began late in 1659[2] and dragged on until the 17 September 1664[3] when judgement was given in favour of the Prince. The documents relating to the trial were discovered in the Doria Pamphili Archives, and published by Miss Montalto.

There is a plea from Mola to Monsignor Nini,[4] Maestro di Camera to Alexander VII, in which he asks whether it might be possible for Monsignor Nini together with Monsignor Bevilacqua to try and settle Mola's differences with the Prince amicably. This attempt to find a peaceable solution must be dated between 20 December 1658, when Mola received the last payment for his work in Valmontone, and 10 August 1659, when Prince Don Camillo Pamphili appointed Antonio Plotino to act on his behalf in the trial.

For the Prince the case was a simple one of non-fulfilment of a contract. His servants[5] and the independent gentleman Niccolò Sega all gave evidence that a contract was made, under which Mola would have received 300 scudi for his fresco in the Stanza dell' Aria. Although one of the documents found by Miss Montalto is in the form of a written contract[6] between Mola and Prince Don Camillo Pamphili for the fresco, the fact that this is not signed and that Niccolò Sega[7] explicitly said that the agreement between Mola and the Prince was verbal, suggests that it may have been added to the documents later. Another consideration supports this, for Mola is unlikely to have pleaded that he stopped work on the fresco because there was no agreement, if he had in fact signed a contract. But this is exactly what he

[1] Montalto, 1955, p. 291, Doc. XIII, there seems to be no basis in the published documents for Montalto's statement, p. 275, that the payments to Mola for his work in Valmontone begin on the 16 July 1657. There is a payment to Mola on the 16 November 1657, but this seems to be for work in Rome, and the other payments in Montalto, Doc. XIII, are specifically stated to be for work at Valmontone.

[2] Montalto, 1955, p. 292, Doc. XV.

[3] Montalto, 1955, p. 302, Doc. XXIX.

[4] Montalto, 1955, p. 288, Doc. VII and see also Cat. 35.

[5] cf. Montalto, 1955, p. 293, Doc. XVI '. . . habbiamo inteso che (Mola) prima di cominciare à lavorare in quel luogo fè lui patto con li SS. Carlo Centofiorini e Nicolò Sega, . . . e compiacuto per lavorare . . ., poichè havesse lui per la mercede di quell' opera riceuta dall' Ecc. Sig. Pnpe scudi 300'

[6] Montalto, 1955, p. 286, Doc. III.

[7] Montalto, 1955, p. 301, Doc. XXVIII, '(Mola) accettò il detto Patto di scudi 300 e fu alla presenza mia, e di altri . . . e gli altri ch' erano potevano ancor loro sentire perchè nell' Anticamera non si parla in confessione'

does say in a document addressed to the Pope which must be dated 1663.[1] In this document, Mola claims that the judge is biased in favour of Prince Don Camillo, and asks for the case to be transferred to another judge; at the same time he gives the only surviving formulation of his case in the trial.

He claims that no contract had been made and that it was because of this that he stopped work.[2] He states further that only when the Prince gave orders for someone else to complete the fresco did he bring the lawsuit to claim the money which the Prince owed him for the work which he had already done.[3] There are two documents, dated 1662, in which Dughet and Cortese, who had both worked with Mola at Valmontone, put very favourable valuations on his work in the Stanza dell' Aria.[4] Dughet valued it at 600 scudi, while Cortese's valuation was at the even more favourable figure of 800 scudi.

Although the decision to replace Mola must, if we are to believe the artist's evidence, have been taken some time before the trial began in 1659, the contract with Mattia Preti was only signed on 17 March 1661 when he began his frescoes.[5] By this time Mola's fresco, which is only recorded in a group of drawings,[6] must have been destroyed and plastered over. There is a record of a payment to Francesco Cozza, dated 14 March 1659, of twenty giulii for the Stanza dell' Aria,[7] and it has been suggested that this was a payment for the destruction of Mola's fresco.[8] In view of Mola's statement that he brought the lawsuit after the completion of the fresco had been entrusted to another artist, it is possible that at first Cozza completed the frescoes in the Stanza dell' Aria, but that this compromise was not satisfactory and that later it was decided to get Preti to redecorate the whole Stanza.

Besides the support given to Mola during the course of the trial by Dughet and Cortese, and by other unknown artists, there is further evidence that Mola continued to be popular with his fellow artists, for on

[1] Montalto, 1955, p. 300, Doc. XXVII. In this document Mola states that the case has been before Monsignor Ariosti since 1659, and that the latter 'mai ha voluto nel Corso di 4 anni intieri far un minimo decreto favorevole all' Or.e'.

[2] Montalto, 1955, p. 300, 'E perchè non si era ancora pattuito il pezzo di detta Pittura fece di ciò più volte instanza l'oratore, pretestando non voler tornare a fornir l'opera fatta.'

[3] Montalto, 1955, p. 300 '. . . E la fece dipingere ad altri. . . . Per conseguire il povero Or.e la douta sodisfattione del lavoro già fatto, che era la maggior parte della stanza, alla quale non mancava che un vano, fu costretto agitare contro il Sig. Pñpe sin dall' anno 1659.'

[4] Montalto, 1955, p. 299, Doc. XXVI.

[5] Montalto, 1955, p. 297, Doc. XXII.

[6] Published by Cocke, 1968, pp. 558–65.

[7] Montalto, 1955, p. 289, Doc. IX.

[8] By Montalto, 1955, p. 281, note 46.

the 3 July 1662 he was elected President of the Accademia di San Luca in Rome.[1] The other candidates included Carlo Maratta, Pietro Berrettini, Bernadino Mei, Gianlorenzo Bernini, Ercole Ferrata, Carlo Rainaldi, and Francesco Contini. Mola assumed the Presidency of the Accademia on the 24 July 1662, and presided over the meetings until the 15 September 1663 when, because of his illness, Cozza took the chair. Cozza continued to preside in Mola's absence until on the 6 January 1664 Maratta became President.

In 1663 300 scudi were credited to Mola for frescoes to be painted in the Chigi Palace in SS. Apostoli;[2] Golzio suggested that as no further payments are recorded and as there is no trace of any fresco by Mola in the Palace, the frescoes were never carried out. But one of the painters who gave evidence for Mola in the Valmontone trial, Carlo Ronca,[3] says that he had seen Mola working on oil paintings on canvas in the Palace of the Chigi at SS. Apostoli. This deposition is not dated,[4] but as the evidence of Dughet and Cortese on Mola's behalf was dated 1662,[5] it is possible that Ronca's evidence was given in the same year; the more so as it seems to have the same aim as the evidence of Dughet and Cortese, namely to corroborate that Mola had painted a cycle of frescoes at Valmontone. Even if this payment was for a series of frescoes which Mola never undertook, it seems likely that he did do some work for the Chigi around 1662.

Mola's father died in 1665. From the following year dates a letter in the Pamphili Archives from Pier Francesco to the Prince in which he says that he is suffering from a new illness which is worse than that which he had three years before, because with this fresh illness he can no longer continue to paint.[6] Mola again asks the Prince to pay him what he is owed for his work in Valmontone, for as his father has died recently he has had to pay

[1] These and the following references are drawn from volume 43 of the Archivio dell' Accademia di San Luca, Rome, dated 1634-74.

[2] Golzio, 1939, p. 70, no. 38 and p. 13. [3] Montalto, 1955, p. 295, Doc. XX.

[4] But as Golzio, 1939, p. 3 notes, the Chigi only acquired the palace in SS. Apostoli in 1661.

[5] cf. under p. 6.

[6] I am grateful to Dr. Jorg Gärms of the Austrian Institute, Rome for transcribing this letter ADP Scaff 92, n5, 1666: 'Franco mola espone il suo stato, al quale l' ha ridetto il suo male, non solo quello, che gia tre anni sono hebbe disparaliscita ma anche il p(res)ente, quale da sett*me* in qua l' ha travagliato e travaglia ci segue tale, che l' ha reso affatto inhabile al poter essercitare per adesso il suo talento, e da quello viene aggravato anche in una grave spese tanto in riguardo della sua salute, come anco per la casa, e sua famiglia. Per tanto ricorre alla sommo bonta dell' Ecc. V. pregandola degnassi compatirlo con sonvirla, o di tutto, o in parte almeno di quel che V.E. si degnavi ammettere di esserli dovuto in riguardo delle felighe feste in *Valmontone* in servitu di V.E. In oltre in questo tempo e occorso la Morte del Gio Batista suo Padre, e gli e convenuto pagare legeti lasciati nel suo testament.'

a number of bequests in the will. On the 13 May of the same year, Mola himself died of 'Morbo apoplectico'.[1]

After this survey of the documents we must return to a discussion of the lives of Pier Francesco Mola by Passeri and Pascoli. Giovanni Battista Passeri was a contemporary and it has been pointed out that he was a 'censore' in the Accademia di San Luca whilst Mola was President.[2] Pascoli, however, was born after Mola's death, and must have used second-hand information, so although he is often correct in the broad outlines of his narrative, the details are frequently unreliable.

This is true of his account of Mola's death.[3] Passeri mentions Mola's retirement from the Presidency of the Accademia di San Luca, because of ill-health,[4] but rather surprisingly gets the date of his death wrong, giving it as 1668, where Pascoli gives it correctly as 13 May 1666.[5] Pascoli goes on to tell us that Louis XIV was so impressed by Mola's *Voyage of Jacob* that he invited him to come to France as Court painter, but Mola died suddenly before he could leave for Paris.[6]

Mola's letter to the Pamphili,[7] dated 1666, throws some doubt on Pascoli's story. If Mola had really had the generous offer from the French Court which Pascoli mentions, he would have been unlikely to write to a former patron asking for money, which he had already been refused in court. One cause of Mola's difficulties at this time was the new illness which prevented him from painting, so that, if the offer from the French Court had come after the letter to the Pamphili, the dramatic collapse whilst engaged on finishing a commission seems unlikely. Passeri dedicated his *Vite* to Louis XIV,[8] and is therefore likely to have included any story which concerned the King, but he makes no mention of any contact between Mola and the French Court.

Although Pascoli gives a very full account of Mola's activity in Rome, this is of little use as a guide to the chronology of his paintings, for he refers to the *Image of St. Dominic Carried to Soriano* in SS. Domenico e Sisto, which we know to date from 1648,[9] as being later than the Quirinal

[1] Sutherland, 1964, p. 364 and note 7. [2] cf. Sutherland, 1964, p. 367 and note 32.
[3] Pascoli, 1730–1, p. 126. [4] Passeri-Hess, 1934, p. 372.
[5] For the confirmation of Pascoli's date, cf. under note 2.
[6] This may have been the picture formerly in the Crozat Collection, cf. Cat. 11 and L.51.
[7] cf. p. 7, note 6. [8] Passeri-Hess, 1934, p. 6.
[9] Pascoli, 1730, p. 124; for the date of the SS. Domenico e Sisto painting cf. under Cat. 56; for the Quirinal frescoes cf. Cat. 49.

frescoes of 1656–7. The surviving documents confirm the accuracy of the order in which Passeri mentions Mola's work;[1] the only exception being the painting of *St. Barnabas Preaching* in S. Carlo al Corso, Cat. 55, for which there are no documents but which may well be slightly earlier than is implied by Passeri.[2] Passeri, however, makes no explicit statement about the date of this painting, as he does for most of the other works.

As a final example of the relative accuracy of the two biographers we may look at their treatment of the Valmontone trial. Pascoli is aware of a dispute with the Prince, although not of the lawsuit, and of the destruction of Mola's fresco, but he describes the latter incorrectly as the principal rivers of the world together with Pallas introducing the Arts of Painting, Sculpture, Architecture and Poetry.[3]

Passeri on the other hand identifies the room correctly as the Stanza dell' Aria and gives a detailed description of the *Rape of Ganymede*, of which Mola's completion is confirmed by the surviving drawings for the fresco.[4] Passeri also gives an account of the trial which is borne out by the documents which we have already discussed.[5]

There is another life of Mola, that by Nicola Pio in the Vatican,[6] which need not detain us long, since it is little more than a rehash of Pascoli. Pio follows Pascoli's story of Mola's trip to Venice to meet Guercino, and of his departure because of the latter's jealousy, and lists Mola's paintings in Rome in exactly the same order as Pascoli. Pio finishes his life by repeating the story of Louis XIV's offer to Mola, and then gives the only fresh piece of information in the life, his list of Mola's pupils; Francesco Giovane,[7] Giovanni Bonatti,[8] G. B. Bancore,[9]

[1] This was first noted by Sutherland, 1964, pp. 367–8.

[2] Passeri-Hess, 1934, p. 370, where it follows the Gesù frescoes.

[3] Pascoli, 1730, p. 125; but Pascoli's description, whilst it clashes with the account of the Valmontone frescoes given by Cosmo, cf. Montalto, 1955, p. 290, Doc. X, is derived from a drawing by Mola that was probably intended as a project for the Collegio Innocenziano, cf. Cocke, 1968, p. 565 and fig. 37.

[4] cf. Cocke, 1968, pp. 558–65 especially fig. 34.

[5] Passeri-Hess, 1934, p. 370; notably that Mola started the trial because he was worried about the payment that he would receive for this work.

[6] Published by Ozzola, 1908, pp. 51 ff.

[7] cf. Cat. R.1. [8] cf. Cat. R. 44.

[9] There is some confusion over the spelling of this artist's name, since he is presumably to be identified with the pupil whom Pascoli, 1730 Vol. I p. 129 refers to as G. B. Bancuore. There is a life of this otherwise unrecorded artist in the Pio Ms. in the Vatican, according to which he was born in Rome in 1640 and studied under Mola after a trip to Venice. He was elected Principal of the Accademia di San Luca some time before his death in 1701.

Antonio Gherardi,[1] Carlo Ronca,[2] Carlo Asentio[3] and Alessandro Vaselli.[4]

A few letters by Mola survive;[5] but they are all concerned with business matters and throw no light on his artistic theories. No inventory of Mola's possessions has survived to give us an indication of his taste. In his apparent lack of any theoretical interest Mola contrasts with his friend Pietro Testa, who left behind an unpublished Treatise on Painting,[6] and also with Nicholas Poussin, with whom he seems to have had some contact.[7]

[1] cf. Pascoli, Vol. II, 1736 p. 287 ff. and Mezzetti, 1948 pp. 157 ff.

[2] By his own admission, in the evidence which he gave in the Valmontone trial, Ronca was an unsuccessful admirer of Mola; Montalto, 1955 p. 295 Doc. XX.

[3] I know of no other reference to this artist.

[4] Vaselli also gave evidence in the Valmontone trial on behalf of Mola; Montalto, 1955 p. 295 Doc. XIX. According to the Ms. Life by Pio he was born in Cesena in 1637, came to Rome when 17 where he studied with Mola, and then passed to the studio of Giacinto Brandi. He died in 1714.

[5] Three are published by Montalto, 1955, pp. 286–8, Docs. II, IV, and V.

[6] cf. Marabottini, 1954, pp. 217 ff.

[7] I hope to publish the evidence for this elsewhere; see Schaar, 1961, pp. 184 ff., R.14, and Cat. 29. Poussin's theoretical studies are discussed by Blunt, 1957, p. 169 with further references.

2

Mola's Early Work

LITTLE of Mola's early work has survived, and his first documented work, the Coldrerio frescoes, were painted when he was almost thirty. It is now almost impossible to trace the influence of his apprenticeship to Cavaliere D'Arpino, which is mentioned by Passeri,[1] in any of the surviving paintings or drawings, which reveal twin debts to Venice and to Guercino.

Mola executed the frescoes in the Cappella Nuova of the church of the Madonna del Carmelo in 1641–2[2] (Pls. 1–4). We do not know why he had returned to Coldrerio; Passeri, who does not mention the frescoes, says that he went to Milan on family business.[3] Since the payments to Mola show that a special collection had been made to pay him, it seems likely that he returned home by chance and was given the commission.

The Cappella had been begun in 1621, three years after the departure of the Mola family for Rome, and the stucco framework was in place by 1627.[4] Mola had to work in a pre-arranged scheme whose central feature was the statue of the *Madonna del Carmelo*, which had been commissioned from Giulio Mangone in 1618.[5] The statue has now been removed to the high altar, and the *Assumption of the Virgin*[6] which stood on the high altar placed in the Cappella Nuova. The new frame which was provided for the altar by Antonio Monzini in 1767[7] destroyed the original scheme of the frescoes. The statue of the *Madonna del Carmelo* was flanked by frescoes of St. Sebastian and St. Roch in a *Sacra Conversazione* (Pl. 2). St. Sebastian

[1] Passeri-Hess, 1936, p. 367. [2] cf. under Cat. 7. [3] Passeri-Hess, 1934, p. 368.
[4] cf. Vassalli, 1947, p. 19. Vassalli's information is based on the church's archives, which run, with some interruptions, from 1615 to the present day.
[5] cf. Vassalli, 1947, p. 17.
[6] This had been presented to the church in 1588 by the artist, Domenico Pozzi, cf. Vassalli, 1947, p. 15.
[7] cf. Vassalli, 1947, p. 24.

must have gazed at the statue of the Virgin, whilst St. Roch looked out at the spectator. In the upper region God the Father (Pl. 1) blesses both the statue of the Virgin and the spectator.

The handling of these and the other frescoes is broad, with vigorous brush strokes and a rich palette. Mola is most successful with the individual figures. The standing saints are derived from Titian's altarpiece *St. Mark Enthroned with Saints Sebastian, Roch, Cosmas and Damian* now in S. Maria della Salute.[1] God the father, in the upper register, is inspired by Titian's *Assumption* in the Frari.[2]

On the left of the fresco of *God the Father* Mola painted the *Madonna of the Rosary Enthroned Surrounded by Members of the Confraternity* (Pl. 4). In the kneeling members of the Confraternity Mola included portraits, though none of the figures have been identified. The throne on which the Virgin sits is bulky at the front, but is pinched back to make room for the members of the Confraternity. The Madonna and Child are placed centrally and the members of the Confraternity kneel symmetrically on either side. The composition resembles that of Bellini's *Madonna Enthroned with Adoring Doge Barbarigo* in Murano,[3] rather than the more advanced treatment of Titian's Pesaro altarpiece in the Frari, but the motif of the Child raising the Virgin's veil reflects that of the Christ Child in the Pesaro altarpiece.[4] The Corinthian columns are derived from Paolo Veronese.[5]

The *Madonna of the Rosary Saving Souls from Purgatory* (Pl. 3) is the worst preserved of the frescoes, but even now something of its original freshness can be sensed in the landscape on the left. The individual figures are firmly modelled, but are piled meaninglessly on top of one another in a muddled composition.

Our knowledge of Mola's earliest paintings depends upon Passeri's[6] description of his style when he returned to Rome in 1641, and on the frescoes at Coldrerio of the same year. Passeri tells us that 'et incomincio a far vedere delle cose sue con un tingere saporito che havevano grandissimo

[1] The picture remained in Santo Spirito until 1656, when it was transferred to its present site, cf. Tietze, 1937, p. 346.

[2] This is still on view in its original site, cf. Tietze, 1937, p. 344.

[3] Gronau, 1930, pl. 106 dated 1488. [4] cf. Tietze, 1937, p. 344 and pl. 34.

[5] Notably the *Pala di San Zaccaria* now in the Accademia, Venice, but in the seventeenth century still *in situ*, cf. Venice, Mostra . . . Veronese, 1939, no. 39.

[6] Passeri-Hess, 1934, p. 368. For the reliability of Passeri, and the dating of this trip to 1641 cf. further pp. 3–4.

imitacione dello stile del Bassano con l'espressione del costume, e delle forme et anche del colorito di quel Maestro, e procurava d'imitare accidenti d'animali e di personaggi vili simili a quello'. This description fits the *Adoration of the Shepherds* in Vienna (Cat. 66; Pl. 13). The donkey that peers out of the canvas at the spectator, the rustic shepherds and the composition all point to this as the perfect embodiment of a Bassanesque style. The arrangement of the figures, especially the kneeling shepherd on the right of the picture, may reflect Jacopo Bassano's *Adoration of the Shepherds* in the Galleria Nazionale, Rome.[1] The two small boys looking into the scene from the background and the Corinthian pillar may be derived from a lost Titian which is known through a print.[2]

But the handling of this picture is typically baroque, especially in the rich, warm chiaroscuro that suggests the work of the young Guercino. Mola copied Guercino in 1643–4,[3] and it is extremely likely that he would have known his paintings before this. This picture also suggests a knowledge of Annibale Carracci's version of this subject,[4] which is now lost, notably in the young shepherd playing his pipes, and the basket filled with doves to be presented to the Holy Family. These motifs are not found in versions of the subject by the Bassani.

A comparison with the Coldrerio frescoes, in spite of the difference in scale of the two works, confirms the early dating for the Vienna *Adoration*. Both are Venetian in inspiration; the arrangement of the figures in the fresco of the *Madonna of the Rosary Enthroned Surrounded by Members of the Confraternity* (Pl. 4) is similar to that in the Vienna canvas. In both the figures are loosely grouped and set in a shallow space before architecture with a landscape behind. The Virgin and Child are similar in both pictures, and the angel who kneels adoring the child in the Vienna painting is very close in facial type to the *St. Sebastian* at Coldrerio.

[1] cf. Berenson, 1957, no. 1209. [2] cf. Tietze, 1937, fig. 322.

[3] The evidence for this is the drawing after Guercino in the Mahon collection exhibited Cento, 1967, no. 50, fig. 54, attributed to Sir J. Reynolds. Earlier Mr. Mahon had suggested that it could be by Mola, and I believe that comparison with Pls. 8–9 supports this attribution. The drawing cannot be connected with any drawing by Reynolds. Compare for instance, the *Comedy* in the Ashmolean Museum which was exhibited as no. 92 at Birmingham, 1961 and is reproduced on the cover of *English Drawings in the Ashmolean Museum*, 1957 and the drawings in the Herschel album (see Hermann, 1968, pp. 650 ff. especially Figs. 12 and 13). The drawing derives from the preliminary drawing for the, now lost painting of 1644, cf. Cento, 1967, p. 78.

[4] For a full discussion of the repercussions of this on the Carracci school, cf. Schleier, 1962, pp. 246 ff.

The range of sources upon which Mola appears to have drawn in the *Adoration*, and the success with which he synthesizes them emphasizes how limited is our knowledge of his early development since this, the earliest datable painting in Mola's œuvre, was probably painted when he was between twenty-five and thirty.

The *Echo and Narcissus* (Cat. 31; Pl. 17) now in the Ashmolean Museum, Oxford may be earlier than the Vienna *Adoration*. Narcissus is close to the young shepherd on the right of the *Adoration*, and the broad handling to be seen in the figure of Echo behind the tree is comparable to that of the two small boys in the background of the *Adoration*. In the landscape of the Oxford canvas which is simply constructed, Mola exploits for the first time the Venetian device of contrasting the warm brown of the tree on the left with the rich blue of the mountain background. The crossed trees in the foreground anticipate the *St. Bruno* Pl. 136, although there is a wide gulf between the handling of the two pictures. When compared with the other surviving landscapes by Mola the Ashmolean picture suggests the first steps of an artist who is inexperienced in landscape. There is no Venetian proto-type for this treatment of the theme of *Echo and Narcissus*, but the format and the figure types suggest the influence of the small mythological pictures of Scarsellino.[1]

A group of paintings which includes the *Mercury and Argus* (Cat. 30; Pl. 21) at Oberlin, the *Prodigal Son* (Cat. 10; Pl. 18) in Vitale Bloch's collection, the *Landscape with Two Carthusian Monks* (Cat. 17; Pl. 23) and the *Mercury and Argus* (Cat. 16; Pl. 19) both in the Mahon Collection can be linked with the Vienna *Adoration*. These pictures are characterized by their strong chiaroscuro, and by a certain clumsiness in the handling of the powerfully conceived figures. They are darker and more monumental in conception than the *Adoration of the Shepherds* and can be dated later, probably to the period 1640-5.

The figures in the Oberlin *Mercury and Argus* (Pl. 21) are more monu-mental than in either of the two pictures so far discussed, and the landscape is more fully developed than in the Ashmolean picture. There is some uncertainty in the spatial relationship of the two figures. Mercury is reminiscent of the shepherd on the right of the Vienna *Adoration* (Pl. 13), although the drapery is more sculptural. The lighting of the two pictures is

[1] cf. nos. 117 and 118 in the Borghese Collection which were first recorded in Rome in 1693, cf. Pergola, 1955, p. 67.

very similar, but the composition of the *Mercury and Argus* suggests a Bolognese source. The arrangement of the two figures, and their relationship to the background is strongly reminiscent of Annibale Carracci's *Bacchus and Silenus* now in the National Gallery, London.[1] This painting may be associated with the beginning of Mola's contact with Albani in Bologna, perhaps in 1645. A study of a man's head sold recently on the London market (Cat. 21; Pl. 20), is close to the Argus in the Oberlin picture. It may have been a preparatory oil sketch for this painting, although the features of the head have here been modified, notably the length of Argus' beard. There is one later example of a comparable oil study, the Doria *Head of a Young Woman* (Pl. 94), which may have been painted in connexion with the Colonna *Hagar and Ishmael* (Pl. 93).

This monumentality of the figures, and their rather uncomfortable relationship to the landscape, is also found in the *Prodigal Son* (Pl. 18) in the Vitale Bloch collection. The prodigal kneels picking up acorns to assuage his hunger. Behind him rises a mountainous landscape, but if he were to stand up he would tower unrealistically over the background. This discrepancy is heightened by the disparity between the soft even lighting of the background and the more intense and dark handling of the shadows on the prodigal.

Some of the motifs in the landscape are Venetian; the high horizon, the waterfall in the background and the long ridge introduced to give depth to the landscape recall Giorgione's *Adoration of the Shepherds* in Washington.[2] But the execution is not Venetian in character, as the strong chiaroscuro, which is derived from that of early Guercino,[3] eliminates any local colour in the landscape. Both the lighting of the figure which plunges one half of an arm into shadow, and the bulky sense of form are more strongly reminiscent of Guercino than are any other of Mola's paintings, and it is probably to be dated to 1643–4, the period when he was most closely studying the master.

Another small picture, the Mahon *Landscape with Two Carthusian Monks* (Pl. 23) may date from the same period. The landscape, dominated by

[1] The picture was first mentioned in the Palazzo Lancelotti in Rome in 1664, cf. Carracci Exhibition, Bologna, 1956, no. 97.

[2] This was first pointed out in conversation by Mr. Andrew Martindale.

[3] As exemplified in the *Elijah* in the Mahon collection, of 1620, cf. Royal Academy, London, 1960, no. 382, p. 148.

the receding mountain falling from left to right, recalls a formula first introduced into seventeenth-century landscape by Elsheimer,[1] but in its handling and in the romantic quality of the lighting it is again influenced by Guercino, and is probably quite close in date to the Vienna *Adoration*.

Mola seems to have studied with Albani from 1645, until his return to Rome in 1647.[2] By the decade 1640–50 Albani's style had hardened into an uninventive repetition of Annibale Carracci's late Roman style. Albani's *Noli Me Tangere* in Santa Maria dei Servi in Bologna,[3] which is documented to 1644, is derived from Annibale Carracci's *Domine Quo Vadis*, now in the National Gallery, London.[4] The figures have lost the power and monumentality of the Annibale, and the clear bright colours are now almost saccharine. Mola was perhaps attracted to study with Albani because in this work there is also an explicit link with Venetian sixteenth century painting, notably with the version of this theme by Titian now in the National Gallery, London, which was in the Muselli Collection in Verona in the mid-seventeenth century.[5]

The influence of Albani is most clearly marked in the *Baptism of Christ* now in the Pope-Hennessy collection, London (Cat. 20; Pl. 28). The Mola derives from Albani's version now in Lyon, A.245 (Pl. 144), which is first recorded in 1684 when together with its companion the *St. John the Baptist Preaching* (Pl. 143) it entered the French Royal Collection.[6] We know little about Albani's small scale paintings during the decade 1640–50,[7] but Mola's dependence upon this pair of pictures suggests that they can be dated to 1645–7. He has followed the Lyon picture so closely in the central group and in the genre-like background that his picture is almost a copy of it. The firm fluent modelling of the flesh tones, and the energetic plasticity of the handling over the red ground hark back to Mola's earlier Venetian training. The canvas, although still darker than the Albani, marks the beginning of a new approach to colour.[8] No other picture by Mola is so closely modelled upon the work of another artist, and by following Albani's composition, Mola was able to concentrate upon lightening his palette.

[1] In the *Aurora* in Brunswick, illustrated in *L'Ideale Classico*, Bologna, 1962, no. 121.

[2] cf. further p. 3. [3] cf. *L'Ideale Classico*, Bologna, 1962, p. 147.

[4] cf. Carracci Exhibition, Bologna, 1956, no. 107. [5] London, National Gallery, 1959, p. 110.

[6] cf. Bailly, 1709–10 ed. Engerand, 1899, pp. 182–3 nos. 7 and 8. [7] cf. Schaack, 1963, pp. 49–51.

[8] The most notable example of the brilliance of Albani's colour is the recently cleaned *Virgin with Angels and SS. Roch and Sebastian* from S. Giovanni in Persicolo, which in 1968 was on display in the Pinacoteca in Bologna, cf. Boschetto 1948, pp. 109 ff.

To this period can be dated a further group of paintings which include three versions of the *Rest on the Flight* – at Bowood (Cat. 3; Pl. 25), in the National Gallery, London (Cat. 18; Pl. 24), and in a Milan Private Collection (Cat. 25; Pl. 26) – the *Mercury and Argus* in Berlin (Cat. 2; Pl. 31), the two versions of *Hagar and Ishmael* – in the Louvre (Cat. 32; Pl. 33), and in the Suida-Manning collection, New York (Cat. 28; Pl. 32) – and, finally, the *Erminia Guarding her Flock*, in a Milan Private Collection (Cat. 26; Pl. 27). These pictures share the same small dimensions and, in contrast with the earlier group, are landscapes with subordinate figures. They continue in the tradition of Annibale Carracci's Aldobrandini lunettes,[1] a tradition which was carried on in Bologna by Albani. The pictures of this group retain the fluid touch that is characteristic of Mola and a reminder of the impact of Venice, but at the same time they are increasingly influenced by Bologna. There is not enough evidence to enable us to date these paintings with any precision, but we can suggest Mola's development in the three versions of the *Rest on the Flight*.

Perhaps the earliest is the Bowood panel (Pl. 25); the landscape recalls the Ashmolean *Echo and Narcissus* (Pl. 17), but Mola has introduced a brighter range of colour, notably in the rich blue of the mountain background, and a more even lighting of the panel. The trees in both share the same rather insubstantial handling, but the composition of the Bowood picture is more advanced; the mountain behind the Holy Family gives a firm articulation to the recession. The figures reflect Albani's many versions of this theme, both in their handling, and in their characteristic gestures.

Mola introduces a long ridge into the centre of the National Gallery version (Pl. 24) to create further depth in the background, a depth which he enhances by changing from a mountain to a forest setting, while by contrasting the red of the Virgin's cloak with the darker browns of the forest, he adds a romantic note to his interpretation.

In the *Rest on the Flight* (Pl. 26) in a Milan Private Collection there is greater elaboration of the recession. Mola introduces a pyramid into the distance to suggest Egypt, and closes the right-hand side of the landscape with a castle. In this decade Poussin was developing a new kind of landscape from the Bolognese tradition, in which the recession into depth is care-

[1] The payments for these, which establish the importance of Albani, were published by Hibbard, 1964, pp. 183–4.

fully controlled and the whole landscape becomes expressive.[1] Mola, however, stays within the Bolognese convention, making his subject matter of secondary importance and inviting the eye to wander restlessly over the painting to the horizon and then back to the figures in the foreground.

In this *Rest on the Flight* Mola comes closest to the Bolognese tradition, but the handling and the use of colour are still reminiscent of his earlier Venetian pictures.

It is difficult to establish a chronology for the other paintings in this group; but the Louvre *Hagar and Ishmael*[2] (Pl. 33) is very close to the National Gallery *Rest on the Flight* (Pl. 24). The articulation of the wooded landscape is similar in both pictures, and the Hagar is painted with the same rich colours as the Virgin.

The figures in the Suida-Manning version of the *Hagar* (Pl. 32) are slightly larger than in the Louvre picture, and Mola has added Hagar's bundle on the left of the canvas. These changes together with the alteration of the landscape background in a version which is otherwise closely related to the Louvre picture suggest that it is an autograph variant which may be slightly later in date than the Louvre picture.

The figures in the Berlin *Mercury and Argus* (Pl. 31) have something of the elegance of the Suida *Hagar*. This suggests that it should also be dated to the end of the period 1645–7. The landscape is dominated by a town and a castle, and this is closely related to the landscape in the last of the series of the *Rest on the Flight* in Milan. As with the Oberlin version of this subject the Berlin picture finds its inspiration in the Annibale Carracci *Bacchus and Silenus* in the National Gallery; but now Mola is influenced not only by its composition, but also by its handling.

Erminia (Pl. 27) may fit in with this group. There are parallels between the figures of Erminia and the Virgin of the National Gallery *Rest on the Flight*, but the handling of the landscape with the vivid blue mountains on the horizon is richer and more assured than that of any of the other pictures of this group. It marks the culmination of the new approach to Venetian colour that Mola had begun, under Albani's influence, in the *Baptism of Christ* (Pl. 28).

[1] For Poussin's landscapes cf. Blunt, 1944, pp. 144 ff.
[2] The figure of Hagar is reminiscent of the Virgin in Albani's *Annunciation* of 1633 in S. Bartolomeo, Bologna, cf. Boschetto, 1948, pp. 137 ff. and fig. 166.

3

The Early Roman Period

MOLA returned to Rome in 1647 and *The Image of St. Dominic Carried to Soriano* (Cat. 56; Pl. 35) was placed in SS. Domenico e Sisto in 1648 by Vincenza Costaguti who had joined the order the previous year. This is the earliest easel painting by Mola with almost life-size figures to have survived. Much of the architectural setting at the top of the canvas is hidden under dark varnish.[1] The stylistic implications of the *St. Dominic* can best be understood by a comparison with one of the Coldrerio frescoes of 1641, the *Madonna Enthroned* (Pl. 4). In both the figures are placed on a narrow platform in front of an architectural setting, which has a romantic view through to a landscape of trees. In the Roman picture the arrangement of the figures is asymmetrical and the female Saints are heavier and more classical than are any of the figures in the Coldrerio frescoes, or in any of the easel pictures so far discussed.

Because the subject of the SS. Domenico e Sisto painting is unusual,[2] Mola turned for guidance to the iconography of a more familiar subject. The composition resembles that of Sacchi's *St. Bonaventura* in S. Maria della Concezione.[3] The resemblance is only very general; Mola separates his kneeling Dominican from the three Saints carrying the image of St. Dominic, whilst Sacchi linked St. Bonaventura to the Virgin and Child in one great baroque diagonal across the canvas. Mola may have been inspired by one of the models on which Sacchi had drawn.[4] The source for the heavier, more monumental, female Saints in the Mola is Bolognese, but the

[1] This can be seen from the drawing Pl. 34.

[2] The iconography is discussed by Mâle 1951 p. 471. [3] Posse, 1925 Plate XVIII and p. 104.

[4] Notably Reni's *Madonna of the Rosary*, Basilica di San Luca, Bologna, of 1595–8, cf. Gnudi and Cavalli, 1955, p. 53, no. 2; or Lodovico Carracci's *The Virgin Appears to St. Hyacinth* now in the Louvre, but in S. Domenico, Bologna until 1797, cf. Bodmer, 1939, p. 136, no. 80.

work of Bolognese artists in Rome; comparable figures are to be found on the right of Domenichino's *Flagellation of St. Andrew*, which was completed by 1628, in S. Andrea della Valle, and in his easel paintings of the same period such as the *St. Mary Magdalene*[1] in the Mahon Collection.

In the *St. Dominic* Mola was attempting, not altogether successfully, to fuse together two traditions; for in addition to these Bolognese sources he turned to Venice for the landscape background and for the kneeling Dominican, who is close in handling to the shepherds of the Vienna *Adoration* (Pl. 13). In the *Bacchus and Ariadne* (Cat. 46; Pl. 40), also painted for the Costaguti, Mola succeeded in fusing together these two traditions, and the fresco may be later than the *Image of St. Dominic*.

Mola's dependence upon the work of Bolognese artists in Rome in the *St. Dominic* suggests that a small group of his landscapes which continue the Bolognese traditions of the earlier pictures, but which also show Roman influences, should be linked with his early Roman period. This is most explicit in the *Prophet Elijah and the Widow of Zarepath* (Cat. 62; Pl. 37) and the *Prophet Elisha and the Rich Woman of Shunem* (Cat. 61; Pl. 38), both in Sarasota. The format of the *Elijah*, the organization of the landscape and the gesture of the figure are strikingly close to the 1648 fresco of *Elijah Prophesying a Storm* by Grimaldi in S. Martino ai Monti.[2] The *Elisha* recalls another fresco by Grimaldi, *Elijah Crossing the Jordan*(?) in S. Martino,[3] in its use of a river behind the main protagonists. The figures in the Sarasota pictures are close to the *Hagar* in the Suida-Manning Collection, but the composition of the landscape, enclosed by massive trees, is firmer and more solid. This greater compactness reveals Mola's debt to Grimaldi.

The relationship of the Sarasota pictures to the decoration of S. Martino may be significant, for some of the payments to Dughet for frescoes in this church were made by the Milanese Omodei,[4] who in the next decade was to be a patron of Mola. As Mola had only just come to Rome from the North, where he might have met Omodei, it is possible that the two Sarasota paintings were commissioned in connexion with the S. Martino scheme to which their theme would have been appropriate. This suggests a

[1] Borea, 1965, pl. 84, and Bologna, 1962, no. 30.
[2] The payments were published in Sutherland, 1964, pp. 63 ff. and fig. 17.
[3] This is clearest in the copy published by Heidemann, 1964, fig. 31, opposite p. 378.
[4] Published in Sutherland, 1964, p. 66.

date of *c*. 1648–50 for these pictures and they fit in well with the 1648 *Image of St. Dominic* (Pl. 35). The tree and the romantic landscape in the latter recall the handling of the trees in the Sarasota *Elijah*, and the kneeling monk in the *St. Dominic* is reminiscent of the figures in the *Elijah*.

The other landscape which, although it differs from them in many respects, can be grouped with the two paintings in Sarasota is the Corehouse *Echo and Narcissus* (Cat. 8; Pl. 36). It fits in with the tradition of small landscapes, in which Mola appears to have worked in Bologna, and yet continues the more monumental forms of the Sarasota pictures. The arrangement of the landscape is similar to that of the *Elijah* (Pl. 37), but the horizon has been raised to achieve a more complex recession. A comparison of the Narcissus in the Corehouse and Ashmolean pictures (Pl. 17) reveals the more massive forms which Mola has adopted in the later painting, which recalls Annibale Carracci's *St. John* in the Mahon Collection[1] in its compact solidity. As in the *St. Dominic* there is a Venetian element in the landscape background of this painting, with the blue mountains on the horizon, and these parallels suggest that it should be dated to 1648–50.

There is no documentation for the fresco of *Bacchus and Ariadne* (Pl. 40) that Mola painted for the Costaguti, but it is reasonable to date it to the beginning of his period in Rome. Passeri[2] tells us that it was one of the first works that Mola painted on his return, and he worked for the Costaguti in SS. Domenico e Sisto in 1648. The fresco was part of the redecoration of the Palace that was undertaken by Giovanni Battista Costaguti, who had been born in 1636.[3] The format of the fresco is similar to that of Romanelli's *Orion*[4] and it is likely that these two frescoes form part of the same decorative scheme. It seems probable that Romanelli's fresco was completed between his two visits to France in 1646–7, and 1655.[5] On the verso of one of the preparatory drawings for the Costaguti fresco Mola drew St. John the Baptist Preaching.[6] This is related to the Ojetti painting of this subject, which on

[1] The picture, which is datable *c*. 1592, was first mentioned as in Rome in the mid-nineteenth century, cf. Carracci Exhibition, Bologna, 1956, no. 73.

[2] Passeri-Hess, 1934, p. 368.

[3] For details of Giovanni Costaguti's career see Guarnacci, 1751, vol. I, pp. 351–4; Sutherland, 1964, p. 368, note 34, refers this fresco to Vincenzo Costaguti. The drawings mentioned below confirm Passeri's identification.

[4] Voss, 1924, p. 266.

[5] cf. Blunt, 1957, p. 149. This dating is supported by Passeri who discusses Romanelli's Costaguti fresco together with his work in the Palazzo Lante, which he dates to 1653; cf. Passeri-Hess, 1934, p. 310.

[6] Pl. 46.

stylistic grounds can be dated *c*. 1650. This date would fit well with the *Bacchus and Ariadne* whose figures lack the monumentality that is so marked in the frescoes of the next decade.

Mola and Romanelli had similar fresco sites on which to work. Their modest 'quadri riportati' do not compete with the magnificent unified decorations carried out in the same palace by Lanfranco, Guercino and Domenichino.[1]

The *Bacchus and Ariadne* reflects Mola's training in Bologna. The composition sets Bacchus and Ariadne on a narrow strip in the foreground; in this way Mola was able to relate the main figures together and to set them in movement. The colour of the fresco, which has been restored recently, is more subdued than that of the frescoes at Coldrerio (Pls. 1–4) and reflects the influence of Albani. Both the composition and the motif of Bacchus moving to meet Ariadne may be derived from Albani's *Venus and Adonis* in the Borghese Collection, which was in Rome by 1622.[2] The handling of Bacchus, especially in the unconvincing anatomy of his legs, is close to that of the St. Sebastian at Coldrerio.

The boat in the distance, the dancing mænads with their cymbals and the slumped Silenus on his donkey reveal clearly the influence of Titian's *Bacchus and Ariadne*, now in the National Gallery in London, but in the seventeenth century still in Rome.[3] Mola further follows Titian in leaving his landscape open on the right, in contrast with Albani who had closed both sides of his *Venus and Adonis*. The one touch of colour in the fresco is provided by Bacchus' red robe; this, too, reflecting the influence of Titian. The stars which are an attribute of Ariadne may also allude to the Costaguti, whose *stemma* includes stars.

With the Louvre *Barbary Pirate* (Cat. 36; Pl. 45) of 1650 we find the first signs of the influence of contemporary Roman painting on Mola, who uses here a more subdued palette than in the *St. Dominic* (Pl. 35), and in the oriental dress of this strange figure gives free rein to his interest in the exotic. This suggests contact with the contemporary work of Salvator Rosa, who had returned to Rome from Tuscany in 1649[4] and whose style,

[1] There is no adequate discussion of the earlier decoration of the palace, but cf. Wittkower, 1958, p. 48.
[2] cf. Pergola, 1955, Vol. 1., Cat. 3.
[3] cf. London, 1959, p. 104 who notes that it was in the Villa Aldobrandini in Rome from 1638 until 1765.
[4] A letter dated 21 February 1649 announcing Rosa's return to Rome is quoted in Salerno, 1963, p. 94.

as shown in the *Parable of St. Matthew* in Capodimonte[1] and in the *Portrait of a Man* in Leningrad,[2] is notable for its restrained, dark colours and for the artist's interest in exotic headgear. But the freedom with which Mola paints, even when his palette is limited, contrasts with the more laboured and stiff handling of Rosa.

The use that the Barbary Pirate makes of his arrow recalls Titian's portraiture, notably the *Francesco Maria delle Rovere* in the Uffizi.[3] But the Mola differs from the Titian in its viewpoint, for the figure towers over us. In its size and scale the *Barbary Pirate* marks an important break with the paintings which we have so far discussed and points to the work of the next decade.

The connexion with the work of Rosa is also evident in the *St. John the Baptist Preaching* (Cat. 9; Pl. 51) in the Ojetti Collection and the *St. Barnabas Preaching* (Cat. 55; Pl. 55) in S. Carlo al Corso, which are close in date to the *Barbary Pirate* of 1650. Probably the earlier is the Ojetti picture, the composition of which is drawn from Bolognese sources. The figure of the Baptist, the gesture of his raised left hand, and his relationship to the spectators are all derived from a version of this subject by Albani in Lyon[4] (Pl. 143), but Mola's version is more monumental and concentrated, and there is a more coherent, baroque grouping of the figures. In the preliminary drawings Mola had used a wooden stile with a group of spectators leaning on it, and a boat in the background. These occur in Albani's picture, but Mola rejected them for the final painting. The drawings confirm the date of *c.* 1650 for the Ojetti *St. John*, as the composition was originally sketched on the verso of one of the drawings for the Costaguti fresco of *Bacchus and Ariadne* which is datable *c.* 1650.

The motif of the horseman on the right of the *St. John* is drawn from Domenichino's *Flagellation of St. Andrew* in S. Gregorio al Celio,[5] and the woman sitting with her child in front of the horseman is probably derived from his *Martyrdom of St. Andrew* in S. Andrea della Valle.[6] But these Bolognese sources have been transformed by the influence of Rosa. This is notable in the oriental costumes of the Baptist's audience as well as in the jagged

[1] Salerno, 1963, no. 29, dated 1651.　　　[2] Salerno, 1963, no. 27, but suggesting no date.

[3] Tietze, 1950 ed., pl. 102. The picture, which has been cut down, was evidently in Florence by 1631.

[4] Lyon, Musée, Inventory no. A.127, see also p. 16.

[5] Borea, 1965, pl. 14, of 1608.　　　[6] Borea, 1965, pl. 84, completed by 1628.

outline of the trees, which is paralleled in Rosa's *St. John the Baptist* in Glasgow.[1] In contrast with his earlier landscapes Mola enhances the romantic mood of the picture by adopting backlighting, from behind the horizon, and Rosa's influence is equally notable in the dark tones and limited palette of the painting. The handling is reminiscent of that of the *Barbary Pirate* and the horseman of the Ojetti painting is close both in facial type and in costume to the Pirate. The Ojetti picture is probably to be dated before the Louvre canvas which it does not rival in mastery or scale.

The *St. Barnabas* (Pl. 55) was probably painted in 1652, the year in which Omodei, who had commissioned it, was made a cardinal. It is related to the *Barbary Pirate* in the scale of its figures, their exotic costumes and in the influence of Rosa. The handling of the two pictures is different. The figures in the S. Carlo picture are flatter and less fully modelled than the *Barbary Pirate* and the texture of St. Barnabas' cloak is stiff but thin, and the crisp white of his robe is reminiscent of Saraceni. The overall tone of the picture is still dark, but brighter local colours have been introduced in the costumes. The listening crowd is merged into one shadowy group, but all the figures are parallel to the picture plane as is St. Barnabas. Mola synthesizes a wide range of sources in the *St. Barnabas*. The gesture of the spectator on the left of the canvas whose right hand is clasped to his chest is derived, although in reverse, from Rosa's *Diogenes* in Copenhagen, which was exhibited in Rome in 1652 and which was subsequently bought by Niccolò Sagredo, the Venetian Ambassador in Rome.[2]

The figures are arranged on a narrow platform in front of a landscape, which is closed by a bridge in the background and by architecture on the right. This is a formula which Poussin had used in the 1630s,[3] and which had been revived by Rosa, notably in the *Diogenes* and the *Democritus*. By the size of its figures and its dramatic lighting the *St. Barnabas* suggests Rosa rather than Poussin, although Mola derived the broken pillar behind the Saint from Poussin's Neo-Venetian paintings.[4]

The costume and the *decolleté* of the female figure with her back to the

[1] Illustrated by Salerno, 1963, Tav. XVI. Salerno suggests convincingly that the picture must be later than Rosa's Tuscan period.

[2] Salerno, 1963, no. 31.

[3] The Chatsworth *Arcadian Shepherds*, of *c.* 1630 is a typical example, cf. Blunt, 1966, no. 119.

[4] cf. the *Rest on the Flight* in Karlsruhe, Blunt, 1966, no. 48 of *c.* 1627.

spectator recall the portraits of Palma Vecchio,[1] while the Saint appears to be derived from Testa's *St. Theodore*[2] in Lucca. There is a drawing after the latter Saint attributable to Mola[3] which apparently dates from this period and may have been drawn from memory in preparation for this painting.

There is no record of any payment to Mola for his fresco of *The Martyrdom of SS. Abdon and Sennon*[4] (Cat. 57; Pl. 56) in S. Marco, but the surviving documentation establishes a bracket of 1653–5. Passeri tells us that the redecoration was commissioned by Niccolò Sagredo in 1653.[5] An anonymous chronicler writing about the redecoration in 1659 says that it began with the windows.[6] Since the frescoes in the nave, of which Mola's is one, are placed between the windows, it seems reasonable to assume that they formed the first part of the redecoration. Mola received a payment for his altarpiece in S. Marco in December 1655; this further commission may have meant that his fresco was already completed.

As with the Costaguti fresco, the composition of the *Martyrdom of SS. Abdon and Sennon* is derived from Bolognese sources. The sloping foreground on which the action takes place, closed off by buildings on top of which are spectators, is derived from Domenichino's fresco of the *Martyrdom of St. Andrew* in S. Andrea della Valle.[7] This compositional device enabled Mola to accommodate the six main protagonists in the foreground, and better to express the drama of the martyrdom.

The figures are more monumental and expressive than those in the Costaguti fresco. The most heroic of the figures is the older of the two martyrs; his pose is derived from that of the St. Stephen in Raphael's tapestry of the *Stoning of St. Stephen*.[8] The younger saint is not painted on the same scale, and is still reminiscent of the St. Sebastian at Coldrerio. The executioners are similar to the figures in the frescoes by Guglielmo Cortese also at S. Marco.[9] Both sets of figures reflect the influence of Cortona, as

[1] cf. especially the *Flora* in the National Gallery, London, Gombosi, 1937, p. 82.

[2] The attribution to Testa of this painting, which was published by Lopresti, 1921, p. 7, fig. 11, depends upon Baldinucci, 1847, p. 312. The painting is not dated, but it is close to the S. Martino S. *Angelo Carmelitano* of 1645–6; cf. Marabottini, 1954, fig. 15, and the payments published by Sutherland, 1964, p. 62.

[3] cf. Sutherland Harris, 1967, Fig. 59. The style of this drawing is close to that of Pl. 53.

[4] The frescoes were correctly reidentified by Salvagnini, 1935, pp. 167 ff.

[5] Passeri-Hess, 1934, p. 368.

[6] Quoted by Dengel, 1913, p. 92.

[7] cf. Borea, 1965, fig. 85, completed by 1628.

[8] cf. Gronau, 1936, p. 142.

[9] cf. Salvagnini, 1935, pp. 167 ff. and figs. 2–7.

exemplified by his *Martyrdom of St. Lawrence* in S. Lorenzo in Miranda, Rome.[1]

The *Martyrdom of SS. Abdon and Sennon* is more accomplished and monumental than any of Mola's previous frescoes. The figures, which are effectively related together and subordinated to the narrative, point to the more monumental style of the Quirinal fresco. Unfortunately the condition of the S. Marco fresco does not make it possible to judge the colour; what can be made out suggests that Mola is freeing his palette from the constraint which he had adopted in the Costaguti fresco, and that he is moving towards the richer colour of the Quirinal fresco.

To the Venetian and Bolognese elements that he had synthesized in the Costaguti fresco Mola has added a new one drawn from the Roman High Renaissance. This line of development is carried further in the next documented work, the impressive Quirinal *Joseph Greeting his Brothers* (Cat. 49; Pl. 60). The payments show that Mola was working on the fresco in 1656 and that he had completed it by July 1657.[2] As one of the senior artists Mola had been given one of the best sites in the palace, to which he responded with his masterpiece in fresco. The importance of the fresco is reflected in the number of drawings for it which have survived.

Mola also appears to have issued an etching of the design (Pl. 62). This was known to Mariette[3] but the differences between the etching and the fresco as executed have never been discussed. The format of the etching, which measures 35.9 by 44.2 cm. and is reversed, is rectangular where the fresco is nearly square. In the engraving, there are columns behind Joseph and the figures are slenderer than their counterparts in the fresco and are carefully separated from each other, whereas the fresco is closed by pilasters on the left and the figures form one group. The architecture of the palace on the right of the engraving is reminiscent of that in the courtyard of Michelozzo's Palazzo Medici in Florence, whilst that in the fresco is closer in spirit to Cortona's architecture, notably to the interior of SS. Martina e Luca. The surviving drawings appear to prepare the design of the engraving, which presumably represents a first design which was later rejected in favour of the more Cortonesque composition actually executed.

[1] cf. Briganti, 1962, p. 240; the picture is dated 1646.
[2] cf. Wibiral, 1960, p. 163, Docs. 66–9.
[3] cf. Mariette, 1851–60, Vol. IV, p. 4. The engraving, Bartsch XIX 1, is not signed; Bartsch records that a state was issued by Mola.

The earliest of the drawings is presumably Pl. 65, which is furthest both from the fresco and the engraving. It shows Mola searching both for a grouping of the brothers which would express their reactions to Joseph's revelation, and for a suitable architectural setting. The building in the background is a version of Sansovino's library in Venice, stripped of its ornamental detail, and there are faint traces of pyramids on the right which are introduced to give local colour. In the drawing at Montpellier (Pl. 66) Mola has concentrated on setting the brothers in greater depth, so that they are no longer spread in single file, and in achieving a more coherent, baroque grouping. In both these sheets Joseph runs to greet Benjamin, but this intimate and personal gesture does not link Joseph and Benjamin with the other brothers. The next stage is probably represented by Pl. 67; here Joseph welcomes Benjamin with open arms, and so includes all the brothers in his greeting. In Pl. 70 Mola extends the idea of kneeling figures which he had first used in Pl. 65 to the leading brothers who kneel in a group, one of whom stretches out both arms in amazement.

The changes introduced in Pls. 67 and 70 are embodied in the next drawing to show the overall design, Pl. 71, in which Mola combines the foremost group of kneeling brothers with a standing group at the back. In Pl. 71 the leading brother stretches out only his right arm. His reaction is depicted more clearly and he is linked more effectively to the brothers behind him. In Pl. 71 the architectural setting is drawn in greater detail; there is an important change in the background, where there is a clear separation between the landscape on the right and the architecture on the left, which is close to the solution finally adopted. The figure grouping of Pl. 71 is found in Pl. 72, where, however, the figures are so spaced that greater weight is given to each gesture and where they become less squat and dumpy. The changes between Pl. 71 and Pl. 72 are, in part at least, worked out in a drawing at Dijon, Pls. 68 and 69. The recto of this sheet, Pl. 69, has a grey chalk study of the central group of brothers in which Mola clarifies the transition from the kneeling figures to the standing; on the verso there is an alternative grouping for the brothers on the right of Pl. 71 that is adopted in Pl. 72. That Pl. 72 follows Pl. 69 seems to be confirmed by the chalk sketch in the upper half of Pl. 72, which elaborates the central standing group of three brothers which had been worked out tentatively on the recto of the Dijon drawing, Pl. 69. The composition of

Pl. 72 is embodied in Pl. 61 where the slim elegance of the architectural setting matches the figure style. The format of this drawing shows that it was designed to fit the field of the fresco as executed, but in the disposition of the figures and the architecture it corresponds almost exactly to the etching.

The handling of the etching comes close to that of the other engravings issued by Mola;[1] so this etching appears to have been issued by the artist to record a design for the fresco which he did not use. There does not seem to be any reason to accept Mariette's suggestion that the engraving is by Maratta. The engraved design shows us an artist working in a Bolognese idiom derived from the work of Domenichino in Rome, but the fresco as executed reveals an artist who has fully absorbed the lessons of Cortona's Pamphili ceiling.[2] In the fresco (Pl. 60) the composition is more successful than in any earlier work by Mola. The narrative is clear, with Joseph on the left of the fresco greeting his brothers, who are grouped on the right. Joseph is linked to this group by the leading brother who kneels, slightly separated from the others by the standing figure of Benjamin.

The skill with which the narrative is handled, the monumentality of the figure style and the skilful relationship of the figures to their setting, reveal Mola's debt to the Raphael tapestries. The composition is derived from the *Sacrifice at Lystra*,[3] although the kneeling figures also suggest a debt to the *Miraculous Draught of Fishes*.[4] This awareness of Raphael differentiates Mola's fresco in the Quirinal from those of the other artists engaged on the scheme. But the richness of Mola's vivid colours reveals the extent of his debt to Cortona.

This analysis of the development of Mola's design for the Quirinal helps to date the frescoes which he executed in the Ravenna chapel of the Gesù (Cat. 52 and 53; Pls. 73 and 74). The composition and figure types of the left-hand fresco, the *St. Peter Baptizing in Prison*, have many links both with the S. Marco fresco and the engraved design for the Quirinal. As in the etching the composition stresses the isolation of the prisoners so that there is a lack of a 'centro focale'.[5] The arrangement of the figures on a platform of rising ground that is closed by the architectural background is a continua-

[1] Notably the *Rest on the Flight* after Albani, Bartsch XIX 4, Pl. 81.
[2] Which was completed by 1654, cf. Briganti, 1962, p. 250.
[3] cf. Gronau, 1936, p. 139. [4] cf. Gronau, 1936, p. 134. [5] Wibiral, 1960, p. 143.

tion of the principle first applied in the S. Marco fresco. The prisoner on the left has the same massive and expressive quality as the older of the martyred saints in the S. Marco fresco.

The composition of the *St. Peter Baptizing* reflects that of Domenichino's *Martyrdom of St. Cecilia* in S. Luigi dei Francesi.[1] The motif of the light behind a grille is derived from Raphael's *Freeing of St. Peter* in the Stanza d'Eliodoro.[2] These elements had been synthesized by Camassei in his now destroyed fresco of *St. Peter Baptizing* formerly in St. Peter's.[3] Mola's treatment of the subject clearly refers back to the Camassei, but differs in showing St. Peter striking the floor rather than baptizing. The gesture of St. Peter is derived from that of the old man on the left of the Raphael tapestry, the *Sacrifice at Lystra*,[4] but in reverse. The major influence on the composition of the fresco is Bolognese; but the old man huddled up on the right is derived from a Cortonesque figure type.[5]

The companion fresco in the Gesù, the *Conversion of St. Paul* (Pl. 72) is on the right-hand wall of the chapel, opposite the *St. Peter Baptizing*. The *Conversion of St. Paul* has been carefully designed for its site. The composition is unified by a spiralling 'S' movement which links together God the Father, the fallen apostle and the soldier in the foreground, who with his raised arm and backwards glance acts as a massive cæsura. The importance of the apostle is stressed by his horse on the right of the fresco. The action is adapted to the viewpoint of the spectator about to enter the chapel, in contrast with the *St. Peter Baptizing* which can only be fully understood after the spectator has entered. The massive scale of the figures in the *Conversion of St. Paul*, and the richness of the landscape come very close to the Quirinal *Joseph Greeting his Brothers*.

The motif of the fallen Paul supported by a soldier is taken from Michelangelo's fresco of the same theme in the Cappella Paolina,[6] but Mola has changed the costumes of the apostle and of his attendant. This change reflects Raphael's tapestry of the *Conversion of St. Paul*[7] and the derivation is further confirmed by Mola's use of the motif of the runaway horse with its attendant.

[1] cf. Borea, 1965, fig. 36, of 1615–17. [2] cf. Gronau, 1936, p. 89.
[3] Waterhouse, 1937, p. 52 identified Vatican 829 as a modello for the fresco. [4] cf. Gronau, 1936, p. 139.
[5] Notably in the Pamphili frescoes, cf. Briganti, 1962, Pl. 264.
[6] cf. Wölfflin, 1952, p. 199. This was first noted by Dr. Shearman. [7] cf. Gronau, 1936, p. 136.

The *St. Peter Baptizing*, the S. Marco *Martyrdom of SS. Abdon and Sennon*, and the engraved design for the Quirinal can be linked together as successors to the Bolognese traditions of Domenichino. The frescoes of *Joseph Greeting his Brothers* and the *Conversion of St. Paul* reveal, in contrast, an artist inspired by the High Renaissance, and deeply indebted to Cortona for the richness of his palette and for his figure style. This change presumably dates to the period during which Mola was working at the Quirinal, 1656–7, and this points to a date around these years for his work in the Gesù. This agrees with Passeri who says of Mola that, 'Dopo quest' opera [Quirinal fresco] e quasi nel medesimo tempo il Mola dipinse nella Chiesa del Gesù.'[1]

The *Rest on the Flight* (Cat. 47; Pl. 85) in the Palazzo Doria can be dated to 1652–6, and a large number of pictures can be linked to form a group datable to the same period. They include the Capitoline *Diana and Endymion* (Cat. 40; Pl. 88) and *Expulsion of Hagar and Ishmael* (Cat. 39; Pl. 92), the Spada *Bacchus* (Cat. 51; Pl. 91), the Busiri-Vici *Death of Archimedes* (Cat. 38; Pl. 90), and the Toronto *Boy with a Dove* (Cat. 63; Pl. 89). Mola turns away from the influence of Rosa back to mainly Bolognese sources, but these are more monumental than before. Some of the pictures may be influenced by Pietro da Cortona, although this is never as marked as in the Quirinal frescoes. Mola's colour is less dark and subdued than in the pictures of the previous group, and the handling of the figures has an assurance that contrasts with the clumsiness of the 1640–5 group.

The only documented picture of this group is the Doria *Rest on the Flight*, and this has a wide bracket of 1652–6. The scale of the figures and the splendour of the rich Venetian colour contrast with Mola's earlier small versions of this theme. He turned here for inspiration to a composition by Albani which he himself had engraved.[2] This dependence upon Albani is especially notable in the preliminary drawings, for in the painting of the Virgin and of the elegant kneeling angel with her complex drapery he comes closer to Cortona.[3] In the Capitoline *Expulsion of Hagar*, Mola approaches the language of gesture and rhetoric of Cortona, but he uses this dramatic story as a vehicle for a display of his Venetian palette. He

[1] Passeri-Hess, 1934, p. 370.
[2] Bartsch XIX, 4, Pl. 81. The almost life-size figures in the Doria picture are considerably larger than those of most comparable Albani's, cf. Bologna, 1962, no. 53.
[3] Notably the *Madonna and Child with Saint Martina* in the Louvre, Briganti, 1962, no. 93, datable *c.* 1643.

used comparable expressions in the *St. Peter Baptizing in Prison* (Pl. 73) in the Gesù, and Abraham and St. Peter are similar in build and type. Sarah, in the background of the Capitoline picture, places a finger to her lips and one of the spectators in the right background of the Gesù makes a similar gesture. The Gesù fresco is datable 1656–7, probably just before the Quirinal frescoes, and the parallels with the *Expulsion of Hagar* suggest a similar date for this canvas.

The Capitoline *Diana and Endymion* (Pl. 88) and the Spada *Bacchus* (Pl. 91) are both variations on scenes in Annibale Carracci's Farnese ceiling.[1] The *Bacchus* is based on the figure in the central panel of the ceiling, although reversed, and the *Endymion* is taken from Annibale's fresco of this scene, but Mola has clearly set his version at night and has exploited a superb range of soft, dark colours. He achieves here a new certainty in relating these large figures to the canvas, notably in the *Endymion* where the figure, which is placed close to the surface of the picture, forms with the tree behind it a diagonal across the picture. Both these paintings are linked with the other pictures of this group by their colour, and Endymion presents many parallels with the Virgin in the Doria *Rest on the Flight*.

Another picture which may date from this period, 1652–6, is the *Portrait of a Boy with a Dove* (Pl. 89) now at Toronto. The handling of the latter is reminiscent of the Doria *Rest on the Flight* (Pl. 85), especially of the Christ Child. The Toronto canvas has a Venetian quality, very similar to the *Barbary Pirate,* and Titian's *Portrait of a Man with a Falcon,* now in a Private Collection in America,[2] may have suggested to Mola the way in which the little boy plays with the dove, his costume being based on Venetian sixteenth-century painting. The Toronto painting probably dates from 1652–6 rather than from 1650 because, in contrast with the *Barbary Pirate,* the boy is arranged in a sweeping diagonal across the canvas.

This figure occurs often in Mola's paintings; as Ishmael, in a different costume; in the Capitoline *Expulsion of Hagar* (Pl. 92); as the scribe of the aged Homer in the Rome *Homer Dictating* (Pl. 138); and finally he strides across the frescoes by Dughet and Mola in the Sala del Principe at Valmontone (Pl. 106).

[1] Illustrated in Martin, 1965, plates 44 and 69. Martin established a date of 1597–1600 for the ceiling on pp. 52–6.

[2] cf. Tietze, 1937, Pl. 77.

One other, more problematic picture can be linked with this group; it is the Busiri-Vici *Death of Archimedes* (Pl. 90) which is now a wreck. The Archimedes is close to the Abraham in the *Expulsion of Hagar* and must have originated from Mola's hand, probably in this period 1652–6. This figure is derived from Cortona, notably from one of the grisaille figures on the frame of the *Aeneas* frescoes in the Palazzo Pamphili.[1]

The next certain point in Mola's life is the payment to him 'al conto' on 21 December 1655 for the painting of *St. Michael Confounding Lucifer* (Cat. 59; Pl. 100) in S. Marco, which was completed by 1659 at the latest. Four other pictures can be linked with the *St. Michael*; the *St. John the Baptist* (Cat. 54; Pl. 101) in S. Anastasia, the *Rebecca and Eliezer* (Cat. 41) and the *Angel Appearing to Hagar and Ishmael* (Cat. 42; Pl. 93) in the Galleria Colonna and the *Philosopher Teaching*(?) (Cat. 22; Pl. 99) in Lugano. Mola introduces a stronger sense of sunlight into these pictures, which otherwise continue the rich warm colours of the previous group and the massive and expressive figures set against token landscapes.

The iconography of the *St. Michael* is unusual. The Saint sweeps down through the sky with only a thunderbolt in his right hand, and does not trample Lucifer underfoot. Raphael had painted what had become the standard treatment of this theme in his *St. Michael*, now in the Louvre,[2] in which the Saint stands on Lucifer, whom he menaces with the sword in his right hand. This type had been revived in the seventeenth century by Guido Reni,[3] in his picture in Santa Maria della Concezione, Rome. The *St. Michael* in SS. Giovanni e Paolo,[4] Venice, attributed to Bonifazio Veronese, may have served as an iconographical precedent for Mola in whose picture the Saint hovers over the figure of Lucifer, although it is otherwise a distant reflection of the Raphael.

The effect of the Saint sweeping down across the canvas in the Mola is paralleled in the late religious painting of Cortona;[5] Mola may have derived the gesture of the Saint from Cortona's earlier *Victory of Alexander over Darius*, once in the Sacchetti collection and now in the Capitoline Galleries.[6]

[1] cf. Briganti, 1962, pp. 250–1 and Pl. 264.

[2] cf. Gronau, 1936, p. 158. The Raphael is documented to 1518.

[3] The picture was in place by 1636, cf. Gnudi & Cavalli, 1955, p. 87, and Pl. 145.

[4] Illustrated in Boccazzi, 1965, fig. 123, with further discussion on p. 208.

[5] Especially to the *Annunciation* in Cortona, for which Briganti, 1962, p. 266 suggests a convincing date of *c*. 1665.

[6] Datable *c*. 1635; cf. Briganti, 1962, p. 212 and Pl. 154.

The warrior holding the spear in the centre of the Cortona is similar, when reversed, to the Saint in the Mola. The sunlight which breaks over the clouds behind the Saint is also reminiscent of Cortona, but the facial type, and to a limited extent the handling, are suggestive of Poussin, notably his *St. Margaret* in Turin.[1]

The firm bright handling of the St. John in the painting in S. Anastasia (Pl. 101) recalls that of the St. Michael, and the facial type is similar, allowing for the difference in their ages. The Baptist is placed on a narrow platform in front of a screen of trees with a landscape in the distance. This formula, as we have already noted, was used by Poussin in the 1630s, and here is reminiscent of the *Inspiration of the Poet* now in the Louvre[2] in the pose of the Baptist; the handling recalls that of Poussin's *Childhood of Bacchus* in the National Gallery, London. This painting continues the type of the young St. John the Baptist found in the picture from the studio of Raphael now in the Accademia, Florence,[3] in which the solitary figure is shown preaching to the spectator.

The Colonna *Hagar and Ishmael* (Pl. 93) and the *Rebecca and Eliezer* were probably painted for Lorenzo Onofrio Colonna, who was appointed Grand Constable of the Kingdom of Naples in 1659. The preliminary drawing for the *Rebecca and Eliezer* (Pl. 96) is close in style to one of the drawings for the Quirinal fresco (Pl. 63), and the light tonality and the firm handling of the flesh in the *Hagar and Ishmael* are close to that of the S. Marco altarpiece, and confirm a date of 1655–9, in spite of the fact that Hagar is similar to the female who looks up at the Saint in the *St. Barnabas* (Pl. 55). The *Head of a Young Woman* (Cat. 48; Pl. 94) in the Palazzo Doria may be a preparatory oil sketch for the *Hagar*. The curls and the band in the hair, which do not appear in the final painting, occur also in the preparatory sketch (Pl. 95). *Rebecca and Eliezer* is the most Cortonesque of all Mola's canvases with the graceful and sinuous Rebecca contrasted with the animated Eliezer.

The *Philosopher Teaching*(?) (Pl. 99) in Lugano is the most problematic picture in this group, since if the attribution to Mola is accepted it would

[1] The early history of this picture remains obscure. Mola may have been able to see it in Rome in 1641, or later, perhaps in 1647, although it is generally agreed that it was painted in the later 1630s, cf. Blunt, 1966, no. 104.

[2] Mola may have been able to see the picture before it went to Mazarin (before 1653), cf. Blunt, 1966, no. 124.

[3] Gronau, 1936, p. 166.

be the only genre picture by him. The identification of the scene is not certain, and for long it has been called simply *Gypsy Scene*. The ragged appearance of the boys and the strangeness of their gestures are mysterious. As is explained in greater detail in the catalogue, the mirror is the attribute of Prudenza, and the books an attribute of Philosophy, so that it is possible to identify the old man as a philosopher teaching the gypsies. The choice of subject, if this identification is accepted, reflects the influence of Poussin, who developed obscure philosophical subjects often connected with stoicism;[1] this had affected also the development of Salvator Rosa,[2] and Pietro Testa,[3] but is confined to this single example in Mola's œuvre.

The cracked column in the background is reminiscent of the *St. Barnabas* (Pl. 55), and is derived from the work of Poussin; the young boys on the left of the canvas are close to the St. Michael. In both there is a similar crisp firm handling that suggests the play of light on the flesh. Because of this the picture should probably be dated with the *St. Michael* to 1655–9. The figure of the philosopher is derived from a type that Poussin had created in the 1630s, as shown in the St. Joseph in the *Flight into Egypt* in Dulwich.[4] The folds of drapery over the arm of the younger beggar reaching out to touch the mirror are also reminiscent of those on the costume of the Christ Child in the Dulwich Poussin.

[1] Notably in the Phocion Landscapes, of 1648; cf. Blunt, 1966, nos. 173–4 with further references.

[2] This influence is mentioned by Haskell, 1963 p. 142. Wallace, 1965, pp. 471 ff. in writing of Rosa's *Genius*, mentions the stoicism that is the basis of his later pictures.

[3] With Testa the influence of Poussin is enduring. The Oppé *Adoration of the Shepherds*, datable to the second half of the 1630s is derived from Poussin's Dresden version of this theme. The figure of the dead Christ, to give but one example for the decade 1640–50, in the *Basilides Prophesying to Titus* in Capodimonte is derived from Poussin's second *Extreme Unction* now in the Sutherland Collection, painted in 1644, cf. Blunt, 1966, no. 116. The ideal of a 'Learned Painter', must have influenced Testa in the production of his 'Trattato', now in Düsseldorf, cf. Marabottini, 1954, pp. 217 ff.

[4] It is possible that this picture, which is datable *c.* 1628, was still in Rome when Mola returned either in 1641 or in 1647, cf. Blunt, 1966, no. 68.

4

The Late Work

THE last years of Mola's life were marred by his dispute with the Pamphili over the decoration of their villa at Valmontone, and by his ill health. His personal difficulties coincided with the emergence of Carlo Maratta's grand manner as the major influence on Roman painting in the period 1660–70.[1] Mola's work in this period followed a personal path, and returned more directly to Venetian sixteenth-century painting.

There are some traces of Mola's work for the Pamphili in their summer residence at Valmontone in 1658 (Cat. 64 and 65; Pls 106, 107, 109). The documents confirm the destruction of his frescoes in the Stanza dell' Aria, and their replacement by Preti,[2] but Mola's scheme is recorded in a number of drawings, which reveal that he had divided the ceiling into five compartments, with a painted framework in imitation of stucco. The scheme reflects the divisions that Cortona had developed in the Barberini ceiling.[3] Preti, however, treated the ceiling as a unified whole over which he scattered his figures.[4]

Preti's scheme reflects Cortona's development as a decorative artist, notably in the Sala di Marte in the Pitti Palace,[5] completed at the end of the period 1640–7.

Two sets of figures at Valmontone can however be connected with Mola. There is an allegorical female figure which has been identified as *America*[6] (Pl. 109), but the attributes with which it is equipped, a large leopard

[1] Maratta's chronology has been clarified by Mezzetti, 1955; typical of his style in the 1660s is the *Immaculate Conception* in Sant' Agostino, Siena, cf. Waterhouse, 1962, fig. 69 and pp. 77–8.

[2] cf. p. 6. [3] cf. Cocke, 1968, pp. 558–65. [4] cf. Waterhouse, 1937, p. 31.

[5] There is no mention of the Sala di Marte in the documents published by Geisenheimer, 1909 pp. 1–32. Since this room is the most developed spatially it is likely to have been the last to be designed. The Sala di Apollo, which was completed by Ferri, has extensive stucco, and may have been designed earlier.

[6] Montalto, 1955, fig. 4.

or lion, a cornucopia with ears of corn and snakes on the ground, are given by Ripa to *Africa*.[1] Further *America* should be represented by a Red Indian, which the figure at Valmontone obviously is not. The mistaken identification must have arisen because there is a payment to Mola for a figure of *America*.[2] There are, however, payments to Mola for work at Valmontone on two rooms besides the destroyed stanza, so it is still possible to attribute the figure of *Africa* to Mola.

Stylistic comparisons fully justify such an attribution. The figure is broad and massive like the soldier in the foreground of the Gesù *Conversion of St. Paul* (Pl. 72), her features being similar to those of the Benjamin in the Quirinal fresco (Pl. 60). There is another rather similar figure on the left of the Stanza della Terra at Valmontone.[3] Comparison of these two figures reveals the difference between them; both have the same looseness of construction, but the *Africa* is the more massive and Venetian. In figure type and costume the *Africa* is derived from the dancer on the right of Titian's *Andrians*, which is now in the Prado, but which Mola may have seen in Rome before its departure for Spain.[4]

The Venetian influence, which is so strong in the *Africa*, can be felt also in the figures placed behind the balustrade in the frescoes by Dughet in the Sala del Principe at Valmontone[5] (Pls. 106, 107), showing that they too must be by Mola. The little boy striding across the room at Valmontone had also appeared in the Capitoline *Expulsion of Hagar and Ishmael* (Pl. 92). The women, who peer down from the balcony (Pl. 106), are very similar in type to the Ariadne of the Brunswick version of *Bacchus and Ariadne* (Pl. 126). Veronese had created the prototype for this fresco decoration, in which figures peer down from the architecture at the spectator; Mola may not have known Veronese's frescoes at Maser,[6] but the delightful figures which he has inserted into Dughet's frescoes reveal the extent of his debt to Venetian sixteenth-century painting.

This Venetian influence is also prominent in the three datable paintings of this late period: the *St. John the Baptist Preaching* (Cat. 35; Pl. 110) in the

[1] Ripa, 1611, pp. 358–60. I am grateful to Dr. Montague for helping me identify this figure.

[2] Montalto, 1955, p. 291, Doc. XII, dated 1658 and L.4.

[3] Montalto, 1955, fig. 12. The attribution to Cortese is unlikely.

[4] In July 1638 cf. Garas, 1967, p. 288.

[5] Montalto, 1955, figs. 14–17. The payments to Dughet for his work at Valmontone are dated 1658.

[6] cf. Pallucchini, 1939, figs. 29 and 31; even if Mola did not have access to Maser his interest in Veronese is revealed in Pl. 108, which is discussed further under Cat. 65.

Louvre of *c.* 1659, the Brera *St. John the Baptist* (Cat. 24; Pl. 127) of *c.* 1662, in which the landscape is by Dughet, and the Incisa version of the *Vision of St. Bruno* (Cat. 45; Pl. 136) which is probably after 1663. The lithe and vigorous figures in this group of paintings are set in a landscape which is dominated by the sun playing on rolling clouds.

Each of the three datable paintings can be linked with other undated paintings to fill out the picture of Mola's development in this decade. The *Jacob and Rachel* (Cat. 11; Pl. 113) and the *Rest on the Flight* (Cat. 12; Pl. 114), both in the Hermitage, and the small *Erminia Guarding her Flock* (Cat. 33; Pl. 123) in the Louvre can be linked with the Louvre *St. John* of *c.* 1659.

In the latter Mola has adopted the idea of St. John pointing out the distant Christ from Domenichino's fresco of this scene in S. Andrea della Valle.[1] Mola's treatment has none of the austere monumentality of the Domenichino, and the landscape background, which in the Domenichino is broken into two separate parts, is unified in the Mola. He has also turned to Venetian sources. Compared with the Ojetti version of this subject (Pl. 51) the Louvre *St. John* is strikingly asymmetrical, balancing a large crowd on the right of the canvas against the solitary figure of Christ on the left; this movement is echoed in the trees of the landscape which sweep down from the right to the distant branches behind Christ. The Louvre picture recalls Veronese's *St. John the Baptist*,[2] which Mola may have been able to see in Rome from about 1650, and in which the crowd is balanced against the isolated figure of Christ. The costume of the girl who sits listening to the Baptist with her back to the spectator recalls female portraits by Palma Vecchio. The soldier on the right of the crowd derives from the soldier in Titian's Pesaro altarpiece,[3] and hence from a Giorgionesque prototype;[4] the two turbaned figures to the immediate right of the Baptist are very similar to figures by Domenico Fetti,[5] although their execution is more liquid and fluent. The handling of the landscape background, notably the palm trees, is also stylistically reminiscent of Fetti, although, apparently, Fetti never introduced palm trees into his paintings.

[1] Borea, 1965, Pl. 82.

[2] In the Borghese collection; probably recorded in Rome in 1648 by Ridolfi, cf. *Mostra di P. Veronese,* Venice, 1939, no. 45.

[3] Tietze, 1937, p. 87. [4] The *Self Portrait* at Brunswick, cf. Berenson, 1957, Vol. II, figs. 677–80.

[5] cf. Waterhouse, 1962, p. 122 and fig. 104.

The figures are placed in the landscape, not poised in front of a backdrop as in the *Rest on the Flight* (Pl. 85) in the Palazzo Doria, and this together with the fluent grouping reflects the relationship of figures to landscape which Poussin had introduced into his paintings from about 1649.[1] The influence of Poussin is even more explicit in the other two pictures of this group.

Mola derived the Rachel in his *Jacob and Rachel* (Pl. 113) from the Rebecca in Poussin's *Rebecca and Eliezer*[2] now in the Louvre, but the source for the composition is the fresco of this subject in the Logge by the school of Raphael.[3] This dependence is even clearer in the preliminary drawing (Pl. 112) where there is a small sketch in pen on the bottom right of the sheet, which, with Jacob's right hand outstretched is even closer to the Raphael fresco. The main lines of Mola's composition, with Rachel and Jacob linked together by the sheep drinking from the well in the centre, are derived from the Raphael, but Rachel sits at the well with her servants behind her, and Jacob, leaning forward with one foot on a small rock, is painted in a more complicated pose than in the Raphael. These changes and the unity which Mola has introduced into the background are used with great compositional skill. Rachel and Jacob form a tightly knit group and Jacob's head has been placed carefully so that whilst breaking over the line of the distant blue hills, it is not isolated as in the Raphael.

The *Jacob and Rachel* recalls the Louvre *St. John the Baptist* in setting a group of figures, seen from a low viewpoint, in a landscape which is Venetian in its richness, and yet indebted to Poussin for its spatial arrangement. The landscape background is Venetian because the motif of the flock of sheep driven to the horizon is derived from Titian,[4] as is the handling of the landscape which exploits the warm brown trees on the right against the rich blue of the background. Mola had first used this device in Pl. 17, but now his handling of the motif is more assured and mature. The similarities between the Louvre *St. John* and the Hermitage *Jacob and Rachel* extend, however, beyond those of the compositional principles. Jacob is identical with the St. John in face, build, and gesture, and the treatment of the

[1] This begins with the *Holy Family with Ten Figures* in Dublin of 1649, cf. Blunt, 1966, no. 59.

[2] Painted in 1648, cf. Blunt, 1966, no. 8.

[3] Gronau, 1936, Pl. 177; finished in 1519. This was also noted by Rowlands, 1964, p. 274.

[4] Notably the *Madonna and Child with St. Catherine and St. John* now in the London National Gallery, but which according to Garas, 1967, p. 343 was no. 44 in the Ludovisi Collection in Rome in 1633.

foliage in both pictures and the execution of the trees are very close.

The group of the Holy Family in the Hermitage *Rest on the Flight* (Pl.114), and the composition, are derived from Poussin. The development to a more convincing placing of figures in space can be felt by comparison with the earlier Doria version of this subject. The prominence of the sphinx in the Hermitage painting is another indication of Mola's debt to Poussin, whose *Holy Family in Egypt* of 1655–7,[1] in the Hermitage, had given a fresh impulse to archeological accuracy. The composition and the figure style are close to those of the *Jacob and Rachel* and the *St. John the Baptist* so that a dating of *c.* 1659 for this picture also seems reasonable. Here too the handling of the blue mountains in the background recalls Titian, as does the device of contrasting the dark, almost colourless, mass of the sphinx on the left of the canvas with the sudden view of the landscape on the right.[2]

Mola painted his *St. John the Baptist* (Pl. 127) with Gaspard Dughet as part of Cardinal Omodei's redecoration of S. Maria della Vittoria, Milan. There is no conclusive documentary evidence for the date of this picture, but, as suggested in the catalogue, it may be dated to *c.* 1662. In the Milan painting Mola repeated the figure and the pose which he had originally worked out in the S. Anastasia painting (Pl. 101), and achieves here a greater elegance, and a smooth almost academic quality in the handling. The three versions of *Bacchus and Ariadne* (Cat. 4, 67, 69; Pls. 125, 126), the lovely Kress *Erminia and Vafrino Tending the Wounded Tancred* (Cat. 60; Pl. 131) and the *St. John the Baptist* (Cat. 19; Pl. 129) in the National Gallery can be grouped with the Milan picture in *c.* 1662. These pictures all share the grace and elegance of the Milan *St. John*, notably in the delicate gesture of Erminia's right hand as she tends the wounded Tancred, and again in the gentle flexing of Ariadne's left hand. Mola has taken great care with the composition of these paintings, especially in the skilful arrangement of Erminia, Vafrino and Tancred parallel to the surface of the canvas. In the pictures of this group Mola is interested in the contrast of light and shade, exemplified in the latest paintings by the *St. Bruno* (Pl. 136) where towards the top of the Saint's outstretched hand there is a sudden passage of shadow.

[1] Blunt, 1966, no. 65.
[2] First used by Titian in the fresco *St. Anthony Healing a New Born Child* in the Scuola del Santo, Padua, of 1511, cf. Tietze, 1937, fig. 8.

The three versions of the *Bacchus and Ariadne* (Pls. 125, 126 and frontis-
piece) are all autograph; the picture is a variation on the left-hand section
of Titian's *Three Ages of Man* of c. 1515 now in the Sutherland Collection.
Before entering Queen Christina's collection the Titian was in the Pamphili
collection[1] where Mola could have had access to it, at least until 1659
when the Valmontone trial began.

Mola had previously turned to a similar period of Titian's output in his
Coldrerio frescoes of 1641 (cf. Pl. 2), but his approach to his sources is
now freer and more inventive than in the frescoes. The lighting of the two
figures has a wider range of contrast than in the Titian and Mola daringly
uses Ariadne's dark green, almost black, robe as a foil to heighten the con-
trast with her white sleeve, which forms the focal centre of the painting.
Mola appears to have derived Ariadne's features from Veronese's *Esther
Before Ahasuerus* on the ceiling of the church of S. Sebastiano in Venice.
He has altered the format and the landscape background of the Titian, and
the pose of the figures is rationalized by setting them on a bank. The poetic,
atmospheric landscape of Titian's Sutherland painting has been replaced
by the dramatic sweep of the trees behind Bacchus, and the rolling clouds.
This formula was to be repeated in the *St. Bruno*, but the main note of
the *Bacchus and Ariadne* is tender and idyllic.

This mood is also the key to the Kress *Tancred and Erminia* (Pl. 131), one
of the most subtle and controlled of all Mola's paintings. It is close to the
Bacchus and Ariadne in the handling of the figures, notably the Bacchus who,
with his arm and legs in sunlight while the rest of his body is in shadow,
resembles Tancred. The trees in both paintings are similar, but a stronger
wind blows through the *Bacchus* creating the drama of the background.

The *Tancred and Erminia* is based on a version of this subject by Poussin.[2]
Mola has chosen to illustrate a different moment so that Erminia is not
cutting off her hair, but is tending the fallen warrior. The sombre romantic
mood of the Poussin is replaced by one of calm tenderness. The elegance
and control of the Kress painting reflect more recent paintings by Poussin
notably the *Rebecca and Eliezer* in the Louvre. Mola had painted an earlier

[1] The early history of the Titian is established in the Queen Christina Exhibition, Stockholm, 1966, no.
1192; it was listed as no. 328 in the 1682 inventory of Olimpia Aldobrandini's Collection, cf. Pergola, 1962,
p. 75.

[2] There are two versions, one in the Hermitage, the other in the Barber Institute, Birmingham. The
Mola is closer to the latter version; both pictures, cf. Blunt, 1966, nos. 206 and 207, date from 1630–5.

version of the theme of *Tancred and Erminia*, now known only from drawings[1] which contrasts with the Kress painting in that the figures are arranged in front of a hill, and the Tancred is not parallel to the canvas but is sharply foreshortened. This earlier composition was derived from Pietro da Cortona.

The *St. John the Baptist* in the National Gallery in London is apparently datable to this period, *c.* 1662; the handling and conception of Christ are strikingly similar to the Bacchus. The landscape is close to that of the *Tancred and Erminia* especially in the foliage of the trees. The composition of the picture is influenced by the Domenichino in S. Andrea della Valle, but the spectators listening to the Baptist, like some of those in the Louvre version of this theme, are derived from Domenico Fetti.

The landscape in the *Bacchus and Ariadne* was more dramatic and full of movement than that of any earlier painting, even though the mood of the whole picture was calm, and this drama is continued and extended in the *Vision of St. Bruno* (Cat. 45; Pl. 136), where the trees and the rolling clouds echo the mood of the Saint's vision. The composition of the *St. Bruno* with the large figure in the foreground, one side of the composition closed by tall trees, and a vista through to a landscape recalls Titian's *St. Peter Martyr*[2] which was in SS. Giovanni e Paolo, Venice, until its destruction in the fire of 1867. In the latter the landscape, for the first time in Italian painting, mirrors the drama,[3] and in the *St. Bruno* Mola has adopted this expressive role for his background. The simplified recession into depth and the intense blue of the hills on the horizon are also Venetian; the handling of the palm trees in the distance recalls the landscapes of Domenico Fetti. The contrast between the white robed monk and the landscape is derived, however, not from any sixteenth-century Venetian source, but from Sacchi's *St. Romualdo*[4] now in the Vatican.

The landscape of the *St. Bruno* is dominated by the play of sunlight on (rolling) clouds. Mola uses natural effects to create the heroic drama of his canvas, and this mood is picked up and intensified in the *St. Jerome* (Cat. 6; Pl. 138) at Buscot, where the landscape is dominated by the sunlight which

[1] cf. Pl. 52 and under Cat. 55. [2] Wölfflin, 1952, fig. 191 and Tietze, 1937, p. 344.
[3] This was first pointed out by Wölfflin, 1952, p. 282.
[4] Illustrated in Waterhouse, 1962, p. 58, fig. 49. Dr. Sutherland Harris tells me that she dates this picture to *c.* 1630.

transforms Mola's model, the version of this theme by Veronese now in the church of St. Peter Martyr, Murano.[1] The gesture of the Saint with his arms thrown out wide is, however, more baroque and expressive than that of the Veronese, and the handling is more powerful with its emphasis on the broken brush strokes which build up the Saint's torso with a vivid play of light and shade.

The *Homer Dictating* (Cat. 43; Pl. 138) in Rome can be linked with the *St. Bruno* as a late painting. Homer sits playing his viol, and dictating to his young scribe. The bright sunlight which floods the canvas, the firmness and crispness of the painting with its rich colours and dramatic contrasts of light and shade, connect it with the *St. Bruno*. But the aged poet's blindness is most movingly revealed, and his figure is based on the Homer in Raphael's fresco of *Parnassus* in the Stanza della Segnatura,[2] and hence ultimately on the Laocoon.[3] The instrument which he plays is derived from the viol that Apollo plays in the Raphael.

[1] Ridolfi, 1648, ed. Von Hadeln, 1914, vol. I, p. 331, notes that this picture is in the Church of the Angeli, near that of St. Peter Martyr.

[2] Pigler, 1956, Vol. II, p. 306, implies this by including the Raphael.

[3] This was noted by Popham & Wilde, 1949, p. 311, no. 796.

Catalogue Raisonné

A.

PAINTINGS AND FRESCOES

1. ARNHEM, Hendriks Collection
St. Jerome. **Pl. 105**
Canvas, 123 × 190 cm.
Provenance Haagen Collection, Arnhem Gelderse Kastelenstichting, by 1955; acquired in 1957.
Drawings Teyler Museum, A.91, pen and ink, 10·6 × 15·3 cm., Pl. 104; Art Museum, Princeton, 48–760, pen, brown ink and wash, 25·2 × 22·4 cm., Pls. 102 and 103.

The picture was first identified as a Mola and related to the drawings by Czobor, 1968. The background is dirty and the surface is badly rubbed, with much paint loss, notably in the Saint's head which is down to the underpaint. The poor condition may have misled Miss Czobor into over-emphasising its 'Riberesque' quality.

The composition derives from Titian, notably the two versions of this subject now in the Louvre and the Brera, illustrated by Tietze, 1937, p. 89 and p. 215. Mola could have seen the Brera picture in Santa Maria Nuova in Venice (see Ridolfi, 1648, ed. Hadeln, 1914, Vol. I, p. 205). Van Dyck had turned to the same source in his *St. Jerome* of *c.* 1616, which is known through versions at Dresden and in the collection of the Earl Spencer (see Agnew, 1968, p. 13, no. 1).

The picture is difficult to date because of the condition of the canvas but *c.* 1652 seems most likely. The spiky outlines in the trees recur in Cat. 9 and the handling of the Saint is closer to that of the St. Barnabas in Cat. 55 than to the complex broken brush strokes of the Buscot *St. Jerome*, Cat. 6.

The drawings confirm this dating. The crawling figures outside the framed St. Jerome in Pl. 104 are close to those of Pl. 79, one of the drawings for Cat. 53. The massive figure on the recto of the Princeton drawing, Pl. 102, recalls the brothers on the right of Pl. 70, one of the drawings for Cat. 49. The relationship of the drawings to the picture is complicated by the existence of another version, Cat. 14, of which no photograph is at present available, but I believe that they relate to the present painting.

The inscription on the verso of Pl. 104 reads: '. . . erano il sig. Gio Batta serva come Agense . . . Cagliari, et il Sig Paolo Giodano Come Agente d. il Montalto Re di Sardegna, da una parte, et il Sig. Mola dall' altro.' Then comes the following list: 'Sig. Simonelli⁻; . . . ; Paese Grande; Sig. Gio Franco⁻; Sig. Ambrogio⁻; . . Venetia⁻; il guasaro⁻; Sig Gio Maria forejn(?): /La Giuditta-/ Il Presepio-; il figlio Prodiglio-/ il Monsignor Omodei./ altri quadri in fermine (?)'.

The inscription shows that the painting must date from before 1652, the year in which Omodei was appointed a Cardinal. The contract drawn up with the King of Sardinia may relate to a passage in Pio's life of G. B. Mola, p. 113, in which he refers to him as having designed the famous Royal Palace in Sardinia, which was rebuilt in 1769 (see Noehles, in Mola–Noehles, 1967, p. 31 for further comment). Simonelli, who was a friend of Mola, was an amateur dealer (see Haskell, 1963, p. 142). The painting of the *Prodigal Son* mentioned in the list may be associated with a drawing in the Louvre, Pl. 77 (see under Cat. 53). If, as seems reasonable, Montalto can be identified as Cardinal Peretti Montalto, then this would further confirm an early dating. Peretti Montalto, who was created a Cardinal in December 1641, was appointed Archibishop of Monreale in 1649 and died in 1655 (see Cardella, 1792, Vol. VII, pp. 11–12).
Bibliography van Regteren Altena, 1966, p. 118; Bean, 1966, p. 41, no. 55; Czobor, 1968, p. 566.

2. BERLIN, Staatliche Museen (no. 383)
Mercury and Argus. **Pl. 31**
Canvas, 61 × 51 cm.
Drawing Düsseldorf FP 848, pen, ink and wash with white heightening on blue paper, 14·5 × 19·5 cm., Pl. 29.

CATALOGUE RAISONNÉ

Provenance Acquired by the Museum from the Royal Collection in 1833 (as Grimaldi).

The history of this canvas before its acquisition by the Museum has not been traced. The painting, which is discoloured by dirt and old varnish, has been cut down. The damage is particularly noticeable at the sides and its original format must have been the same as that of the drawing. The attribution to Mola, which is modern, is justified on p. 18 where a dating to the end of the period 1645–7 is suggested.

Although the Mercury is reversed in the drawing, he is close to the figure in the painting. Both are seated playing their pipes with a cow behind. The drawing represents a further development of the composition of Cat. 30. The style and the technique of the drawing reflect the influence of Annibale Carracci, who had exploited white heightening on tinted paper in a drawing now at Chatsworth, no. 414 (see Martin, 1965, no. 72).
Bibliography Voss, 1924, p. 561; Düsseldorf, Katalog, 1964, no. 116, p. 42.

3. BOWOOD HOUSE, Wiltshire
Rest on the Flight. **Pl. 25**
Panel, 9 × 11 in.
Provenance In the Lansdowne Collection by 1854.

The figures in this lovely small panel are close to those in Cat. 18 whose attribution to Mola can be traced back to 1727. Mola may have taken this picture, which was probably painted in Bologna under the influence of Albani (see p. 17) to Rome, since it appears to have formed the starting point for Bancuore's *Vision of the Magdalene* now in the Pallavicini Collection (see R.49). Bancuore, who probably began his career in the early 1660s, based the putto on the left of his canvas on the Christ Child in the Bowood picture. The comparison underlines the quality of the present picture in contrast with the work of Mola's studio.
Bibliography Waagen, 1854–7, Vol. III, p. 158; *Athenaeum*, 2 February 1884, p. 157; Ambrose, 1897, no. 141.
Exhibitions Royal Academy, *Old Masters*, 1884, no. 259; Agnew, *Lansdowne Collection*, 1955, no. 49.

4. BRUNSWICK, Herzog Anton Ulrich Museum (no. 477)
Bacchus and Ariadne. **Pl. 126**
Canvas, 175 × 87 cm.
Drawing Sold on the London market recently (as

Domenichino) pen and ink, 12·3 × 24·5 cm., Pl. 124.
Provenance In the Collection of Herzog Anton Ulrich by 1710.

The picture was bought by Herzog Anton Ulrich (1633–1714) in whose Salzdahlem Gallery it was catalogued in 1710 as a Titian. Later it was attributed to Annibale Carracci, until it was recognized as a Mola by Roberto Longhi. The attribution rests on that of Cat. 67 which was mentioned as a Mola by Gambarini in 1731. The quality of both these versions and of that of Cat. 69 suggests that all three are autograph, and that they therefore date from before Mola's illness in 1663.

Voss in 1924 noted the connection with the Titian *Three Ages of Man* now in the Sutherland Collection. The freedom of the handling and the changes which Mola introduces on the right of the drawing, which was brought to my attention by Mr. John Gere, reveal that this copy of the Titian was made from memory. Since Mola could have had access to the Titian when it was in the Pamphili Collection at least until the beginning of the Valmontone trial in 1659, it seems likely that the drawing and the painting can be dated after 1659.
Bibliography Flechsig, 1922, p. 63, no. 477; Voss, 1924, p. 561.

5. BURGHLEY HOUSE, Stamford
Vision of St. Bruno.
Canvas, 51⅜ × 37½ in.
Provenance 9th Earl of Exeter (1725–91); thence by descent.

According to the present Marquis of Exeter the picture was in the collection by the time of the 9th Earl. There is some paint loss, notably in the sky and in the Saint's head, where the underpainting is not of the same quality as the rest of the canvas. It seems likely that the picture was laid in by the studio, and then retouched by Mola, see further under Cat. 45.
Bibliography Marchioness of Exeter, 1954, no. 308.

6. BUSCOT PARK, Faringdon
St. Jerome. **Pl. 137**
Canvas, 69 × 59½ in.
Provenance In the Palazzo Barberini by 1824 (as Rosa); Colnaghi 1964; acquired by Lord Faringdon in 1965.

The picture was first attributed to Mola by Arslan who rightly suggested that it was late, link-

44

ing it with the Incisa *St. Bruno*, Cat. 45. Arslan's suggestion that it can be identified with no. 196 in the 1783 Colonna Catalogue is rightly discounted in the Faringdon Collection Catalogue, where it is suggested that it was seen in the Palazzo Barberini (as a Rosa) by Lady Morgan in 1824.

Bibliography Arslan, 1928 p. 74; Buscot Park *Catalogue of the Faringdon Collection*, 1966.

7. COLDRERIO, Cappella Nuova of the Madonna del Carmelo

St. Sebastian; St. Roch; Madonna of the Rosary Enthroned with Members of the Confraternity; God the Father Blessing; Madonna of the Rosary Saving Souls from Purgatory. **Pls. 1–4**

Frescoes, with life-size figures.

Drawings British Museum, 1898–12–16–1, pen and brown ink and wash, 28·4 × 20·8 cm., Pls. 11 and 12; Uffizi, 6813 s, grey chalk, 12·7 × 17·6 cm., Pl. 10; Warsaw, Codice Bonola, no. 99, pen and ink retouched in red chalk and pen, 27·5 × 20·5 cm., Pl. 5; H.M. the Queen, Windsor Castle, no. 6785, pen and ink over red chalk 13·8 × 7·6 cm., Pl. 7; Musée du Louvre, 8423, pen, ink and brown wash, 12·5 × 18·3 cm., Pl. 8; Musée du Louvre, 12345, pen, ink and brown wash, 9 × 6·5 cm., Pl. 9; Matthiesen Collection, London, pen and ink, Pl. 6.

The frescoes were first published by Voss, who established the dating of 1641–2. The documents from folio 60 of the archives of the Church were transcribed by Brentani, 1937–63, Vol. II, p. 142: '1641. Al Signore Pietro Francesco Mola lire trentanove imperiale a bon conto delle pitture che deve fare nel nova capella della Madonna (pagam. 15 Agosto) – lire 39-datte in diverse volte, al sudetto pittore Franchescho Mola, per compito pagamento (registr. tra il 15 Agosto e il 28 Aprile 1642) Lire 125 (17)' and '1641. recevute a nome della sudetta Compagnia delle cassette, bussole et elominosine de particolari fatte a fine per far fine la sudetta Capella di dipengere del sudetto signore Francesco Mola, pittore lire 125'.

Genty noted that the *Madonna of the Rosary Saving Souls from Purgatory* derives from Cerano's *Mass of S. Gregory for the Souls in Purgatory* in S. Vittore in Varese (his fig. 10) of *c.* 1617.

The Uffizi drawing, Pl. 10, may be an early stage in the design of the *God the Father Blessing* (Pl. 1); he rests his arm on the globe, which is shown in the British Museum drawing, Pl. 11, in which Mola has roughly indicated the shape of the field to be frescoed. The recto of this sheet, Pl. 12

shows a view across to the neighbouring village of Brusada, which is inscribed in Mola's own hand 'pianta Vecchia da mela nel me Ciosco', 'Chiesa di S. Antonio genestre', 'Colle di Brusada' and 'timonte di Maria monte'.

The Warsaw drawing, Pl. 5, represents an early stage in the preparation of the *Madonna of the Rosary Enthroned with Members of the Confraternity* (Pl. 4). Mola has not yet derived the motif of the Child raising the Virgin's cloak from Titian's Pesaro altar. In the Windsor drawing, which shows a later stage in the design in which the Christ Child stands in the Virgin's lap, Mola has drawn her left arm so that she both holds the Christ Child and extends a rosary. The two drawings in the Louvre (Pls. 8 and 9) show Mola working towards the Windsor sheet. Mola only evolved the motif of the standing Christ Child on the left of Pl. 8. This drawing has been connected by Rowlands, 1964, p. 274 with Cat. 12, but the figures are close to those in another early drawing, also in the Louvre, Pl. 14, and the weaknesses in the drawing are not compatible with a dating of *c.* 1658.

The drawing in the Matthiesen Collection, in which the Virgin and Child are adored by two angels, is certainly early and could represent a stage in the development of the *Madonna of the Rosary Saving Souls from Purgatory*.

Bibliography Voss, 1910, pp. 177 ff.; Parker, 1927, pl. 27; Brentani, 1937–63, Vol. II, p. 142; Donati, 1942, fig. 491; (Vassalli), 1947; Mrozinska, 1959, p. 99; Blunt and Cooke, 1960, p. 71 no. 549; Genty, 1968, pp. 3–31.

8. COREHOUSE, Lanark, Col. E. A. Cranstoun.

Echo and Narcissus. **Pl. 36**

Canvas, 26 × 19 in.

Provenance Bought before 1850; thence by descent.

The traditional attribution goes back to the mid-nineteenth century, when, according to the present owner, the picture was bought in Italy for Lord Corehouse (died 1850). It is discoloured by a heavy coat of varnish. For the dating of 1648–50 see p. 21.

9. FLORENCE, Ojetti Collection

St. John the Baptist Preaching. **Pl. 51**

Canvas, 29 × 39 in.

Drawings Teyler Museum, Haarlem, K.I. 78 (Verso), pen, ink and wash over red and black chalks, 20·8 × 26·9 cm., Pl. 46; École des Beaux-

Arts, 205, pen, ink and wash, 13 × 19·7 cm., Pl. 47; D. P. Gurney, New York, pen and brown ink, brown and red wash, red chalk, 12 × 27·4 cm., Pl. 48; Musée du Louvre, 8,405, pen, ink and wash, 16 × 17·6 cm., Pl. 49; Musée du Louvre, 8,406, pen and ink over black chalk, 20·7 × 27·6 cm., Pl. 50.

Provenance Baron de Breteuil; Orléans Collection by 1727; sold to Walkuers 1792; bought by Laborde de Méréville in the same year; bought for a group of amateurs by Bryan in 1798; bought by Earl Gower; thence to Stafford House; acquired 1914.

Bonnaffé, 1884, p. 42 identifies M. de Breteuil as the Baron de Breteuil who died *c.* 1713. The picture was catalogued as a Mola by Dubois de Saint-Gelais in 1727. After passing to the Sutherland Collection at Stafford House, where it was seen by Waagen, it was sold in the Sutherland Sale, Christie, 11 July 1913, Lot 70.

The drawings reveal that the painting may have been commissioned by Giovanni Battista Costaguti, since Pl. 46 is on the verso of Pl. 39, one of the preparatory sketches for the Costaguti, *Bacchus and Ariadne*, Cat. 46. G. B. Costaguti owned the *St. John the Baptist* by Mola, Cat. 54, and also the *St. John the Baptist Preaching*, by Rosa now in the Walter Chrysler Collection, see Detroit, 1965, no. 156.

In Pl. 46 the Baptist preaches to a group of spectators on the left of the sheet. In the next stage, Pl. 47, Mola extends the composition and introduces the horseman on the left. He had already begun to move the Baptist to the centre of the sheet and this is taken a step further in Pl. 48, in which the boat in the background and the railing on which the Baptist leans are derived from the Albani now at Lyon, see further p. 23. In the next stage, Pl. 49, Mola shows the seated Baptist, now on the left of the sheet, preaching to the crowd which is derived from that on the left of the previous drawing. The design of this sheet is close to that of the first in the series, Pl. 46. In the foreground of Pl. 49 Mola has lightly sketched the Baptist in the alternative pose which he reworks on the left of the sheet and then uses again in the last drawing of the series, Pl. 50. In the listening crowd he uses motifs from the earlier sheets, notably the figures leaning on a stile and the horsemen, without achieving the monumentality of the painting.

The pastel drawing of a man's head in the Incisa Collection (see Martinelli, 1958, p. 106, Tav. XLIV, fig. 10), which was no. 229 in the 1692 inventory

of the Chigi Collection, was an independent study which Mola used in Cat. 9 for the bearded man sitting listening to the Baptist.

The drawing in the Louvre, Inv. 14,160, see Bean, 1967, p. 68, is not, in my opinion, by Mola. *Engravings* Le Bas in Duc d'Orléans Collection; Delaunay, no. IV in the *Galerie du Palais Royal*, 1786.

Bibliography Dubois de Saint-Gelais, 1727, p. 398; Buchanan, 1824, Vol. I, p. 108; Waagen, 1854–7, Vol. II, p. 65 and p. 492; Voss, 1924, p. 560 and fig. 282; Vitzthum, 1961, p. 517; Bean, 1967, p. 68, no. 99.

10. THE HAGUE, Vitale Bloch Collection
The Prodigal Son. **Pl. 18**
Canvas, 95·2 × 113 cm.

The attribution of this striking canvas to Mola is modern. The lighting reflects the influence of Guercino, as was first noted by D. Mahon in the Catalogue of the 1955 exhibition, but the firm even quality of the handling is very different from the broken brush strokes with which Guercino modelled forms, and recalls Mola's Venetian training.

Mola's conception of this scene is strikingly individual when compared with that of Testa, Bartsch XX, p. 217, no. 7, or of Rosa, now in the Hermitage, see Salerno, 1963, no. 37.

Another later version of this theme, now lost, is shown on the recto of Louvre, 8419, Pl. 77. This version is probably the one referred to on the verso of Teyler, A.91, Pl. 104 (see under Cat. 1).
Exhibitions Wildenstein, London, 1955, no. 56.

11. LENINGRAD, Hermitage (no. 141)
Jacob and Rachel. **Pl. 113**
Canvas, 72 × 98 cm.
Drawing Ashmolean Museum, Oxford, Inv. no. 910, pen, brush and brown ink on blue paper, 26 × 39·9 cm., Pl. 112.
Provenance Pierre Crozat; Louis-François Crozat, Marquis du Châtel; Louis Antoine Crozat, Baron de Thiers; Catherine II.

The picture was first catalogued as Mola in the 1740 Inventory of Pierre Crozat's Collection. Clément de Ris noted that after Pierre Crozat's death in 1740 his paintings were left to his nephew Louis-François Crozat, Marquis du Châtel. They were divided into three lots, one of which passed to Louis-Antoine Crozat, the younger brother of the Marquis du Châtel, in whose collection this

painting was catalogued in 1755. Louis Antoine Crozat's collection was sold to Catherine II of Russia in 1772, and Cat. 11 was included in the 1774 Catalogue of the Hermitage.

Pascoli, 1730–36, Vol. I, p. 126 refers to the *Voyage of Jacob* which had so impressed Louis XIV that he had invited Mola to France. cf. Cat. L.51.

See p. 37 where a dating of *c.* 1659 is proposed. *Engraving* Jeaurat, when in the Pierre Crozat Collection, in Paris, *Recueil*, Vol. II, 1742 no. CXI. *Bibliography* Stuffman, 1968, p. 60, no. 28; Paris, *Catalogue . . . du Baron de Thiers*, 1755, p. 47; 1774, Hermitage Catalogue, ed. Lacroix, 1861-2, XIV, p. 219, no. 1148; Clément de Ris, 1877, p. 206; Voss, 1924, p. 562; Rowlands, 1964, pp. 211 ff.

12. LENINGRAD, Hermitage (no. 1530)
Rest on the Flight into Egypt. **Pl. 114**
Canvas, 73·5 × 98·5 cm.
Drawings Musée du Louvre, 8414, pen and ink over red chalk, 21·8 × 15·6 cm., Pl. 115; Berlin-Dahlem, K.d.Z., 163336, pen, ink and wash, 13 × 19·6 cm., Pl. 116; British Museum, 1946–713–720 (Verso), red chalk, pen and ink, Pl. 117; Pierre Rosenberg, Paris, pen and ink over red chalk, Pls. 119 and 120; Museo Nazionale, Capodimonte, Naples red chalk, Pl. 118.
Provenance Pierre Crozat; Louis-François Crozat, Marquis du Châtel; Louis Antoine Crozat, Baron de Thiers; Catherine II.

The picture has the same history as its companion catalogued above. The dating of *c.* 1659, suggested on p. 37, is confirmed by the broad firm style of the drawings which is close to that of the drawings for the Stanza dell' Aria at Valmontone, designed in 1658, cf. Cocke, 1968, pp. 558–565, especially Fig. 32.

The Louvre drawing, Pl. 115, probably represents the earliest stage in the design. As in the preparation of Cat. 35 Mola began by referring back to the design of an earlier version, in this case the Doria *Rest on the Flight*, Cat. 47. The introduction of the Sphinx and the pyramid links the drawing with the Hermitage picture. In the Berlin drawing, Pl. 116, Mola abandons the motif of the serving angels and brings the Holy Family into the foreground. This sheet is stuck down, but a drawing of two heads on the verso may connect with Cat. 10. The sheet in the Rosenberg Collection, Pl. 119, represents a further elaboration of the design of Pl. 116 with the introduction of the donkey on the right, and of flying putti above the

Virgin and Child. There is another study of the donkey on the verso of Düsseldorf, FP.950, on whose recto Mola had sketched the *Dream of St. Joseph*, which fits with the other sketches in Pl. 117, which is the next stage in the preparation of the design. In this small sketch Mola switches the Virgin and Child to the left, and indicates the dark mass against which they will be set in the painting. In the free chalk sketches in Pl. 118 Mola evolves the pose of St. Joseph, which, in the upper sketch, corresponds loosely with the painting.
Engraving Jeaurat, when in the Pierre Crozat Collection, in Paris, *Recueil*, Vol. II, 1742 no. CXII. *Bibliography* Stuffman, 1968, p. 60, no. 29; Paris, *Catalogue . . . du Baron de Thiers*, 1755, p. 47; 1774, Hermitage Catalogue, ed. Lacroix, 1861, XIII, p. 256, no. 859; Ris, 1877, p. 206; Voss, 1924, p. 562; Rowlands, 1964, p. 274; Schaar and Sutherland Harris, 1967, p. 55.

13. LENINGRAD, Hermitage
The Prodigal Son
Canvas.

The picture, in the reserve collection of the Hermitage, is a reduced version of Cat. 10. Although in need of cleaning it is most probably autograph.

14. LENINGRAD, Hermitage
St. Jerome
Canvas.

This is another, probably autograph, variant on Cat. 1. The handling is firmer than that of the Arnhem painting, notably in the crisp forms of the Saint's robes, and the blue mountains in the background. The picture may be later than the Arnhem version.

No photograph is at present available, but it may relate to Pl. 104 (see under Cat. 1). Another drawing in the Uffizi, 6818s, relates to this design.

15. LONDON, Mahon Collection
Landscape with St. Bruno in Ecstasy. **Pl. 98**
Canvas, 29 × 38½ in.
Provenance Worsley Collection, Hovingham Hall; acquired 1957.

The picture appeared in the MS. Catalogue of Thomas Worsley (1710–78) as *Fran. Mola, S. Bruno in a landscape* (see London, 1960, p. 147).

The Saint is related in pose and gesture to the figure in an engraving after Mola by A. E. Rousselet

(*fl.* 1726–57), which records a now lost version of this subject, see Cat. L.67. The size of the Louvre drawing for this latter version, Inv. no. 8433, suggests that it was considerably larger than the Mahon picture. The similarity of the Saint's pose in both designs further substantiates the attribution of this picture to Mola.

The dating of Cat. 15 cannot be established with precision. The freedom and atmospheric handling of the landscape point to the later Roman period, and the motif of the loosely painted warm trees on the left contrasted with the horizon is very close to the landscape on the right of Cat. 11. It appears to be datable *c.* 1656–60.

Exhibitions Royal Academy, London, 1960, no. 407.

16. LONDON, Mahon Collection
Mercury and Argus. **Pl. 19**
Canvas, 31·2 × 40·8 cm.
Provenance K. R. Mackenzie; acquired after the war (information from Mr. Mahon).

The figures are close to those in the Berlin picture, Cat. 2. Mola has here illustrated the scene described by Philostratus the elder in his *Imagines,* Loeb ed., London 1931 p. 99. The dark handling of the landscape is close to that of the pictures datable to the period 1640–5, see p. 14, but the figures reflect the beginning of Mola's interest in Annibale Carracci.
Bibliography Briganti, 1953, p. 18, no. 39.

17. LONDON, Mahon Collection
Landscape with Two Carthusian Monks. **Pl. 23**
Canvas, 51·5 × 68 cm.
Provenance Ingram, Temple Newsam House, Leeds, by 1808; thence by descent to the Earls of Halifax; acquired 1947.

The picture, which was seen by Waagen at Temple Newsam, was first attributed to Mola in the 1808 Inventory of the Temple Newsam pictures. The dark romantic handling of the landscape fits with Mola's early pictures, see p. 15. The pose of the left-hand monk is close to that of the Saint in the Incisa *St. Bruno,* Cat. 45. The handling is so different that this does not justify a late dating for this canvas.
Bibliography MS. Inventory of Pictures at Temple Newsam, 1808, no. 26 (quoted in Detroit, 1965, p. 38); Waagen, 1854–7, Vol. III, p. 332; Briganti, 1953, p. 12 and p. 18; Czobor, 1968, p. 570.
Exhibitions Detroit, 1965, p. 38, no. 19.

18. LONDON, National Gallery
Rest on the Flight. **Pl. 24**
Canvas, 30 × 45 cm.
Provenance Orléans Collection; sold to Walkuers in 1792; bought by Laborde de Méréville in the same year; bought for a group of amateurs by Bryan in 1798; bought by the Hon. C. Long; Lord Farnborough Bequest, 1838.

The attribution to Mola goes back to 1727 when the picture was catalogued in the Orléans Collection by Dubois de Saint-Gelais. It was bought at the Orléans sale in 1798 by the Hon. C. Long who was created Lord Farnborough in 1826 (*The Complete Peerage,* 1926, Vol. V, p. 257). It needs to be cleaned. See p. 17.
Engraving J. Mathieu, no. 2 in Couché . . . , *Galerie du Palais-Royal,* 1786.
Bibliography Dubois de Saint-Gelais, 1727, p. 397; Buchanan, 1824, Vol. I, p. 108; Waagen, 1854–57, Vol. II, p. 492; London, *National Gallery Catalogue,* 1929, p. 241, no. 160; Voss, 1957, p. 54 and fig. 42.

19. LONDON, National Gallery
St. John the Baptist Preaching. **Pl. 129**
Canvas, 30 × 45 cm.
Drawing Nationalmuseum Stockholm, N.M. 572/1863. Red chalk, point of the brush and red colour, 24·2 × 27·7, Pl. 128.
Provenance Holwell Carr Bequest, 1831.

The canvas needs to be cleaned and this has evidently slightly falsified the spatial relationship of the spectators to the Baptist. According to the 1929 Catalogue the picture originally came from the Robit Collection, but it is listed in neither of the sale Catalogues of the Robit Collection, and Mr. Michael Levey has kindly informed me that in the MS. inventory of the Holwell Carr Collection (deposited at the National Gallery), which was taken from his Will in 1828, it is listed as 'Robit(?) Collection, Paris'. As early as 1828 there was confusion about the previous history of this picture.

Pl. 128 is a study from the model, who holds a cane rod to support his right arm, to which Mola at a later stage added the landscape and the figure in the foreground. Although reversed the Baptist is close to the painting, where the figure is idealized, especially in the profile outline of the face. The head in the foreground is similar to that of the female spectator on the left of the painting.
Bibliography London, *National Gallery Catalogue,* 1929, p. 241, no. 69; Stockholm, 1965, no. 111.

20. LONDON, Pope–Hennessy Collection
The Baptism of Christ. **Pl. 28**
Canvas, 26 × 34½ in.
Provenance Marquis of Stafford, by descent to the Earls of Ellesmere; purchased 1946.

The picture, which was attributed to G. B. Mola by Ottley, was no. 118 in the Ellesmere Sale, Christie, 18 October 1946. It is clearly by P. F. Mola and can be dated to the beginning of the period when he worked with Albani, see p. 16. For G. B. Mola see Cat. R.48.

No drawings can be related to Cat. 20. N.M. 555/1863 in the Nationalmuseum, Stockholm is a later variant of this design.
Bibliography Ottley, 1818, Vol. 1, p. 21, no. 30.

21. LONDON, Previously Hodgkin Collection
Study of Sheep and a Man's Head. **Pl. 20**
Canvas, 13 × 21 in.
Provenance Sir Abraham Hume Collection; Brownlow Collection.

A nineteenth-century label on the back of the canvas, which had an attribution to Mola, associated it with the Hume Collection. It was Lot no. 48 in the Brownlow Sale, Christie, 4 May 1923, as from the collection of Sir Abraham Hume (1749–1838). It was sold from the Hodgkin Collection at Sotheby 11 March 1964, Lot 72.

The primed red ground can be seen on the right of the man's head, where Mola has indicated a sheep. The head was probably used as a study for the Argus in Cat. 30, and can therefore be dated *c.* 1645.

This type of sketch is unusual in Italy, but was common in Rubens' studio. Comparison with Van Dyck's oil sketch of *Four Negro Heads*, now in the collection of the Earl of Derby, exhibited Agnew, 1968, no. 10, suggests that Mola may have derived this practice from the work of Van Dyck.

22. LUGANO, Museo Civico
Philosopher Teaching(?). **Pl. 99**
Canvas, 120 × 99 cm.
Provenance Goltarra Lussana Collection, Bergamo; Caccia Bequest, 1952.

Longhi suggested the attribution to Mola when this picture was exhibited in Florence, 1922. This is convincing , but not for his reasons. It is not, as Longhi suggested, by the same hand as Cat. R. 56, but although it is unique in Mola's oeuvre in being a genre scene, it is close to Cat. 59, see further p. 32. The recession of the table and of the mirror is unconvincing.

Following Wallace's 1965 discussion of Rosa's etching of *Genius* it seems possible to identify the subject as a *Philosopher Teaching*. The mirror is the attribute of Prudenza. Ripa, 1611, p. 441, notes 'Lo specchiarsi significa la cognitione di se medesimo, non potendo alcuno regolare le sue attioni, se i proprii difetti non conosce'. The books, placed behind the mirror, are 'an attribute of Philosophy', see Ripa, 1611, p. 177. In the Louvre drawing for his *Genius* Rosa characterized the philosopher as pointing to a mirror, see Wallace, 1965, p. 477 and fig. 3. Mola has included all these elements in this picture, but has replaced Rosa's classical robes with genre costumes.
Bibliography Longhi, 1961, p. 506; Moir, 1967, Vol. I, p. 149, Vol. II, fig. 178.
Exhibitions Florence, 1922, no. 908.

23. MADRID, Prado (no. 537)
St. John the Baptist
Canvas, 13 × 17 cm.
Provenance C. Maratta Collection; bought for the Spanish Royal Collection in 1723.

Pérez Sánchez re-established the attribution to Mola, noting that the picture was listed in the 1712 inventory of the Maratta Collection, see Galli, p. 208, as 'S. Giovannino putto del Mola. Otangolo di dentro'. It is next mentioned as 'S. Giovannino con la Pecorella del Mola' in the 1723 list of paintings in the collection of Faustina Maratta, the artist's daughter, which was drawn up by Andrea Proccaccini in 1723 when 124 of the paintings were sold to the Spanish Royal Collection (see Battisti).

The poor condition of the painting does not make a precise dating possible, but presumably it dates from after Mola's return to Rome in 1647.
Bibliography Maratta Inventory, 28 April 1712, published in Galli, 1927, p. 208; Madrid, *Catalogo ... del ... Prado*, 1920, no. 537 (anonymous Bolognese); Battisti, 1960, pp. 77 ff.; Pérez Sánchez, 1965, p. 309.

24. MILAN, Brera
St. John the Baptist in the Wilderness. **Pl. 127**
Canvas, 335 × 228 cm.
The landscape is by Gaspard Dughet.
Provenance Commissioned by Cardinal Omodei for S. Maria della Vittoria, Milan.

The picture was recorded by Torre as by Dughet and Mola (I am grateful to Professor Waterhouse for bringing this reference to my attention). Modern

critics have always agreed that Mola painted the Baptist and his sheep, and that the landscape is by Dughet.

According to Torre the final plaque in S. Maria della Vittoria recording the redecoration of the chapel is dated 1669, and the earliest 1665. The picture may have been commissioned earlier. Salvator Rosa, who also provided pictures for this chapel (see Salerno, 1963, p. 125 and pl. 49) was in contact with Omodei by 1661 (see Limentani, 1953–4, p. 55). These negotiations were for a different commission, but it seems likely that Omodei commissioned the paintings for S. Maria della Vittoria at the same time.

In 1662 Dughet gave evidence on Mola's behalf in the Valmontone trial and their collaboration on this picture could well date to that year. Mola had painted the figures in Dughet's landscape at Valmontone, see Cat. 65. For a further example of their collaboration see L.35.

Bibliography Torre, 1674, p. 103; Voss, 1924, p. 561; Sutton, 1962, p. 22; Waterhouse, 1962, p. 65 and fig. 57.

25. MILAN, Private Collection
Rest on the Flight. **Pl. 26**
Canvas, 14½ × 19 in.

26. MILAN, Private Collection
Erminia Guarding her Flock. **Pl. 27**
Canvas, 14½ × 19 in.
Provenance Perhaps with Cat. 24 in the Jullienne Sale, Paris, 1767, Lot 12.

These two pictures were Lots 16 and 17 at Sotheby, 13 November 1963. The choice of subjects and the dimensions correspond with those of the pictures in the Jullienne Sale, which are given by Rémy as 13 pouces 3 lignes by 18 pouces 3 lignes. That they were not painted as pendants is shown by the fact that the compositions do not balance, and by the incongruity of the subject matter.

Rémy suggested the identification of Cat. 26 as *Angelica writing Medoro's Name on a Tree*, based on Ariosto's *Orlando Furioso*, XIX, 36. Lee, 1967, p. 136 noted that the subject is drawn from Tasso's *La Gerusalemme Liberata*, Canto, VII, see also Cat. 33.

Olsen, 1961, p. 79 published a version of Cat. 26 in a private collection in Copenhagen, in which the sheep on the left of the canvas are omitted and the trees on the right have been changed slightly.

It is, to judge from a photograph, an old copy. There is a studio version at Christ Church; Byam Shaw, 1967, p. 110 no. 204.
Bibliography Rémy, 1767, p. 8.

27. MUNICH, Schleissheim (Inv. no. 924)
Rape of Europa. **Pl. 130**
Canvas, 76 × 94 cm.
Provenance Perhaps no. 21 in the J. B. de Troy Sale, Paris, 1764; gallery of the Elector of Bavaria, deposited at Schleissheim in 1913.

For the early history of the picture see L.64. From the middle of the eighteenth century this picture was attributed to Domenichino. The 1914 catalogue of the Museum suggested that it was by a follower of Albani, identified by Voss as Mola. With the exception of Posse's attempt to give this picture to Sacchi this latter attribution has met with general agreement. There is a detailed refutation of Posse's opinion in Dr. Ann Sutherland's unpublished Ph.D. thesis on Sacchi at London University.

Schaar noted that the composition derives from Albani's *Rape of Europa* now in the Pitti, which was exhibited at Bologna, 1962, no. 50. The painting has usually been dated *c.* 1640, but, in my opinion, it fits better with the paintings of Mola's later Roman period of *c.* 1658–63. The landscape is more complex than those of the group that I have dated 1645–7, the bright light colours and the tree on the left of the canvas are both close to the *Bacchus and Ariadne*, Cat. 4. The plump expressive figures of Europa's companions recall the Ariadne in that picture.

These figures derive from the Europa in Veronese's *Rape of Europa*, now in the Palazzo Ducale, Venice which in the middle of the seventeenth century was still in the Contarini Collection in Venice, see Ridolfi, 1648, ed. Von Hadeln, 1914, Vol. I, p. 337. As with Cat. 4 Mola's return to Venetian sources in this painting appears to be datable to the end of his career.
Bibliography Schleissheim, *Katalog der Gemäldegalerie*, 1914, p. 2; Voss, 1924, p. 262; Posse, 1925, p. 17 and fig. VI; Zeri, 1959, p. 182; Schaar, 1961, p. 187.
Exhibitions Bologna, 1962, p. 340, no. 140.

28. NEW YORK, Suida-Manning Collection
Hagar and Ishmael. **Pl. 32**
Canvas, 17½ × 21¼ in.
Drawing J. McCrindle, pen and brown ink, 9·6 × 9·6 cm. Pl. 30.

Provenance Probably from the Northbrook Collection.

Richter and Weale, 1899, p. 145, list a *Hagar and Ishmael* in the Northbrook Collection whose dimensions, $17\frac{1}{2} \times 21$ in., are the same as those of the Suida picture. The Northbrook picture entered the collection in 1856 from the Earl of Carysfort's collection, and that of Samuel Rogers. This painting, which is no longer in the collection, cannot be traced in either of the Northbrook Sales, Christie, 12 December 1919 and 3 May 1940.

Cat. 28 has been rubbed slightly, but the quality of the handling in the landscape, where Mola balances the brown trees against the blue sky, reveals that it is autograph. The drawing, Pl. 30, looks like a half-way stage between this version and the prime one, Cat. 32, notably in Ishmael's pose. There is a further version at Christ Church, Cat. 31A which, in spite of its poor condition, appears to be autograph. See p. 18.

29. NEVERS, Musée des Beaux-Arts
Rest on the Flight. **Pl. 121**
Canvas, 42 × 33 cm.
Drawing Hessisches Landesmuseum, Darmstadt, AE 1802, pen, ink and wash with white heightening, 22·1 × 15·8 cm. Pl. 122.
Provenance Prince de Carignan; acquired for Louis XV before 1752; deposited by the Musée du Louvre.

The picture was acquired for the Royal Collection by Noël Araignon, together with Cat. 35, from the Carignan Collection. The recent cleaning has revealed the rich Venetian handling of the landscape, but the canvas has suffered considerable damage which has weakened the figures.

In the drawing, Pl. 122, Mola turned to the Hermitage version, Cat. 12, from which he derived the central group of the Virgin and Child. He has already changed the pose of the Christ Child and of the Virgin so that, although reversed, they begin to approximate to the present painting. The composition with the introduction of the architecture behind the figures derives from Poussin, see Blunt, 1966, no. 50. A group of drawings in Stockholm traditionally attributed to Poussin (see Friedländer and Blunt 1939, nos. B.10–12) can, in my opinion, be attributed to Mola and dated *c.* 1647–50. In Cat. 29 Mola develops the composition of these drawings.

The connection with the Hermitage version, Cat. 12 suggests a dating of *c.* 1659 for the present painting.

Bibliography Lépicié, 1752–4, p. 312; Villot, 1873, no. 269; Engerand, 1901, p. 533.

30. OBERLIN COLLEGE, Allen Memorial Art Museum (Ohio)
Mercury and Argus. **Pl. 21**
Canvas, $23\frac{1}{8} \times 39\frac{1}{8}$ in.
Provenance A. Sabatello, Rome; Samuel H. Kress Collection by 1950.

The picture is related to the signed etching of the subject by Mola, Pl. 22, in the romantic chiaroscuro and in the figure types. The composition of the etching, when reversed, is close enough to that of Cat. 30 to suggest that Mola may have used the drawing for the etching as the starting point for the painting.

There is a comparable design of this theme by Cantarini, Bartsch XIX, p. 142, no. 31. Neither the chronology of Mola nor that of Cantarini enables us to establish the nature of this relationship. It is possible that both versions derive from Annibale Carracci's *Bacchus and Silenus* now in the National Gallery, London. See p. 15 where this connexion is used as the basis for a date of *c.* 1645.

For a related oil sketch see Cat. 21. Another, later, version is at Berlin, Cat. 2.
Engraving Mola, Bartsch XIX, 6, Pl. 20.
Bibliography Stechow, 1962, pp. 38–40; Mahon, 1965, p. 386, note 22; Oberlin, 1967, p. 110.
Exhibitions London, Kenwood, 1962, no. 27; Detroit, 1965, no. 18.

31. OXFORD, Ashmolean Museum (A.872)
Echo and Narcissus. **Pl. 17**
Canvas, 50 × 39 cm.
Drawings Capodimonte, Naples, 733, grey chalk, 18·3 × 26·5 cm., Pl. 15; formerly P. M. Turner Collection, pen, ink and wash. Pl. 16.
Provenance Acquired 1954.

Two further versions of this subject are listed in the early sources, L.56, which was smaller than Cat. 31, and L.63. Both these now lost pictures were paired with an *Erminia with the Shepherds*. One of these versions must have inspired the pair of pictures at Hanover, which can be attributed to Giovane, see under Cat. R.1 and L.56 and 57.

The Naples drawing, Pl. 15, although connected with the Ashmolean painting, is closer in pose to Hanover no. 22, except for the inclusion of the dog on the left of the sheet. Since the style of the drawing is close to that of Pl. 10 and hence

early, it seems likely that it may be connected with one of the now lost versions, which Mola must have painted at the same time as Cat. 31. The pose of the Narcissus in Pl. 16 is close to Cat. 31 and is an early stage in the preparation of this design.

As noted on p. 14 the handling of Cat. 31 is close to that of Cat. 66. It is an autograph variant of the now lost version of this subject which is recorded in the Hanover picture, and to which Pl. 15 can be related.

The canvas may have been cut down slightly at the sides.

Bibliography Ashmolean Museum Annual Report, 1954, p. 53; Oxford, *Catalogue of the Ashmolean Museum*, 1961, p. 100.

31A. OXFORD, Christ Church
Hagar and Ishmael.
Canvas, 4·75 × 64 cm.
Provenance Guise Bequest, 1765.
See under Cat. 28.
Bibliography Byam Shaw, 1967, p. 87, no. 142.

32. PARIS, Louvre
Hagar and Ishmael. **Pl. 33**
Copper, 27 × 33 cm.
Provenance M. de Nancré; Duc d'Orléans by 1727; sold to Walkuers in 1792; bought by Laborde de Méréville in the same year; did not come to England but by 1807 was in the Galerie du Musée Napoléon.

The attribution to Mola goes back to Dubois de Saint-Gelais in 1727. Stryienski, 1913, p. 13 identified M. de Nancré as the Capitaine des Suisses at the Palais Royal, who gave the Duc d'Orléans a group of paintings.

The picture is in a poor state of preservation with much loss of paint. Another version, apparently autograph, from Sir Abraham Hume's Collection was in the Brownlow Sale, Christie, 7 May 1923, Lot 139. M. Pierre Rosenberg kindly brought to my attention an eighteenth-century copy at Karlsruhe, published Karlsruhe, 1966, no. 1935.

Engravings J. B. Racine, no. II in Couché..., *Galerie du Palais-Royal*, 1786; no. 40 in Filhol, *Galerie du Musée Napoléon*, Vol. IX, 1807.
Bibliography Dubois de Saint-Gelais, 1727, p. 167; Buchanan, 1824, Vol. I, p. 108; Villot, 1873, no. 268; Stryienski, 1913, p. 13.

33. PARIS, Louvre
Erminia Guarding her Flock. **Pl. 123**
Canvas, 27 × 35 cm.
Provenance Bought for Louis XIV in 1685 from Poncet.

The picture was attributed to Mola when it was bought in 1685. Pl. 123 shows the painting with the additions on all sides which were first noted by Bailly in his inventory of the Royal Collection, drawn up in 1709–10. The painting has been on deposit at the Elysée Palace since 1875.

For the subject, which is derived from Tasso *La Gerusalemme Liberata*, Canto VII, see Lee, 1967. There is a related, but earlier, picture in Milan, see Cat. 26.

For a further discussion of the dating of *c.* 1659, see p. 37.

Engraving Filhol, *Galerie du Musée Napoléon*, Vol. IX, 1807, no. 586.
Bibliography Bailly, 1709 published by Engerand, 1899, p. 214, described as Angelica writing Medoro's name on a tree trunk; Lépicié, 1752-4, p. 314, no. IV; Villot, 1873, p. 169, no. 273; Guiffrey, 1881-1901, Vol. II, Cols. 596, 668; Lee, 1967, pp. 136–41.

34. PARIS, Louvre
Vision of St. Bruno
Canvas, 94 × 74 cm.
Provenance Bought by Louis XIV in 1685 from the painter Hérault.

This smaller version of Cat. 45, which was bought for the Royal Collection in 1685 as a Mola, was first placed in the Louvre in 1785. Together with Cat. 5 it is one of the few replicas of this design which appears to be mainly autograph.

This was one of the paintings copied by Turner in his *Louvre* sketchbook of 1811 (see Ziff).
Engraving Filhol, *Galerie du Musée Napoléon*, Vol. IX, 1807, no. 219.
Bibliography Bailly, 1709 published in Engerand, 1899, p. 214; Lépicié, 1752–4, p. 314 No. III; Turner, 1811, in Ziff, 1963, p. 141 and p. 129, note 19; Villot, 1873, p. 168, no. 272; Guiffrey, 1881–1901, Vol. II, Cols. 596 and 668; Voss, 1924, p. 285 and p. 561; Arslan, 1928, p. 73.
Exhibitions Paris, 1960.

35. PARIS, Louvre
St. John the Baptist Preaching. **Pl. 110**
Canvas, 162 × 123 cm.
Drawing Staatliche Museen, Munich, Inv. no. 2917, grey chalk 12·3 × 17·2 cm., Pl. 111.

Provenance Prince de Carignan; Louis XV.

The picture was first mentioned in the Prince de Carignan Collection as a Mola by Mariette in 1729. Subsequently it was bought for Louis XV, in whose collection it was catalogued by Lépicié in 1752.

The earlier history of the canvas is not certain, but on the basis of the engraving it seems possible to associate it with Giacomo Nini, although it was not mentioned by Silos, 1673, pp. 65–77, in his account of Nini's collection. Nini, who had returned from Germany with Fabio Chigi in 1652 (see Ciacconius, 1677, Vol. IV, p. 760), was created a cardinal on 14 January 1664 (see Pastor, 1940, Vol. 31, pp. 132 ff.).

Early in 1659 Mola issued a plea to Nini asking him to intervene in his dispute with Prince Camillo Pamphili. Mola may have coupled with this plea the dedication of the present picture to Nini since Passeri, ed. Hess, 1934, p. 371, writes of the Valmontone trial that 'Li Notari, Procuratori, Giudici tutti mozzorecchia gli carpivano dalle mani [Mola's] molti quadretti con vanità di speranze...'

This picture must have been in Rome in the 1690s since a drawing in the Städelsches Kunstinstitut, Frankfurt. Inv. no. 4462 (as Veronese), Pl. 146 is a copy after Cat. 35 which can be related to Maratta's drawing of the *Baptism of Christ,* in the Earl of Leicester's Collection, Holkham (see Dowley, 1965, fig. 9), for the altar in S. Maria degli Angeli of c. 1696.

In the preliminary drawing, Pl. 111, Mola has already worked out the grouping of the spectators on the right of the sheet. The Baptist, balanced against this group on the left of the sheet, recalls the Ojetti version, Cat. 9, which Mola appears to have used as the starting point for the design of the Louvre picture. Mola followed a similar working procedure when preparing Cat. 12.

Two further versions of this design are known. Coelemans engraved a version in the Cabinet Boyer d'Aguilles in 1707, which according to Mariette was of the same high quality as the Carignan picture. Another reduced version was stolen in 1950 from the Stuttgart Gallery (formerly no. 299). This picture, which came to the Museum with the Barbini Breganze bequest in 1852, omits the stream in the left foreground of Cat. 35 and the two small figures in the background behind St. John's outstretched arm. In spite of these changes, which do not occur in the Coelemans version, it is, to judge from a photograph, not autograph.

Engraving Pietro Santi Bartoli, with a dedication by Mola to 'Monsignor Giacomo Nini Maestro di Camera di Nostro Alessandro VII di Santità'.
Bibliography Lépicié, 1752–4, p. 313, no. II; Mariette, 1851–60, Vol. IV, p. 4; Villot, 1873, p. 168; Engerand, 1901, pp. 533–4; Voss, 1924, p. 283 and p. 560.

36. PARIS, Louvre
Barbary Pirate. **Pl. 45**
Canvas, 173 × 124 cm.
Provenance Acquired 1950.

Signed 'Pietro Fran Mola' and dated '1650' on the bottom of the bow.

The picture was acquired by the Louvre from an anonymous French owner, in whose family it had been since the middle of the eighteenth century.

It has been suggested that the canvas has been cut at the bottom, but the figure's movement across the canvas, and his arrangement against the sea together with the care with which the viewpoint has been chosen make this unlikely.

In addition to the stylistic parallels mentioned on p. 23, the picture can be connected with the 'testacce' that Rosa was sending to his friends by 1650, see, for instance, the Mahon picture, which is slightly later in date (see Salerno, 1963, p. 94 and fig. 35).
Bibliography Sterling, 1950, pp. 33 ff.; Waterhouse, 1962, p. 66.
Exhibitions Rome, 1956, no. 211.

37. ROME, Accademia di San Luca
Woman Spinning. **Pl. 142**
Canvas, 72 × 61 cm.
Provenance Quadreria del Monte di Pietà; transferred in 1857.

The provenance of this picture, whose attribution to Mola is recent, was established by Faldi. The costume (as Mr. Andrew Martindale has observed) is derived from Venetian sixteenth-century painting, see for example Palma Vecchio's *Portrait of a Woman* now in Vienna, which Mola could have seen in the Della Nave Collection in Venice before 1638 (see the Museum Catalogue, 1965, no. 604). It is not clear whether Mola intended this picture as a portrait, or as a genre study.

The crisp handling of the paint is close to that of Cat. 43, but it is unfinished, most notably in the left arm. This was probably because of Mola's death in 1666 or perhaps because of the illness

which interrupted his work earlier in the year. In spite of certain weaknesses the underpainting is of higher quality than that in Cat. 5.

Bibliography Arslan, 1928, p. 70, fig. 14; Faldi, 1956, p. 5.

38. ROME, Busiri–Vici Collection
Death of Archimedes. **Pl. 90**
Canvas, 128 × 97 cm.
Provenance Queen Christina by 1689; Don Livio Odescalchi; acquired 1721 by the Duc d'Orléans; sold 1792 to Walkuers, bought in the same year by Laborde de Méréville; bought by Bryan for a group of amateurs in 1798; acquired by the Duke of Sutherland; no longer at Stafford House in 1913 (see Stryienski); Christie, 16 December 1949, Lot 105.

The picture passed from the Orléans Collection to Stafford House, where it was seen by Waagen, but was noted as missing by Stryienski. It is identical with the engraving issued when the painting was in the Palais Royal. The picture is a wreck – already the 1786 catalogue of the Palais Royal said 'On regrette qu'il ne soit mieux conservé' – but it appears to be autograph.

The earliest mention of the painting is as no. 266 in the 1689 inventory of Queen Christina's Collection: 'Un altro quadro con una figura d'Archimede in paese applicato ad uno libro, che ha dietro il secario con un pugnate in atto di ammozzarlo del Mola.'

Queen Christina arrived in Rome in 1655 and this may be one of the first contemporary pictures which she bought, since on p. 30 it is argued that it should be dated *c.* 1652–6.

Engraving Morace no. III in Couché . . . , *Galerie du Palais-Royal,* 1786.
Bibliography No. 266 in the 1689 Inventory of Queen Christina's Collection, published by Campori, 1870, p. 373; Dubois de Saint-Gelais, 1727, p. 398; Buchanan, 1824, p. 108; Waagen, 1854–7, Vol. II, p. 492; Granberg, 1897, p. 44; Voss, 1910, p. 177 and p. 209; Stryienski, 1913, p. 13 and p. 174; Busiri-Vici, 1965, pp. 32 ff.

39. ROME, Gallerie Capitoline
Expulsion of Hagar and Ishmael. **Pl. 92**
Canvas, 103 × 199 cm.
Provenance Cardinal Pio, thence by descent; acquired by Benedict XIV in 1750.

This canvas, together with Cat. 40 and R.40 and R.41, was listed as by Mola in the Manuscript catalogue of the Pio Collection drawn up in 1750

when Benedict XIV bought the collection from Prince Gilbert Pio. Carlo Pio, 1622–89, was created a Cardinal in 1654 (Ciacconius, 1677, Vol. I, p. 701) and was made Papal Legate to Ferrara on 22 August 1655 only to return to Rome in 1662 (Cittadella, 1783, p. 285). It is argued on p. 30 that the pictures by Mola which he owned date from the period when he was created a Cardinal rather than from the 1660s.

On his return to Rome Cardinal Pio brought with him Giovanni Bonatti, a young Ferrarese painter, who painted two pictures in the Cardinal's collection which were attributed to Mola in the 1750 inventory, R.44 and 45, and which were certainly deeply influenced by Mola.
Bibliography Rome, MS. Inventory of Pio's Collection, 1750 (deposited at the Capitoline Galleries); Venuti, 1766, Vol. II, p. 331; Voss, 1924, p. 284 and p. 560; Arslan, 1928, p. 70 and fig. 13; Waterhouse, 1937, p. 83; Bocconi, 1950, p. 356.

40. ROME, Gallerie Capitoline
Diana and Endymion. **Pl. 88**
Canvas, 148 × 117 cm.
Drawing Hessisches Landesmuseum, Brunswick 147, pen and ink, 18·8 × 15·1 cm., Pl. 86; Kunstmuseum Düsseldorf, F.P. 795, pen, ink and wash, 18·7 × 14·3, Pl. 87.
Provenance Cardinal Pio; acquired by Benedict XIV in 1750.

The history of this picture is similar to that of Cat. 39. The evidence concerning the life of Cardinal Pio, cited above, supports a dating of *c.* 1652–6, see p. 30, rather than that of 1640–50 proposed by Arslan.

The drawing, Pl. 86, was first connected with Cat. 40 by Voss. In the painting Endymion has been reversed and Diana is seated in the moon. Mola has already indicated the format of the painting in Pl. 86, drawing the frame on the left of the sheet, and the arrangement of the figure against the landscape prepares that of the canvas. Although Pl. 87 represents a different moment in the story, the inclusion of the dog in the foreground and of the putto on the left of the sheet connect the drawing with the painting, as a later stage in the design in which Mola turns more directly to Annibale Carracci than in Pl. 86.
Bibliography Rome, MS. Inventory of the Pio Collection, 1750; Venuti, 1766, Vol. II, p. 339; Voss, 1910, pp. 177 ff.; Voss, 1924, p. 562; Arslan, 1928, p. 62 and fig. 5; Waterhouse, 1937, p. 83; Bocconi, 1950, p. 356.

41. ROME, Galleria Colonna
Rebecca and Eliezer.
Canvas, *c.* 150 × 150 cm.
Drawings Accademia, Venice, no. 747. Grey chalk, with white heightening, 33·9 × 18·9 cm., Pl. 96. Accademia, Venice, no. 744. Grey chalk, with white heightening, 36·6 × 20·6 cm., Pl. 97.
Provenance Probably painted for Lorenzo Onofrio Colonna; thence by descent.

No photograph of this painting is at present available. Pascoli mentions Mola as having painted a *Lot with his Daughters* together with the *Rebecca* for the Contestabile. Since the 1782 Catalogue of the Colonna Gallery does not mention a *Lot with his Daughters* by Mola it seems likely that, as in the case of his description of the Stanza dell' Aria at Valmontone (see p. 9) and of Cat. R.41 and 42 (also connected with the Colonna) Pascoli was mistaken and has confused the *Lot* with the *Hagar and the Angel* Cat. 42 below.

Cat. 41 and 42 were listed in the 1782 catalogue as: 'no. 162 Due quadri di palmi 6 quasi quadrati uno Agar con Ismaele, l'altro Rebecca e Jezer servo d'Abramo = Gio. Francesco Mola di Lugano.'

Lorenzo Onofrio Colonna, who was born in 1637, became Contestabile in 1659 (see Prospero Colonna, 1927, pp. 277 ff.) and began to buy from Claude in 1661 (see Röthlisberger, 1961, p. 374 and Haskell, 1963, p. 155). The two Molas appear to be datable to 1655–9 and may have been bought in 1659 when he was first appointed Contestabile. The picture has suffered, notably Hagar's robes, and if cleaned would probably be close in colour to Cat. 40.

The drawings, Pls. 96–97, confirm the dating of *c.* 1655–9, since the style of the *Rebecca* is similar to that of the Düsseldorf study for Joseph, Pl. 63. The pose of the Rebecca is already close to that used in the painting, but the Eliezer, Pl. 97, differs and may represent an earlier stage in which he was placed on the left of the picture.

There is a red chalk copy in the Hermitage, 8068.
Bibliography Pascoli, 1730–6, Vol. I, p. 125; Rome, *Catalogo . . . casa Colonna*, 1782, p. 27, no. 162; Voss, 1924, p. 284; Arslan, 1928, p. 61.

42. ROME, Galleria Colonna
The Angel Appearing to Hagar and Ishmael. **Pl. 93**
Canvas, *c.* 150 × 150 cm.
Drawing Nationalmuseum, Stockholm N.M. 1863/569, red chalk, 21·8 × 33·7, Pl. 95.
Provenance Probably painted for Lorenzo Onofrio Colonna; thence by descent.

For a discussion of the early history of the painting see above under Cat. 41. For a dating of *c.* 1655–1659 see p. 32. Arslan had suggested that it should be dated *c.* 1640. The surface has cracked badly and unless treated is in danger of considerable paint loss.

The elegant drawing establishes the main lines of the composition and confirms that Mola used the oil sketch of a head, Cat. 48, for the Hagar. The curls in the hair, which are not used in Cat. 42, recur in a modified form in Pl. 95. The style of the drawing represents a development of that of Pl. 39, for Cat. 46.

There is a red chalk copy in the Hermitage, 8069.
Bibliography Rome, *Catalogo . . . Casa Colonna*, 1782, p. 27, no. 162; Voss, 1924, p. 284 and p. 551; Arslan, 1928, p. 61 and fig. 3; Stockholm, 1965, no. 106.

43. ROME, Galleria Nazionale (Palazzo Corsini)
Homer Dictating. **Pl. 138**
Canvas, 98 × 135 cm.
Drawing Mahon Collection, London, pen, ink and brown wash, 12·5 × 9·7 cm., Pl. 140.
Provenance Acquired with the Corsini Bequest in 1883.

The picture, whose attribution to Mola is modern, is dated on p. 42 to the end of Mola's career, 1663–6.

Arslan suggested a date of 1661, because he believed that Mola met Preti at Valmontone in that year, and that this painting reflects the influence of Preti. Mola had left Valmontone by the time that Preti worked there, see p. 6. The firm crisp handling of Cat. 43, with its exaggerated range of light and shade, is not related to Preti's work in this period. The *Marriage Feast at Cana* by Preti in Toledo which was painted for Roomer in Naples (Haskell, 1963, p. 207) can probably be dated to 1656–61 and shows a very different reaction to Venetian sixteenth-century painting. The liquid, dark chiaroscuro recalls Preti's Caravaggesque origins and Tintoretto, in contrast with the crisp surfaces of Cat. 43.

The framing lines on the drawing indicate that Mola thought of the design as either upright or full length, but that he had not yet chosen the present three quarter length format.

The choice of subject, and of the format, may reflect a distant debt to Rembrandt's *Homer Dictating* of 1663 now in the Hague, which had arrived half finished in the Ruffo Collection in 1662 and had then been returned to be completed (see Ruffo, 1916, p. 318) by 1663 (the canvas is dated that

year, see Goldscheider, 1960, p. 184). Ruffo was in contact with Mola by June 1663 (Ruffo, 1916, p. 170), but the present canvas is not listed in the 1710 inventory of Ruffo's Collection, published by Ruffo, 1916.

Bibliography Voss, 1924, p. 286 and p. 561; Arslan, 1928, p. 68 and fig. 10; Waterhouse, 1937, p. 83; Pigler, 1956, Vol. II, p. 306; Goldscheider, 1960, p. 184; Rowlands, 1964, p. 274, fig. 25a.

44. ROME, Galleria Nazionale (Palazzo Barberini)
Portrait of a Woman. **Pl. 141**
Canvas, 70 × 50 cm.
Provenance Barberini Palace; 1935 acquired by A. Muñoz; purchased 1966.

Arslan first suggested the attribution to Mola of this canvas, which Posse had attributed to Sacchi. The crisp handling of the surfaces, the weaknesses in the nose, and the sharp contrast of the light and shade are very close to Cat. 43 and suggests a dating of 1663–6. The treatment of the portrait, notably the eyes, finds a close parallel in Cat. 50.

The lighting of the face, the immediacy of the presentation, and the Venetian handling reflect the portraits of Bernini, notably the *Young Boy* in the Galleria Borghese (see Pergola, Vol. II, 1959, p. 73, no. 108), but Mola's handling is weaker and fussier than the bold direct brushstrokes of the Bernini. Comparison of the Borghese portrait with the *St. Andrew and St. Thomas* by Bernini, now in the National Gallery, London, which was listed in a Barberini inventory of 15 June 1627 (see Martinelli, 1950, p. 96), reveals the contrast in the handling which points to a much later date for the Borghese picture.

Bibliography Posse, 1925, pp. 124 ff.; Arslan, 1928, p. 71 and fig. 15; Attività della Soprintendenza alle Gallerie del Lazio, 1966, Cat. no. 20.

45. ROME, Incisa Collection
Vision of St. Bruno. **Pl. 136**
Canvas, 194 × 137 cm.
Drawings Hessisches Landesmuseum, Darmstadt, AE 1803, red chalk, point of the brush red wash, 22·3 × 17·8 cm., Pl. 133; Hermitage, 4770, pen and ink over black chalk, 24·5 × 18·5 cm., Pl. 132; Städelsches Kunstinstitut, Frankfurt, 423, red chalk, Pls. 134 and 135.
Provenance Prince Agostino Chigi; thence by descent.

Pascoli records that Mola painted a *St. Bruno* nine palms high for Prince Chigi. Agostino Chigi,

1634–1705, moved to Rome from Siena in 1656. After becoming a Prince in 1659 he lived in the family palace in SS. Apostoli (see Pagliucchi, 1906–28, Vol. II, pp. 83 ff.).

There is some indirect evidence which points to a date of 1663–6 for the picture. No payment is recorded by Golzio, 1939. Ronca, who gave evidence for Mola in 1662, says that he had seen Mola painting canvases with landscapes in the Chigi Palace at SS. Apostoli in this period (see p. 7). Ronca gave his evidence in the Valmontone trial to boost Mola's reputation, and because of this he refers to the *Assumption* which Mola painted for the Pamphili in 1656–7. His failure to mention the *St. Bruno*, for his rather vague reference to Mola's work in the Chigi Palace at SS. Apostoli cannot refer to the Incisa painting, suggests that it had not been painted by 1661–2.

Passeri's account of Mola's illness further confirms a dating after 1663 for Cat. 45. He says, ed. Hess, 1934, p. 372, that after the illness which forced Mola to resign from the Presidency of the Accademia di San Luca, datable to 1663 (see p. 7), he further undermined his reputation by having his studio make replicas of his pictures to which he put a few brushstrokes. This account of Mola's working procedure is true, for damage to one version of this painting, Cat. 5, has revealed the disparity between the weak lay-in and the firm, powerful strokes which model the Saint's head. Although Passeri makes no mention of the *St. Bruno* it must have been this painting, and its many replicas, which inspired his comment.

Neither Ronca nor Passeri provide conclusive evidence for dating this picture, but taken together their accounts point to a date in the period 1663–1666.

In addition to the versions catalogued under Cat. 5 and 34 there are at least three other weaker studio versions, one in the Vatican (see Francia, 1960, no. 360) and another in the Palazzo Doria (see Sestieri, 1942, no. 161). Both pictures need to be cleaned, and the Doria painting is in danger of blistering. A third version, which was also produced in Mola's studio, can be attributed to Francesco Giovane, see R.1. There is a further version in the collection of the Duke of Villahermosa, Barcelona, which, to judge from a photograph in the Frick Art Reference Library, is autograph.

There is a copy after Mola's design in the Uffizi, 5730s (as Testa), see Marabottini, 1954, p. 129, n. 15.

Pl. 133 represents an early stage in the prepara-

tion of the composition. Mola used this drawing as the basis for a variant, see Cat. 71, and L.67. The main outlines are established in Pl. 132 in which the landscape is very different, and less Venetian than in the painting. Mola has, however, established the basic elements of the design by the time of Pls. 134 and 135 in which he studies the Saint's pose and his costume with greater care and precision than usual. These two drawings reveal Mola's debt to Sacchi's drawing style of the decade 1630–40 (see for example the *St. Longinus* at Düsseldorf, illustrated Düsseldorf, 1964, no. 142), in the hatching stroke which Mola uses to evoke the play of light over the figure.

St. Bruno, who was canonized in 1514, was made a Saint of the Universal Church in 1623, see Mâle, 1951, p. 505 and p. 212.

Bibliography Pascoli, 1730–6, Vol. I, p. 125; Arslan, 1928, p. 73 and fig. 17; Waterhouse, 1937, p. 83; Sestieri, 1942, p. 117; Dobroklonskij, 1961, p. 170, no. 1104.

Exhibitions Il Seicento Europeo, Rome, 1956, no. 210.

46. ROME, Palazzo Costaguti
Bacchus and Ariadne. **Pl. 40**
Fresco, with slightly under life-size figures.
Drawings Museé du Louvre, 8438, pen and brown ink, 15·3 × 23·2 cm., Pl. 41; H.M. the Queen, Windsor Castle, 6,799, pen and ink, point of the brush over red and black chalks, 20 × 26·1 cm., Pl. 43; Krautheimer Collection, New York, pen and ink, Pls. 42 and 44; Teyler Museum, K.I. 78, red chalk, squared in black chalk, 20·8 × 28·9 cm., Pl. 39.

The fresco, which is usually said to have been commissioned by Vincenzo Costaguti, is linked to G. B. Costaguti on p. 21 and dated *c.* 1650.

In Pl. 41 Mola established the motif of the main group set on a plateau in the foreground. In the Windsor sheet, Pl. 43, he extended the mountains in the background, introduced Silenus on his donkey on the right, and filled the caesura between Bacchus and Ariadne with the two dancing Bacchantes. The flying putti in Pl. 44 are close to those which Mola had indicated lightly at the top of Pl. 43. The verso of this sheet, Pl. 42, shows an independent sketch in which Silenus's donkey crumples under the weight of its load.

Pl. 39 prepares the design of the fresco, from which it still differs in detail, by transferring Silenus to the left of the composition and adding on the right the boat in which Bacchus travelled from India. The putti do not yet play with stars which are both an attribute of Ariadne and a part of the Costaguti stemma.

Bibliography G. B. Mola, 1663, ed. Noehles, 1967, p. 210; Passeri, ed. Hess, 1934, p. 368; Pascoli, 1730–6, Vol. I, p. 125; Arslan, 1928, p. 67 and Fig. 8; Waterhouse, 1937, p. 83; Blunt and Cooke, 1960, no. 538; Rowlands, 1964, pp. 271–6; Sutherland, 1964, p. 368.

47. ROME, Palazzo Doria
Rest on the Flight. **Pl. 85**
Canvas, 289 × 199 cm.
Drawings Berlin–Dahlem, K.d.Z. 15245, pen, ink and brown wash, 25·8 × 18·1 cm., Pl. 83; Teyler Museum, K.I.4, pen, ink and wash over black chalk, 25·3 × 18·5 cm., Pl. 84.
Provenance Painted for Prince Pamphili before 1662; thence by descent.

The picture is first mentioned in Antonio Somigliano's evidence on Mola's behalf in the Valmontone trial, which, as argued on p. 7, can be dated 1662, together with that of Carlo Ronca, and Dughet.

Two other witnesses mention the standard of the *Assumption* that Mola painted for the Pamphili in 1657, see L.3, but neither mention the *Rest on the Flight*, which suggests that they had not seen it. Mola is unlikely to have painted such an important picture for the Pamphili after his unhappy experiences at Valmontone in 1658.

There is therefore a strong presumption that the *Rest on the Flight* was painted before 1657 when Vaselli and Ronca saw the standard of the *Assumption*. Somigliano's evidence bears out this hypothesis since he claims to have studied with Mola: 'il D.to Sig. Mola Cominciai a conoscerlo che sonarano di sedici Anni incirca, con occasione che io ci andai da lui per imparare a dipingere . . . Son stato l'aidante suo et ho imparato à dipingere da lui' (Montalto, 1955, p. 296). Somigliano must, therefore, have met Mola immediately after the latter's arrival in Rome in 1647.

Prince Camillo Pamphili only returned to Rome in 1651 (see Haskell, 1963, p. 148), and Mola must soon have been in contact with him since he worked on the Pamphili Palace at Nettuno in 1652–3, see Cat. L.2.

Somigliano said that he had known Prince Pamphili about eight or ten years. This acquaintance, which must have come through his master Mola, makes it reasonable to date the *Rest on the Flight,* which is referred to by Somigliano as follows: 'in Roma poi a dipinto . . . à oglio una

Madonna in tela grande di dodici palmi in circa che va in Egitto', early in the period 1652–6.

The earliest drawing, Pl. 83, is stuck down, but on the verso Dr. Peter Dreyer has been able to make out 'mando per Giacomo Villa'. The composition, with the squat kneeling angels, recalls Mola's engraving after Albani's *Rest on the Flight*, Bartsch, XIX, 4, Pl. 81. Mola elaborates the background and the trees as well as the donkey and its burden in Pl. 84, which is probably later than Pl. 83. In the painting St. Joseph retires into the middle distance, and the Christ Child has abandoned his cross to pluck fruit from the bowl.

A variant on this design is recorded in the autograph, but unsigned, etching, Bartsch, XIX, 3, Pl. 82.

Bibliography Waterhouse, 1937, p. 83; Sestieri, 1942, p. 76, no. 111; Martinelli, 1966, p. 714.

48. ROME, Palazzo Doria
Head of a Young Woman. **Pl. 94**
Canvas, 40 × 30 cm.
Provenance The picture is first mentioned, with an attribution to Mola, in the 1819 Inventory of the Palace.

This study was used for the Hagar in Cat. 42. For a comparable but earlier oil sketch see Cat. 30. See p. 33.

Bibliography Voss, 1910, pp. 177 ff.; Voss, 1924, p. 560; Arslan, 1928, p. 61; Waterhouse, 1937, p. 83; Sestieri, 1942, p. 175, no. 252.

49. ROME, Palazzo del Quirinale
Joseph Greeting his Brothers. **Pl. 60**
Fresco, 475 × 475 cm.
Drawings British Museum, 1857–6–13–367, pen, brown ink and brown wash over red and grey chalk, 23·2 × 32·2 cm., Pl. 65; Musée Atger, Montpellier, pen and ink with brown wash, 16·5 × 25·7 cm., Pl. 66; Düsseldorf, 11840, pen and ink with brown wash, 17·9 × 23·4 cm., Pl.67; Nationalmuseum, Stockholm, 565/1863, pen, brown ink and wash over red chalk, 13 × 25·4 cm., Pl. 70; Sutherland Collection, Cambridge, pen and ink, point of the brush and wash, 22·8 × 26·8 cm., Pl. 71; Musée des Beaux-Arts, Dijon, Trimolet 170, pen, ink and wash, grey chalk and wash, Pls. 68 and 69; British Museum, 1853–10–8–10, black chalk, brown wash over red and black chalk, perspective scheme drawn over the figures in pen and ink, 32·1 × 44·2 cm., Pl. 72; Düsseldorf, FP 2222, grey chalk with white height-ening, Pl. 63; Earl of Leicester, Holkham, pen, ink and wash with white heightening, 39·5 × 44·5 cm., Pl. 61; Louvre, 15694, black, red and yellow chalks with white heightening, 42 × 27 cm., Pl. 64.

The fresco, which is documented to 1656–7, was part of the redecoration of the Quirinal Palace carried out by a group of artists under the direction of Pietro da Cortona, see p. 4.

In addition to the drawings discussed on p. 27 Dr. Sutherland Harris brought to my attention the fine study of Joseph, Pl. 64 which must have been made after the Holkham drawing, Pl. 61 since the massive draperies are closer to the fresco but Mola has not yet turned the figure as far to the right as in the fresco or yet fully lowered his left arm.

There is a copy after the Holkham drawing, Pl. 61, at Munich, 3134, which has been cut slightly on the left. With this additional strip its width would correspond to that of the Holkham drawing, but it is some 5 centimetres taller than this latter sheet.

A further drawing, in Brian Sewell's collection, does not, in my opinion, fit with the preparatory sketches for the fresco, but is a later 'ricordo' in which Mola has reversed the design and linked the figures in a more unified and baroque grouping.

Engraving An etching after the design of the Holkham drawing, Bartsch, XIX, 1, Pl. 62, is recorded as signed by Mola.

Bibliography G. B. Mola, 1663, ed. Noehles, 1967, p. 217; Passeri, ed. Hess, 1934, p. 370; Titi, 1721, p. 331; Pascoli, 1730–6, Vol. I, p. 124; Voss, 1924, p. 562; Arslan, 1928, pp. 66–7; Waterhouse, 1937, p. 83; Wittkower, 1958, p. 215; Wibiral, 1960, p. 143 and p. 163, Docs. 66–9; Vitzthum, 1961, p. 517; Rowlands, 1964, p. 273; Sutherland, 1964, pp. 367–8; Stockholm, 1965, no. 113.

50. ROME, Pallavicini Collection
Head of an Old Woman. **Pl. 139**
Canvas, the diameter is 41·9 cm.
Provenance Cardinal Lazzaro Pallavicini; thence by descent.

The picture, which is recorded as by Mola in the 1679 Pallavicini Inventory, provides the basis of our knowledge of Mola's portraiture. Even in its present filthy condition it is possible to sense the freedom of handling and directness with which the sitter is presented.

Mola appears to have been influenced by the St. Anne in Caravaggio's *Madonna and Child with St. Anne* which was in the Borghese Collection in the

seventeenth century, see Friedlaender, 1955, p. 192, but the technique and the handling owe a considerable debt to Venetian painting which suggests that it should be dated *c.* 1660–6.

Bibliography Pallavicini Will, 1679, no. 91, ed. Zeri, 1959, p. 182, no. 313.

51. ROME, Spada Collection
Bacchus. **Pl. 91**
Canvas, 97·3 × 73·7
Provenance Perhaps no. 168 in the 1692 inventory of Flavio Chigi; in the Spada Collection by 1759.

For the early history of the picture see L.26. The modern attribution of this picture, which had previously been called 'Scuola di Guido', is discussed further on p. 31 where a dating of 1652–6 is proposed, rather than that of 1660 suggested by Arslan.

Bibliography 1759 Inventory of the Spada Collection no. 668 (published in Zeri); Voss, 1924, p. 562; Arslan, 1928, p. 70 and fig. 11; Waterhouse, 1937, p. 83; Zeri, 1954, p. 98.

52. ROME, Gesù
The Conversion of St. Paul. **Pl. 74**
Fresco, 330 × 450 cm.

53. ROME, Gesù
St. Peter Baptizing in Prison. **Pl. 73**
Fresco, 330 × 450 cm.
Drawings Berlin–Dahlem, K.d.Z 17387, pen, ink and bistre wash, 10·3 × 17·6 cm., Pl. 76; Present whereabouts unknown, pen, ink and brown wash, 19·5 × 26·5 cm., Pl. 75; Musée des Beaux-Arts, Dijon, Coll. Chamblanc, pen and ink with bistre wash, 9·2 × 9·6 cm. Pl. 79; Musée Fabre Montpellier, Canonge Bequest 870–1–175, pen and bistre ink with three washes, 31·5 × 43·0 cm., Pl. 80; Musée du Louvre, 8419, pen, ink and brown wash, 11·6 × 17·9 cm., Pls. 77 and 78.

The frescoes in the Ravenna chapel of the Gesù are not documented, but are mentioned in the early sources. It has not proved possible to identify the patrons responsible for the decoration of this chapel, but it might be Phillippus Ravenna who was a consul in 1652, see Forcella, Vol. I, 1869, p. 2, col. 2.

The older literature followed the dating of 1630–40 proposed by Arslan, but Sutherland established that these frescoes were not included in

Sacchi's *Urban VIII Visiting the Gesù during the Centenary Celebrations of the Order in 1639*, for which the artist was paid in 1641 and 1642, and convincingly referred them to a date after 1647 when Mola returned to Rome from his second visit to the North. For a dating of *c.* 1656–7 see pp. 28 ff.

In the earliest of the drawings, Pl. 76, Mola establishes the motif of St. Peter striking the floor, surrounded by two separate groups. The architectural setting with the grill and the view into the distance was only introduced at a later stage. In the next drawing, Pl. 75, Mola has sketched the rather awkward site on the bottom of the sheet, and has simplified the composition by linking the figures together, but he has not yet decided on the setting, of which he has drawn two alternatives with St. Peter shown again in the upper right of the sheet. The light source is a window behind the gesturing prisoner on the left.

Mola's indecision about the composition is further revealed in Pl. 79, in which he studies again the two prisoners on the right of Pl. 75 in a form which is closer to the fresco. It is possible that they were intended to be on the left of the design, since one appears to lean on the raised frame of the fresco, which Mola had sketched at the bottom of Pl. 79.

The attribution of Pl. 80, which has been extended at the top and on both sides, has been doubted, but, in spite of its rubbed condition, it is close to Pl. 61 and represents an intermediary stage between the previous drawings and the fresco. Pl. 80 differs from the fresco in a number of important details, by including a man walking through the doorway, in omitting the chain that binds together the prisoners on the left of the sheet, and, most notably, in the pose of the gesturing prisoner on the left. This is modified on the verso of the Louvre drawing, Pl. 78, where by making him lean forward Mola integrates him more successfully than in the previous drawings into the composition.

No drawings for Cat. 52 have so far been identified; the drawing in Mrs. Krautheimer's Collection (see Bean, 1967, p. 69, no. 102) is not, in my opinion, by Mola. For a lost version of Cat. 53 see L.55.

Bibliography G. B. Mola, 1663, ed. Noehles, 1967, pp. 187–8; Passeri, ed. Hess, 1934, p. 370; Titi, 1674, p. 196; Pascoli, 1730–6, Vol. 1, p. 123; Arslan, 1928, p. 58; Wibiral, 1960, p. 143; Vitzthum, 1961, p. 517; Rowlands, 1964, pp. 271–6; Sutherland, 1964, pp. 367–8.

54. ROME, S. Anastasia
St. John the Baptist in the Wilderness. **Pl. 101**
Canvas, 200 × 140 cm.
Provenance Giovanni Battista Costaguti.

The picture was placed in this chapel, according to Crescimbeni, by Cardinal G. B. Costaguti, who was created a Cardinal in 1690 and took the title of S. Anastasia in 1692 (see Guarnacci, 1751, pp. 351–354). The date at which Cat. 54 was commissioned is not known, but on p. 32 it is dated *c.* 1655–9.

Crescimbeni is the only early guide to attribute this picture to Mola: '. . . nella destra dell' ingresso, alla meta di essa, verso un Altare fattovi fabricare dal Cardinal Costaguti titolare sotto l'invocazione di S. Gio. Battista; il quale colloco un quadro... opera del celebre Francesco Mola.' The painting, which was mentioned by Titi in 1763 without an attribution but with the comment that it is ruined, has suffered severe paint loss on the face of the Baptist and in the trees on the right, which the modern restoration could not replace.

For another version of this theme see Cat. 24.
Bibliography Crescimbeni, 1722, p. 24; Titi, 1763, p. 78; Voss, 1924, p. 562; Arslan, 1928, p. 76 and fig. 20; Waterhouse, 1937, p. 83.

55. ROME, S. Carlo al Corso
St. Barnabas Preaching. **Pl. 55**
Canvas, 210 × 130 cm.
Drawings Nationalmuseum, Stockholm, N.M. 562/1862, black chalk, point of the brush, brown and grey ink, 32 × 19·5 cm., Pl. 53; Berlin-Dahlem, K.d.Z 21 027, pen, ink and bistre wash, 19·6 × 26·8, Pl. 52; Formerly Skippe Collection, sold Christie, 20/21 November 1958, Lot no. 187(a), pen, ink and bistre wash, 9·4 × 7·3 cm., Pl. 54.
Provenance Commissioned by Cardinal Omodei.

According to Passeri the picture was commissioned by Omodei, born 1608, who was created a Cardinal in 1652 (see Cardella, 1792–7, Vol. VII, pp. 91–3) and who assumed the patronage of the Milanese church in Rome, S. Carlo al Corso. The apocryphal scene of St. Barnabas preaching to the Milanese, which was chosen because of Omodei's connexion with Milan, is not taken from *Acts*, 13–15, but as Passeri first noted, from Eusebius, *Historia Ecclesiastica*, lib. I cap. 12, lib. II cap. 1, which was completed early in the fourth century.

The picture, which has been moved from its original site on the right of the church to the first chapel on the left, is dated 1652, on p. 24.
The earliest drawing, Pl. 53, represents the

saint blessing a kneeling soldier, and includes a pyramid in the background, which is also present in the next drawing, Pl. 52. At this early stage Mola had not placed the scene in Milan, but depicted St. Barnabas on one of his eastern missions mentioned in *Acts*. At the bottom of Pl. 52 Mola envisaged the effect of the picture when placed in the church.

Pl. 54 is closest to the painting, notably in the composition of the figures including on the left the figure derived from Rosa's *Diogenes*, but Mola has not yet introduced the bridge, which Passeri admired so greatly.

There is another related drawing of the *Erminia and Vafrino Tending the Wounded Tancred* shown on Pl. 52 in the Louvre, 8434. See also L.13.
Bibliography G. B. Mola, 1663, ed. Noehles, 1967, p. 152; Passeri, ed. Hess, 1934, p. 370; Titi, 1674, p. 404; Pascoli, 1730–6, Vol. I, pp. 124–5; Voss, 1924, p. 562; Arslan, 1928, p. 67 and fig. 9; Waterhouse, 1937, p. 83; Sutherland, 1964, p. 368.

56. ROME, SS. Domenico e Sisto
The Image of St. Dominic Carried to Soriano by the Virgin, St. Catherine and St. Mary Magdalene. **Pl. 35**
Canvas, 233 × 166 cm.
Drawing Teyler Museum, D.26, pen, ink and bistre wash over traces of black chalk, 23·4 × 18·3 cm., Pl. 34.
Provenance Commissioned by Vincenza Costaguti.

A now lost contemporary chronicle, formerly in the church's archive, is quoted by Berthier: 'La Chapelle de Saint Dominique fut erigée en 1648, le tableau représentant Saint Dominique est de Francesco Mola. Elle est due au zèle des sœurs Paola Maria, Maria Candida, Maria Agnese Prospera, Vincenza Costaguti.' Vincenza Costaguti had joined the order in the previous year; see Berthier.

Arslan suggested that the saints were untypical of Mola, and that they had been repainted. This is unlikely since comparable figures occur in Cat. 55 and in the other pictures which Mola painted in the period 1652–7. The condition of the picture is very bad, the architectural setting has disappeared under a heavy coat of old varnish and the surface is in imminent danger of considerable loss.

In the drawing, Pl. 34, Mola established the outlines of the composition, but only added the architecture afterwards. In the picture the image of St. Dominic is brought closer to the kneeling monk, and all the figures are more monumental.

Mola had used this combination of pen and

wash before, notably in Pl. 11, but comparison with the earlier drawing reveals Mola's keener awareness of the structure of the figures, and a greater richness in the wash which gives the drawing an almost luminous precision. This reflects the influence of Poussin's drawing style of the period 1630–40 (see the drawing for *The Schoolmaster of Falerii* now at Windsor, Friedlaender and Blunt, 1949, no. 123, pl. 97), but, in contrast with Poussin, Mola blurs the structure of his figure through his interest in surface decoration. The Saints in this drawing reflect Poussin's figure types, notably the Virgin of the *Holy Family of the Steps* of 1648, now in the National Gallery, Washington, see Blunt, 1966, no. 53.

The small frescoes surrounding the first altar on the left of the church have been wrongly attributed to Mola by Voss. The drawings which Rowlands related to these frescoes are, in my opinion, by Cantarini rather than Mola.

For the vision, which occurred in 1530, see Mâle, 1951, p. 470.

Bibliography G. B. Mola, 1663, ed. Noehles, 1967, p. 192; Titi, 1674, p. 312; Pascoli, 1730–6, Vol. I, p. 124; Berthier, 1919–20, Vol. II, p. 202; Voss, 1924, p. 562; Arslan, 1928, p. 64 and fig. 7; Waterhouse, 1937, p. 83; Rowlands, 1964, p. 262.

57. ROME, S. Marco
The Martyrdom of SS. Abdon and Sennon. **Pl. 56**
Fresco, with almost life-size figures.
Drawings Gabinetto Nazionale, Rome, F.C. 124340, grey chalk mingled with touches of red, 20·2 × 35·5 cm., Pl. 57; Gabinetto Nazionale, Rome, F.C. 128395, grey chalk with white heightening on blue tinted paper, 22·6 × 20·5 cm., Pls. 58 and 59.

The fresco, which was part of the redecoration of the church undertaken for Niccolò Sagredo, is not documented but the evidence, discussed on p. 25, suggests that it can be dated 1653–5. Arslan confused this fresco with that of Borgognone, and the correct reidentification is due to Salvagnini.

It is unusual for Mola to prepare this stage of the composition in chalk, as he has done in Pl. 57. The drawing differs from the fresco in the saints, who are not yet derived from Raphael, and in the background. Mola has indicated the margin of the fresco field on the left of the sheet. The style of this sheet derives from Annibale Carracci, notably the chalk study at Windsor for the *Combat of*

Perseus and Phineus in the Farnese Gallery (see Martin, 1965, no. 133).

The verso of the second Roman drawing, Pl. 58, appears to relate to the legs of the executioner in the centre of Pl. 57, and the two putti on the recto, Pl. 59, are similar in type to those in the fresco, and may represent an early stage in the composition.

Bibliography G. B. Mola, 1663, ed. Noehles, 1967, p. 127; Passeri, ed. Hess, 1934, p. 368; Titi, 1674, p. 198; Pascoli, 1730–6, Vol. I, p. 123; Dengel, 1913, pp. 90–95; Arslan, 1928, p. 66; Salvagnini, 1935, pp. 167 ff.; Waterhouse, 1937, p. 83; Sutherland, 1964, p. 368.

58. ROME, S. Marco
Niccolò Sagredo
Canvas.

The picture, which is identified by an inscription on its frame in the Sacristy, was published by Martinelli. In spite of its poor condition, and of the dirt which obscures it, the picture is clearly by Mola and fits with his one fully authenticated portrait, Cat. 50.

Bibliography Martinelli, 1966, p. 715 and fig. 459a.

59. ROME, S. Marco
St. Michael Confounding Lucifer. **Pl. 100**
Canvas, 200 × 120 cm.
Provenance Commissioned by Niccolò Sagredo.

According to Passeri, Niccolò Sagredo, who was the Venetian Ambassador to the Holy See from 1650 until 1656 (see Hess, in Passeri, 1934, p. 369, note 1) began the restoration of the Venetian church in Rome, San Marco, in 1653. Sagredo collected contemporary Roman paintings, notably Salvator Rosa, so that his employment of Mola on this commission does not by itself prove that Mola had any connexion with Venice.

The payment for this picture was published by Dengel: '21 Dec. 1655; Al Francesco Mola al Conto del Quadro di San Michele Scudi 25.' No other payments are recorded, but since the last payment for the redecoration was made to Canini on 15 October 1659, it is reasonable to date the painting 1655–9.

Bibliography G. B. Mola, 1663, ed. Noehles, 1967, p. 127; Passeri, ed. Hess, 1934, p. 368; Titi, 1674, p. 200; Pascoli, 1730–6, Vol. I, p. 123; Dengel, 1913, pp. 93–4; Arslan, 1928, p. 66; Waterhouse, 1937, p. 83; Martinelli, 1966, p. 714.

60. SAN FRANCISCO, M. H. de Young
Memorial Museum (K.1969)
Erminia and Vafrino Tending the Wounded Tancred.
Pl. 131
Canvas, $27\frac{1}{8} \times 36\frac{1}{8}$ in.
Provenance Jolly; Louis XIV; Musée du Louvre.

The picture was bought for Louis XIV's collection in 1685, when it was already attributed to Mola (see Guiffrey). After passing to the Louvre in 1785 the picture was deposited in the Elysée Palace in 1875 and was subsequently acquired by the Kress Collection from a Paris dealer in 1955. There can be no doubt that this is the Louvre picture, which is missing, since it is identical with the engraving and the dimensions correspond to those given by Villot, 69 × 93 cm. It is one of the pictures which were copied by Turner in 1811 (see Ziff).

Bailly's description of the picture as round must refer to the frame, since there are no later additions to the canvas. Bailly also describes Cat. 34 as round.

For an earlier version of the subject, which is now known only through drawings, see Pl. 52 under Cat. 55. The subject, which derives from Tasso's *La Gerusalemme Liberata* XIX, is discussed by Lee.

See further p. 39.
Engraving No. 286 in Filhol, *Galerie du Musée Napoléon*, Vol. IX, 1807.
Bibliography Bailly, 1709, published in Engerand, 1899, p. 213; Turner, 1811, in Ziff, 1963, p. 128, note 19; Villot, 1873, p. 169, no. 274; Guiffrey, 1881–1901, Vol. II, p. 593; Lee, 1967, pp. 136–41.

61. SARASOTA, Ringling Museum (State no. 139)
The Prophet Elisha and the Rich Woman of Shunem.
Pl. 38
Canvas, $25\frac{7}{8} \times 19\frac{3}{8}$ in.
Provenance Aufrère Collection; Yarborough Collection; acquired 1929.

The picture, together with its companion Cat. 62 below, was part of the Aufrère Collection which passed to George Aufrère's son-in-law, Baron Yarborough in 1804 (see Faulkner). It was sold in the Yarborough Sale, Christie, 12 July 1929, Lot 52.

The subject, which is connected with the Carmelite Order (see Boase, 1939–40, p. 108), suggests that the two pictures may have been commissioned, perhaps by Omodei, in connection with the decoration of S. Martino ai Monti, see

further p. 20.
Bibliography Faulkner, 1829, Vol. II, p. 297; Voss in Thieme–Becker, 1931, p. 29; Suida, 1949, no. 139.

62. SARASOTA, Ringling Museum (State no. 138)
The Prophet Elijah and the Widow of Zarepath.
Pl. 37
Canvas, $25\frac{3}{4} \times 19\frac{1}{4}$.
Provenance Aufrère Collection; Yarborough Collection by 1804; acquired 1929.

The history of this picture, which was sold in the Yarborough Sale, Christie, 12 July 1929, Lot 53, is identical with that of its pendant.
Bibliography Faulkner, 1829, Vol. II, p. 297; Voss in Thieme–Becker, 1931, p. 29; Suida, 1949, no. 138.

63. TORONTO, Art Gallery of Ontario
Boy with a Dove. **Pl. 89**
Canvas, $39 \times 29\frac{1}{4}$ in.
Drawings Real Accademia de San Fernando, Madrid, Inventory 244, red chalk 17 × 14 cm.
Provenance Duke of Bedford; acquired 1954.

The picture, which was first attributed to Mola by Phillips when it was in the Bedford Collection, was sold at Christie, 30 June 1827, Lot 105 (Nobleman of High Rank), when it was bought in. Waagen saw the painting at the Duke's town house, 81 Eaton Sq., where it was catalogued by Scharf, and where it remained until its sale at Christie, 19 January 1951, no. 41, when it passed through Colnaghi to its present owners.

The style of the picture, which I know only from a photograph, is discussed further on p. 31.
Engraving C. Phillips, issued by J. Boydell, 1766.
Bibliography Waagen, 1854–7, Vol. II, p. 285; Scharf, 1877, p. 38, no. 44.

64. VALMONTONE, Palazzo Pamphili
Africa. **Pl. 109**
Fresco, with slightly under life-size figures.

This figure forms part of Mola's decoration of Prince Camillo Pamphili's summer Palace at Valmontone, in 1658 (see Montalto). Only two of Mola's frescoes now survive, see L.4. Montalto identified Cat. 64 as *America*, but its attributes, a large feline animal, a cornucopia with ears of corn and snakes on the ground are said to be those of *Africa* by Ripa, 1611, pp. 358–60.

See further p. 35.
Bibliography Montalto, 1955, p. 291 and Fig. 4.

CATALOGUE RAISONNÉ

65. VALMONTONE, Palazzo Pamphili
The figures in the Sala del Principe. **Pls. 106 and 107**
Fresco.

Waterhouse was the first to connect Mola with the decoration of this room. After the publication, by Montalto, 1955, p. 292, of the payments to Dughet it became clear that as with Cat. 24 Mola was responsible for the figures and Dughet for the landscape. There is a break in the plaster surrounding the figures, which were probably painted after the landscape.

The figures are Venetian in inspiration and can be connected with a copy after Veronese's *Martyrdom of SS. Mark and Marcellinus* in the Teyler Museum, I.6, Pl. 108, which is by the same hand as Mola's copy after Veronese's *Mars and Venus* now in the Codice Bonola, Warsaw (published by Mrozinska, 1959, p. 123).
Bibliography Waterhouse, 1937, p. 84; Montalto, 1955, p. 292, Figs. 14–17.

66. VIENNA, Kunsthistorisches Museum (no. 9117)
Adoration of the Shepherds. **Pl. 13**
Canvas, 75 × 100 cm.
Drawing Louvre, 8413, pen, ink and bistre wash over red chalk, 17·8 × 26·3 cm., Pl. 14.
Provenance Duke of Rutland; acquired 1953.

The picture is signed 'P.F.M.F.' on the basket of the boy on the right.

The picture which was catalogued as a Mola by Eller, was sold in the Rutland Sale, Christie, 16 April 1926, Lot 1 (as Albani), when it was bought by Leger from whom it passed to the Museum in 1953.

In the drawing, Pl. 14, Mola has established the central group of the Virgin, the Child and the adoring angel. In the painting the shepherd on the left of the sheet is transferred to the right, and Mola elaborates the column and the motif of the boys peering into the barn. The flat, insubstantial figures are close to those in Pl. 11.

There is another version of the picture at the Musée des Beaux-Arts, Nîmes, no. 482, which is at present so dirty that a decision on its status must await its cleaning. For a discussion of the dating of Cat. 66 see p. 13.
Bibliography Eller, 1841, p. 248; Vienna, *Katalog der Gemäldegalerie . . .*, 1963–5, no. 595.

67. WILTON HOUSE, Wiltshire
Bacchus and Ariadne. **Frontispiece and Pl. 125**
Canvas, 20 × 26 in.
Provenance Acquired before 1730.

The picture is catalogued by Gambarini as, 'Francisco Mola. Bacchus and Ariadne arguing earnestly together.' This autograph replica of Cat. 4 has been changed in minor details, the tree behind Bacchus has been raised slightly and his legs have been altered. This suggests that the Wilton picture was designed for its present format, and that it has not been cut down.

The subject matter is unusual since this moment is depicted nowhere else in seventeenth-century art (see Pigler, 1956, Vol. II), and Mola himself had followed Titian's conflation of classical sources (see London, 1959, p. 102, with further references to Ovid, Catullus and Philostratus) in Cat. 46.

For a further discussion see under Cat. 4 and p. 39.
Bibliography Gambarini, 1731, p. 54; Wilkinson, 1907, p. 191, no. 58; Pembroke, Sidney 16th Earl of, 1968, pp. 79–80, no. 212.
Exhibitions London, Royal Academy, 1938, no. 310.

68. PRESENT LOCATION UNKNOWN
The Money Lender
The picture, which I know only from a photograph, appears to be by Mola. The figure is reminiscent of the *Barbary Pirate*, Cat. 36, and the painting of the book is close to that of the drapery on the female with her back turned to the spectator in Cat. 55.
Exhibitions Florence, 1922, no. 693.

69. PRESENT LOCATION UNKNOWN
Bacchus and Ariadne
Canvas, 120 × 90 cm.
The picture, which I know only from a photograph, is an autograph variant of Cats. 4 and 67. According to the mount in the Witt Collection the painting was in the Heinemann Collection, Munich, but it has not so far proved possible to trace this picture, which is not in the Heinemann Collection in New York.

70. PRESENT LOCATION UNKNOWN
St. Bruno in a Landscape
The picture, which I know only from a reproduction, was in a Roman Private Collection. It appears to be autograph.
Bibliography Buscaroli, 1935, p. 294, Pl. LIV.

71. PRESENT LOCATION UNKNOWN
Vision of St. Bruno
The picture, which was in the Donati Collection in Rome, is a version of Cat. 45. Mola used the Darmstadt drawing, Pl. 133, as the basis for the

design, a variant of which was engraved by Rousselet, L.67.

The Donati painting is, to judge from a reproduction, probably a studio version of this design.
Bibliography Donati, 1942, pp. 589 ff. and fig. 502.

72. PRESENT LOCATION UNKNOWN
Children Playing in a Landscape

The picture, which I know only from a photograph, was with Peter Claas, London in 1950. It appears to have been cut down on all sides. The figures are close to those in Cat. 4.

B.

REJECTED ATTRIBUTIONS

R.1. ALNWICK Castle, Northumberland
Vision of St. Bruno
Canvas, 16 × 12½ in.
Provenance Camuccini Collection; acquired 1856.

The picture, which was considered by Waagen to be a sketch for Cat. 45, is a studio replica. The landscape is better than the feeble Saint, whose inexpressive head, and claw-like hands are also found in the *Presentation of the Virgin*, one of the small pictures framing the first altar on the right in S. Maria in Trivio, which are attributed by Titi, 1686, p. 321 to Gio: Francesco Bolognese. Since the pictures have no connexion with any work by Grimaldi, it seems reasonable to assume that Titi means Francesco Giovane, 1611–69, who, according to the Manuscript Lives of 1724 in the Vatican (see p. 9) by Pio, was a pupil in Mola's studio until the latter's death in 1666. A reference on the verso of Pl. 104 (see under Cat. 1) to 'Sig. Gio Franco' could relate to Francesco Giovane.

The painting must date to *c.* 1663–9. Other pictures which can be identified with this same feeble hand are Cats. R.6, R.11, R.48, R.50, and R.51 and two pictures at Hanover, see L.57 and 58. For another group of paintings also attributable to Giovane see Cat. R.35 and R.36.
Bibliography Waagen, 1854–7, Vol. IV, p. 465 and p. 471.

R.2–5. ARICCIA, Palazzo Chigi
Homer, Hyacinth, Bacchus, Narcissus
Canvas, with slightly under life-size figures.

The four pictures were first identified as the senses of Smell, Sight, Taste and Hearing by Professor Waterhouse, who suggested the attribution to Mola. They are not, in my opinion, autograph but from Mola's studio. *Bacchus* is weaker than Cat. 4 and *Homer* cannot be compared with Cat. 43. The figures, which clearly derive from prototypes by Mola, have been stretched unhappily into the elongated format of the paintings, and the dull handling is not typical of Mola. The pictures could be by Bonatti or perhaps by Antonio Gherardi (see R.45).

The paintings need cleaning, most notably *Hyacinth* whose left knee is badly torn.
Bibliography Waterhouse, 1937, p. 82; Martinelli, 1966, pp. 716–7 and figs. 462–3.

R.6. BUDAPEST, Private Collection
St. Jerome
Canvas, 64 × 51 cm.

The picture, which I know only from a photograph, is clearly by the same hand as Cat. R.51. The feebleness with which the forms are realized and the lack of coherence in the design reveal in my opinion, that neither picture is by Mola, but that they are by the same hand as R.1, and they thus form part of the group of pictures by Francesco Giovane.
Bibliography Czobor, 1968, p. 569 and Fig. 1.

R.7. BUDAPEST, Museum of Fine Arts
St. Jerome
Canvas, 65·5 × 48 cm.

The picture, which I know only from a photograph, was attributed to Mola by Miss Czobor, who linked it unconvincingly with R.18. The bloated, clumsy surfaces of this picture are not, in my opinion, by Mola but may link with R.35 by Giovane.
Bibliography Czobor, 1968, p. 633 and fig. 51.

R.8. BURGHLEY HOUSE, Stamford (no. 318)
Winter
Canvas, 37¼ × 29¾ in.
Provenance Cardinal Altieri; 9th Earl of Exeter.

The Marchioness of Exeter suggests that the picture may have come from the Barberini Collection, but the inscription on the back of the

canvas, which reads 'Legato dett Emo Sig Card Patuzzo Altieri li 31 lugo. 1698', establishes that it comes from the Altieri Collection. There is a full account of Cardinal Patuzzo Altieri's career in Pastor, 1953, Vol. 31, pp. 443 ff.

The attribution has always been controversial, since the picture was mentioned by the 9th Earl of Exeter (1725–91) as by Gaulli. Professor Waterhouse noted that it is by the same hand as the *Homer with His Scribe* in the Weston Collection, which he has convincingly identified as the picture by Loth sold in the Anthony Hoevenaer Sale, Amsterdam, 15 April 1693 (see Ewald, 1965, p. 123, no. 550). The picture would also, as Professor Waterhouse concluded, be acceptable as an early Loth.

Bibliography Marchioness of Exeter, 1954, no. 318.

R.9. BURGHLEY HOUSE, Stamford

Jupiter and Mercury

Canvas, 19 × 25⅜ in.

The painting is a weaker version of a picture now in a private collection in Switzerland. The Mercury in this latter canvas is close to the Magdalene in Cat. R.49 and the picture could also be by Bancuore. The composition derives from Dosso Dossi's version of this theme, now in Vienna, but which, as noted by Mezzetti 1965, p. 123, no. 219, was in Venice in 1663.

The attribution of the picture to Bancuore would confirm Pio's account of his trip to Venice. The painting is later than R.49 and can probably be dated to the end of the decade 1660–70.

Bibliography Marchioness of Exeter, 1954, no. 175.

R.10. BURGHLEY HOUSE, Stamford

Tobias and the Angel

Canvas, 48¼ × 44 in.

The dark, unatmospheric landscape and the raw, clumsy figures are not by Mola, and, at best, the picture might be a distant derivation from a now lost Mola.

Bibliography Marchioness of Exeter, 1954, no. 175.

R.11 CHICAGO, Art Institute

Homer Dictating

Canvas, 71·2 × 96·5 cm.

Provenance C. H. Worcester Bequest, 1930.

The composition of the picture derives from Cat. 43, but a comparison of the two pictures underlines the gulf between them. The small boy derives from a type that Mola had used in Cat. 65, but the handling is weaker and the mask-like, and inexpressive features are reminiscent of the Virgin in the *Presentation in the Temple* in S. Maria in Trivio by Giovane (see under Cat. R.1). Since the clumsy head of Homer, with its overstrong contrast of light and shade is close to no. 570 of the 1713 Pallavicini Inventory by Giovane (see under Cat. R.35), it seems convincing to attribute the picture to Giovane, and to date it to the period 1666–9.

Another version, in the Rumentzoff Gallery, Moscow which was illustrated by Voss, 1924, p. 286, differs slightly in the table in the foreground and in Homer's gesture. It is also, to judge from a reproduction, by Giovane.

Bibliography Voss, in Thieme-Becker, 1931, p. 29.

R.14. CLEVELAND, Museum of Fine Arts

Amor Vincit Omnia

Canvas, 97·5 × 127·5 cm.

Dr. Schaar connected the picture with the drawing of this subject in the Lugt Collection, and attributed it to Mola. The old attribution to Poussin has been abandoned (see Blunt, 1966, p. 173, R.58).

The heavy forms of the women and the crisp fluffy textures of the trees are not typical of Mola, and the attribution is not, in my opinion, convincing. The drawing, which is certainly by Mola since the landscape is similar to that in Pl. 12 is close enough to the painting to suggest that it is a copy, in which there are a few minor alterations.

It is difficult to understand why Mola copied this picture for which no convincing attribution can be made. Testa has been suggested, and it is an attractive hypothesis that Mola would have copied the work of his friend, but it is difficult to reconcile the style of the painting with that of Testa.

The certain early pictures by Testa, the *Moses Striking the Rock* from the Giustiniani Collection datable before 1638 (see Salerno, 1960, no. 105), the related, but probably earlier, *Massacre of the Innocents* in the Spada Collection, and the *Venus and Adonis* in the Vienna Academy, cannot be by the same hand as the Cleveland painting whose attribution remains problematical (see Sutherland Harris, 1967, pp. 39–40). The figures in Mola's drawing are close to those in Pl. 34 and so it can probably be dated to the period after Mola's return to Rome in 1647.

Bibliography Schaar, 1961, pp. 184 ff., Blunt, 1960, p. 400; Sutherland, 1967, p. 39.
Exhibitions Paris, . . . *Poussin*, 1960, no. 33

R.15. COPENHAGEN, Statens Museum fur Kunst
Rest on the Flight
Canvas, 9·7 × 18 cm.
Provenance Bought for the Royal Collection from Magnus Berg in 1739 (as Mola).

The heavy laboured handling and the lack of atmosphere in the landscape, which preclude an attribution to Mola, betray a distant debt to Salvator Rosa.

The picture was no. 532 in the 1848 MS. Catalogue of the Royal Collection drawn up by Stroe.
Bibliography Olsen, 1961, p. 79.

R.15A. CORTONA, S. Marco
Trinity
Canvas.
See under Cat. L.68.

R.16. DARMSTADT, Hessisches Landesmuseum
Hagar and Ishmael in the Wilderness
Canvas, 136 × 96 cm.

The picture is attributed by the museum to Romanelli. This is more convincing than the old attribution to Mola, but since the composition appears to reflect Mola's *St. Bruno*, Cat. 45, which was probably painted after 1663 the picture may be by a follower of Romanelli, who died in 1662.
Bibliography Voss, 1924, p. 562.

R.17. DRESDEN, Gemäldegalerie (No. 715)
Homer Dictating
Canvas, 95 × 131 cm.
Provenance In the Collection of Frederick Augustus III by 1754.

Voss's attribution to Mola of the picture, which was recorded in the 1754 Royal Inventory as by Valentin, cannot be sustained. Although it is a variant of Cat. 43 the poor and laboured execution is not autograph, but is close in quality to that in the underpainting in Cat. 5.
Bibliography Voss, 1924, p. 561; Dresden, Gemäldegalerie 1929, p. 190, no. 175.

R.18. EDINBURGH, National Galleries of Scotland
St. Jerome
Canvas, 23¼ × 30½ in.

Provenance De Franchi Collection, Genoa; acquired by the Edinburgh Royal Institution about 1830.

The picture, which was acquired as by Franceschini, is close to Guercino, but the author of the catalogue hesitated to pronounce it authentic, and more recently Denis Mahon's attribution to Mola has been accepted.

The broken handling in the forehead of the Saint is closer to early Guercino, notably the *St. Jerome Sealing a Letter* in a Roman Private Collection which was exhibited as no. 22 in the 1968 Bologna Exhibition, than to Mola (compare, for example, the *Prodigal Son*, Cat. 10).

The picture is by an unidentified follower of Guercino, not Mola.
Bibliography Edinburgh, catalogue, 1957, p. 116; Czobor, 1968, p. 569.

R.19. FELTRE, Museo Civico
Philosopher
Canvas, 127 × 97 cm.
Provenance Sala del Consiglio del Palazzo Comunale, Feltre.
Bibliography Valcanover, 1954.

R.20. FELTRE, Museo Civico
Prophet
Canvas, 127 × 97 cm.
Provenance as above.

The attribution to Mola of these two pictures, which have been cut down, was suggested by Fiocco. It is unconvincing. The pictures are not by the same hand, the lumpish heavy *Philosopher* may be by the artist responsible for Cat. R.57. The handling of R.20 is freer than that of R.19 with a richer brown and red tonality in the flesh tones. Neither in pose, nor in choice of subject are the pictures related.
Bibliography Valcanover, 1954.

R.21. FLORENCE, Palazzo Pitti
A Poet
Canvas, 75 × 89 cm.

The old attribution to Salvator Rosa has been exchanged for an equally improbable one to Mola, with whom the picture has no connexion.
Bibliography Inghirami, 1828, p. 40, no. 13 (as Rosa).

R.22. GLASGOW, City Art Gallery and Museum (No. 166)

St. John the Baptist Preaching
Canvas, 26⅜ × 20⅝ in.
Provenance M'Lellan Bequest of 1854, as Mola.

The museum now follows Arslan's convincing attribution to Zuccarelli.
Bibliography Voss in Thieme-Becker, 1931, p. 29; Arslan, 1934, p. 509.

R.23. LENINGRAD, Hermitage

Rebecca and Eliezer at the Well
Canvas.

The picture, as Mrs. Vsevoloshkája noted, is related to a version in the Tel Aviv Museum, attributed to Rosa da Tivoli. Neither picture can be by Mola, but they derive from the style of his early paintings, notably Cat. 66. The handling is weaker, and the lighting less rich and Venetian than in the Mola.

R.24. LONDON, Colnaghi

Hermits in a Landscape
Canvas, 28¾ × 38¼ in.

The picture is close to Mola, but the landscape is more complex than those which he painted in the decade 1640–50, see Cat. 61, and the handling is darker and less Venetian. The figures are not so accomplished as those in Cat. 62.

This accomplished essay in Mola's style is by an otherwise unidentified follower.

R.25. LONDON, formerly Colnaghi

Joseph Explaining his Dreams to his Brothers
Canvas, 26½ × 37⅐ in.

The picture is related to a painting in the Cassa dei Depositi e Prestiti, Rome, which was exhibited in the Palazzo Barberini, Rome, 1956, no. 11, fig. V. This picture, which the nineteenth-century Catalogue of the Quadreria del Monte di Pietà attributed to the school of Lanfranco, has been convincingly attributed to Baldi by Professor Faldi. A similar attribution is acceptable for the present picture, which is too clumsy to be by Mola but which was influenced by the landscapes from the last decade of his career.

R.26. LONDON, Colnaghi

Landscape with St. Bernard Adoring the Instruments of the Passion
Canvas, 78¾ × 58¾ in.

The landscape is attributed to Dughet. The modern attribution to Mola and Dughet rests on an unconvincing comparison with Cat. 24.

The weak forms of the landscape do not carry conviction as Dughet, and the further comparisons with nos. 112 and 113 in the Bologna, 1962, exhibition weaken the case for an attribution to him. The slack, sentimental forms of the Saint are, perhaps, closer to Le Sueur (see the *St. Bruno* formerly in Berlin illustrated in Blunt, 1957, Plate 145 (A)) than to Mola.
Exhibitions Colnaghi, 1963, no. 27.

R.27. LONDON, Royal Academy

Christ Succoured by Angels in the Wilderness
Canvas, 47 × 40 in.
Provenance Presented by Henry Thomson, R.A., in 1827.

The picture, which cannot be traced before the beginning of the last century, is not in my opinion autograph. Comparison with Cats. 3 and 18 reveal that the svelte figures are not by Mola. The landscape derives from that of Cat. 61, but lacks the clarity of structure found in the Mola. The picture is by an unidentified follower of Mola.
Bibliography Voss, in Thieme-Becker, 1931, p. 29.
Exhibitions R.A. Winter Exhibition, 1891, no. 111; London, Royal Academy, 1963, no. 38.

R.28. MADRID, Private Collection

St. Onofrio
Canvas.
Bibliography Pérez Sánchez, 1965, p. 309 and fig. 84.

R.29. MADRID, Private Collection

St. Jerome
Canvas.

The earlier history of these companion pictures, whose attribution is modern, is unknown. The pictures have nothing to do with Mola.
Bibliography Pérez Sánchez, 1965, p. 309 and fig. 84.

R.30. MADRID, Prado (deposited at the Museo de Zamora)

St. John the Baptist Preaching
Canvas, 98 × 136 cm.
Provenance Acquired in 1914, as Mola.

This academic painting cannot be by Mola; it seems to date from later in the century and to be by an artist influenced by Mola.
Bibliography Pérez Sánchez, 1965, p. 309 and fig. 85.

R.31. MONTPELLIER, Musée Fabre
St. John the Baptist Preaching
Panel, 37 × 27 cm.
Provenance Deposited by the Louvre.

This reversed copy after Cat. 35, based on the engraving, is too feeble to be by Mola.
Bibliography Villot, 1873, no. 271.

R.32. MUNICH, Schleissheim
Baptism of Christ
Canvas, 148 × 117 cm.
Provenance Elector Palatine in Düsseldorf by 1778.

The 1805 Catalogue of the Elector Palatine's Collection, which follows the Basle edition of 1778, attributes the picture to Mola. Modern scholars have abandoned this attribution and it was exhibited in Bologna as a Ludovico Carracci. The attribution is not (as Mr. Michael Kitson observed) wholly convincing, and it seems likely that the picture is by an unidentified Bolognese artist and that it can be dated to the period 1600–20.
Bibliography Düsseldorf Catalogue of the Elector Palatine's Collection, 1805, no. 141.
Exhibitions Bologna, 1956, no. 3.

R.33. OXFORD, Ashmolean Museum
An Oriental
Canvas, 99 × 74 cm.
Provenance Purchased in 1960.

The modern attribution to Mola rests on a mistaken comparison with Cat. R.57. The two pictures are not by the same hand, and the Ashmolean painting is closer to Castiglione than to Mola.
Bibliography Oxford, Catalogue, 1961, no. A.937.

R.34. OXFORD, Christ Church
Diogenes with his Lamp
Canvas, 77 × 56 cm.
Provenance Guise Bequest, 1765.

The picture, which was attributed to Ribera in the 1776 Catalogue, is in poor condition which makes judgement difficult. The weaknesses with which the forms are realized suggest that it is, at best, by a follower rather than autograph.
Bibliography Byam Shaw, 1967, p. 87, no. 140.

R.35. ROME, Accademia di San Luca
Head of an Old Man
Canvas, 66 × 50 cm.
Bibliography Golzio, 1964, no. 368.

R.36. ROME, Accademia di San Luca
Head of an Old Man
Canvas, 66 × 50 cm.

The heads derive from that of the *St. Bruno*, Cat. 45, but the handling is looser and weaker. The same hand was responsible for the *Head of an Old Man* no. 570 in the Pallavicini Collection, which the 1713 inventory attributes to Francesco Giovane (see Zeri, 1959, p. 143). The attribution of this group of heads to Giovane confirms the account of Pio (see under Cat. R.1) that after studying with Andrea Sacchi he worked in Mola's studio. Other paintings by the same hand are listed under Cats. R.7 and 11. A further picture, the *St. Jerome*, no. 0–2892 in the Narodni Gallery, Prague, can be added to this group.
Bibliography Golzio, 1964, no. 366.

R.37. ROME, Barberini Collection
Head of a Poet
Canvas.

The picture, which I know only from a photograph, is, as Martinelli noted, close to Cats. R.35 and 36. The loose handling of the forms suggests an attribution to Giovane. Since Martinelli did not specify the dimensions it is not possible to verify his claim that the picture is no. 971 in the 1782 Catalogue of the Colonna Collection. This catalogue is not reliable, see L.56 and 57.
Bibliography Martinelli, 1966, p. 717, fig. 464.

R.37A–40. ROME, Busiri Vici Collection
St. Jerome in the Desert; Franciscan Monks; Monk in a Landscape; The Penitent Magdalene
Canvas, 35 × 46 cm., each.

The pictures share the same dimensions. According to the catalogue of the Rome exhibition there is an old inscription to Mola on the back of the canvases. The freedom with which the pictures are handled, which was stressed by the author of the Rome catalogue who referred to their revolutionary quality, indicates that they should be dated after Mola's death. The handling finds its closest counterpart in the *Baptism of Christ*, no. 402 in the Vatican Galleries, which is attributed to Paul Troger, and is included among his certain works in Thieme-Becker, Vol. XXXIII, 1933, p. 417.

The artist must have been aware of Mola's *St.*

Bruno, since the landscape, notably the crossed trees in the *Penitent Magdalene*, refers to Cat. 45. The freedom of the handling suggests that the artist was not trained by Mola.
Exhibitions Il Seicento Europeo, Rome, 1956, nos. 212–14.

R.41. ROME, Cassa Depositi e Prestiti
The Return of the Spies from the Promised Land
Canvas, 74 × 90 cm.
Provenance Quadreria del Monte di Pietà; acquired in 1874.
Bibliography Catalogue, 1857, no. 561 (quoted in Faldi); Faldi, 1956, no. 83.

R.42. ROME, Cassa Depositi e Prestiti
Cain Slaying Abel
Canvas, 73 × 100 cm.
Provenance As above.

The nineteenth-century Catalogue of the Quadreria del Monte di Pietà, which from 1852–7 was run by Giovan Pietro Campana, records the pictures as old copies after Mola. This is convincing since no autograph painting by Mola has such formless figures as those of the companions of Moses. The pictures are not by the same hand, R.41 is closer to late Mola, notably Cat. 45, but the forms in R.42 are slacker and less controlled.

The pictures are studio versions of two designs which Mola undertook in the last year of his life for the Colonna for which at least three autograph drawings survive (which I hope to publish elsewhere).
Bibliography Catalogue, 1857, no. 217 (quoted in Faldi); Faldi, 1956, no. 82.

R.43. ROME, Galleria Borghese
St. Peter Liberated from Prison
Canvas, 195 × 144 cm.

The picture, which was catalogued in the 1693 Borghese Inventory as Valentin, was first attributed to Mola in the 1790 Inventory. It has been accepted by all modern critics except Waterhouse, 1937, who rightly excluded it from his list of works by Mola. The stiff mechanical handling, the dark background and the failure to relate the figures to each other preclude an attribution to Mola. The picture is probably by a weak follower of Caravaggio.
Bibliography Arslan, 1928, p. 63 and fig. 6; Pergola, 1959, no. 155.
Exhibitions Florence, 1922, no. 688.

R.44. ROME, Gallerie Capitoline
Nathan Rebukes David
Canvas, 105 × 192 cm.
Provenance Pio Collection; acquired by Benedict XIV in 1750.

Professor Pietrangeli drew my attention to the passage in Cittadella's life of Bonatti which refers to the *Nathan before David* which he painted for his protector Pio. It is reasonable to associate the picture with this passage, for although it was called Mola in 1750 it cannot be by him. The arms of David and Nathan do not relate together, and the handling, which derives from that of late Mola, loses substance in the shadows. The composition reflects that of the pictures which Mola painted in the period 1663–6, notably that of Cat. 43, since (as noted under Cat. 39) Cardinal Carlo Pio returned to Rome with Bonatti in 1662.
Bibliography Rome, Pio Collection Inventory, 1750 (as Mola); Venuti, 1766, Vol. II, p. 338; Cittadella, 1782–3, Vol. III, pp. 285 ff.; Arslan, 1928, p. 58 and fig. 2; Waterhouse, 1937, p. 83; Pietrangeli, 1954, p. 59.

R.45. ROME, Gallerie Capitoline
Esther before Ahasuerus
Canvas, 105 × 192 cm.
Provenance Pio Collection; acquired by Benedict XIV, in 1750.

Professor Pietrangeli kindly brought to my attention the unpublished 1697 Pio Inventory in which the picture is listed as: 'Il re Assuero con la Moglie svenuta di Gio. Bonatti da 7 e 6.' Arslan, who did not know of this inventory, noted a falling off in the picture which it is possible to appreciate as an indication that it is not by Mola. No other pictures from a comparable phase of Bonatti's development have been identified, but comparison with Cat. 4 reveals his debt to Mola and the difference in quality.

The composition derives from Veronese's ceiling in S. Sebastiano, Venice, but as with the contemporary pictures by Antonio Gherardi, notably his early frescoes illustrating scenes from the life of Esther at 2 via Monterone (see Mezzetti, 1948, pp. 157 ff. and figs. 4–7), this Venetian source reflects the impact of Mola's late style.
Bibliography Rome, Pio Inventory, 1750 (as Mola); Venuti, 1766, Vol. II, p. 331; Arslan, 1928, p. 70 and fig. 12; Waterhouse, 1937, p. 83; Bocconi, 1950, p. 356.

R.46. ROME, Galleria Colonna (No. 142)
Cain and Abel
Canvas.

The Gallery maintains the attribution, which was first made in the 1782 Catalogue: '976 Un quadro 6½ quasi quadrato rappresentante il Fratricido di Caino = Pier Francesco Mola ad imitazione di Tiziano.' The modern literature has rightly ignored the picture which has no connection with Mola.
Bibliography Rome, *Catalogo ... Casa Colonna*, 1782, p. 126.

R.47. ROME, Incisa Collection
Portrait of Alexander VII
Canvas, 119 × 95 cm.
Provenance Given to Agostino Chigi by Favolo Falconieri in 1701; thence by descent.

The provenance is recorded on a label on the back of the canvas. Martinelli identified the picture with the Portrait of Alexander VII (1655–67) mentioned by Pascoli, 1730, p. 124.

The picture does not fit with the surviving visual evidence for Mola's portrait. A drawing at Stockholm, 554/1863, by A. Masucci (see Clark, 1967, p. 15, no. 71) shows Mola painting the Pope. The composition recorded on the canvas in Masucci's drawing is not the same as that of the present painting

Martinelli rightly identified two drawings in the Fogg Museum, 1932.237 and 1932.239, as by Mola. Comparison with the drawing in Stockholm confirms Martinelli's identification of the sitter as Alexander VII, but reveals that they cannot be connected with the portrait recorded by Masucci. The attribution to Mola of the drawings, which Lavin, 1956, pp. 55–9 had attributed to Pietro da Cortona, does not rest upon their connexion with the present picture, since they show the Pope blessing with his right arm which in the painting rests on the chair, but upon their relationship with the certain drawings by Mola, notably Edinburgh, D.762 (see Rowlands, 1964, p. 27).

The picture's history further makes it extremely unlikely to be the portrait mentioned by Pascoli. Since Alexander VII was a Chigi, there was no reason for such an important portrait of the Pope to be acquired by the family as late as 1701.

The painting is not, to judge from a photograph, close to Mola's authenticated portraits. The attribution is, apparently, due to Martinelli.
Bibliography Martinelli, 1958, pp. 99 ff.

R.48. ROME, Pallavicini Collection
Holy Family
Canvas, 61·9 × 51 cm.
Provenance Cardinal Lazzaro Pallavicini; thence by descent.

The picture, which was catalogued in the 1679 Will of Lazzaro Pallavicini as 'Del Mola, allievo dell' Albano', cannot be by Mola. Zeri rightly noted the difficulty with the attribution and suggested that it might be by the mysterious G. B. Mola. This hypothesis is attractive since the entry in the 1679 Will contrasts with that of the autograph Cat. 50, which is recorded as by 'Mola'. This picture cannot be by the same hand as the one autograph painting by G. B. Mola, the *Holy Family with St. John the Baptist* now in Seattle, Pl. 145. The picture, which is signed 'J. Mola' and dated 1657 was probably no. 433 in the 1740 inventory of Pierre Crozat's collection (see Stuffman, 1968, p. 60, no. 27) since its dimensions, twenty inches by fifteen, correspond with those of the Seattle painting, twenty-five and eleven-sixteenth inches by eighteen and a half inches. The signature of the Seattle painting, although not calligraphically similar, corresponds with that which Mola's father used on his drawings, see for example Inventory no. P.114–1890 in the Victoria and Albert Museum published by Mola-Noehles, 1967, Pl. 1. The picture confirms Pio's story that G. B Mola was active as a painter.

The Pallavicini picture, which derives from Albani (see Bologna, 1962, p. 148, no. 53), may date from the end of the 1650s The weak clumsy forms, and mask-like faces are close to those in the group of paintings by Giovane, see Cat. R.1, and could be by him. That it was thought to be by Mola as early as 1679 suggests that it was painted in his studio.
Bibliography Pallavicini Will 1679, no. 135 (published in Zeri); Zeri, 1959, p. 182, no. 314.

R.49. ROME, Pallavicini Collection
Vision of the Magdalene
Canvas, 34 × 26·1 cm.
Provenance As above.

The picture, which was catalogued in the 1679 Will as 'Del Mola, discepolo dell' Albano', has been dated to c. 1640 by Zeri. It is weaker than the paintings which can be connected with the period when Mola was working with Albani, see Cats. 18 and 20, with a schematic contrast between the blue horizon and the clumsy, badly drawn figures.

The mechanical and stiff putti are by the same hand as those in the *Rest on the Flight* in the Sestieri

Collection, Rome which has an old attribution to Bancuore. Since, according to Pio, Bancuore was born in 1640 the picture must be dated *c.* 1660, before his trip to Venice, see R.9. The motif of the flying putti derives from Cat. 3, which Mola must have painted in Bologna.
Bibliography Pallavicini Will, 1679, no. 69 (published by Zeri); Zeri, 1959, p. 182, no. 311.

R.50. ROME, Pallavicini Collection
St. John the Baptist
Canvas, 62·5 × 39 cm.
This picture, which Zeri compared with Cat. 54, is by Francesco Giovane. The execrable quality of the rigid inexpressive head which derives from the Baptist in Cat. 24, is close to the *Presentation of the Virgin* in S. Maria in Trivio (see Cat. R.1).
Bibliography Inventory, 1708, no. 323, as Mola (quoted by Zeri); Zeri, 1959, p. 182, no. 312.

R.51. ROME, Vatican Galleries
St. Jerome in Ectasy
Canvas, 62 × 46 cm.
Provenance Added to the Vatican Galleries in 1909.
Francia, p. 63, established that the picture, which did not form part of the original nucleus of paintings in the Vatican Galleries, was added in the reorganization of 1909. Arslan suggested that this might be a late work by Mola, but the weak quality and incoherent handling reveal the hand of Giovane, see Cat. R.1 and the related picture in Budapest, R.6.
Bibliography Arslan, 1928, p. 74 and fig. 18; Francia, 1960, no. 285; Czobor, 1968, p. 569.

R.52. ROME, Vatican Galleries
St. Jerome
Canvas, 135 × 98 cm.
Provenance As above.
This accomplished painting with its striking red drapery and rich heavy impasto in the flesh is unlike any certain Mola, and is closer to Langetti.
Bibliography Francia, 1960, no. 301.

R.53. ROME, Vatican Galleries (no. 383)
The Incredulity of St. Thomas
Canvas, 115·5 × 142·5 cm.
The picture is a version of the painting by Guercino now in the National Gallery, London. Its attribution to Guercino was in doubt when it came from the Quirinal in 1792, but it is unlikely to be by Mola. The handling reflects the style of Guercino, not that of Mola (see under Cat. 10).
Bibliography Bologna, 1968, no. 47, p. 106.

R.54. ROME, S. Marco
Assumption of the Virgin
Canvas, with slightly under life-size figures.
The picture is recorded in the Titi of 1674 together with the *St. Michael*, Cat. 59 as by Mola. The attribution is a mistake since the picture, which has nothing to do with Mola, is related to the *Assumption of the Virgin* on the ceiling of the first chapel on the right of the main altar in S. Maria in Aracoeli, which is attributed by Titi, 1686, p. 169 to Giuseppe Ghezzi.
Bibliography Titi, 1674, p. 200; Hermanin, 1932, p. 30; Waterhouse, 1937, p. 83.

R.55. VALMONTONE, Palazzo Pamphili
Asia
Fresco, with slightly under life-size figures.
This figure which Montalto, 1955 fig. 3 attributed to Mola is closer to the allegorical frescoes by Cozza in Palazzo Altieri, published by Montalto, 1956 Fig. 9.

R.56. VENICE, Gallerie dell' Accademia
Homer
Canvas, 102 × 81 cm.
The picture is not listed in any of the nineteenth-century Catalogues of the Accademia. The clumsy handling, and heavy chiaroscuro preclude an attribution to Mola. The composition suggests a knowledge of Cat. 43.
Bibliography Fogolari, 1934, p. 15, no. XVI.

R.57. VENICE, Gallerie dell' Accademia
Sleeping Turk
Canvas, 76 × 115 cm.
Provenance Rava Collection; acquired 1955.
The modern attribution is due to Fiocco, who suggested that this might be an example of Mola's early Venetian style, as described by Passeri. Identification of Cat. 66 as an early work makes this unlikely since the style of R.57 is clumsier and more awkward than that of Cat. 66 with its romantic warm lighting.
The Venetian element in R.57 derives from Mola's mature style, as exemplified in Cat. 45, and the picture, which is clearly from Mola's studio, may be by Bonatti (see especially Cat. R.44).
Bibliography Moir, 1967, Vol. II, fig. 177 and Vol. I, p. 149.
Exhibitions Florence, 1922, no. 694; Venice, 1959, no. 91.

C

PAINTINGS ATTRIBUTED TO P.F. MOLA THAT CAN NO LONGER BE TRACED

The pictures listed in this section are based on references before 1766, one hundred years after Mola's death. Later references are no longer reliable. The entries are listed chronologically, finishing with engravings after Mola.

L.1 Copy after Veronese

Boschini, 1660, p. 194 refers to Mola's copies after the decoration of Ca' Nani for Cardinal Bichi, which can be dated *c*. 1644, see further p. 2. The decorations were presumably the seven cartoons of the *Life of Esther* described by Ridolfi, 1648, ed. Von Hadeln, 1914, Vol. I, p. 341.

L.2 Frescoes in the Pamphili Palace at Nettuno

These frescoes are referred to in the documentation on the Valmontone trial, notably by Niccolò Sega who dated them to *c*. 1653 (see Montalto, 1955, p. 301), and by G. B. Mola, 1663, ed. Noehles, 1967, p. 214. Nibby, 1848–9 no longer refers to this Palace in his account of Anzio.

L.3 *Assumption of the Virgin*

A standard of this subject is mentioned as having been painted for the Pamphili in 1657 by Vaselli, Ronca and Somigliano, although there is some disagreement about the subject (see pp. 4, 56).

L.4 *America*

Mola received the final payment for this fresco at Valmontone on 20 October 1658 (see Montalto, 1955, p. 291). It is no longer possible to trace the fresco, which may still exist (see Cocke, 1968, p. 558, note 1).

L.5 *Stigmatization of St. Francis, and Crucifixion*

These pictures were described in the Ospedale dei Mendicanti, Rome, by G. B. Mola, 1663, ed. Noehles, 1967, p. 167. The church, as noted by Wibiral, 1960, p. 158, was destroyed between 1877 and 1887 (see Forcella, 1869–84, Vol. X, p. 413 and Armellini, 1887, Vol. I, p. 520).

L.6 Unidentified pictures

Mola worked for the Chigi in their Palace at SS. Apostoli, in 1662–3 (see Montalto, 1955, p. 295 and under Cat. 45 and p. 7).

L.7 *Portrait of a Woman*

The picture, which measured $2\frac{1}{2} \times 2$ palms, was acquired for the Ruffo collection in 1670 (see Ruffo, 1916, p. 186 and p. 317).

L.8 *Penitent Magdalene*

The picture was no. 27 in the 1677 inventory of Robert Harpur drawn up in Rome (see Burdon, 1960, p. 25).

L.9 *Soldier*

The picture was no. 28 in Harpur's collection (see Burdon, 1960, p. 25).

L.10 *St. John the Baptist*

The inventory of Cardinal Massimi's collection, which was drawn up on 11 October 1677, MS. Vatican 260 Cappon. unpaginated (which I know from a photocopy in the Warburg Institute) included: 'Un quadro di S. Gio col calice mezza fig. a alto 2 scanti (?) ea largo P .mi $1\frac{1}{2}$ di mano del Mola.'

L.11 *Virgin and Child*

The 1677 inventory of Cardinal Massimi's collection also included: 'Un tondino d'un pm.a con la Madd.na e il Bambino di mano del Mola.'

L.12 *Lot and his Daughters*

The picture was no. 160 in the 1679 inventory of Cardinal Lazzaro Pallavicini's collection: 'Lot imbriacato dalle due figlie, figure intiere in piccolo in un quadro . . . del Mola' (see Zeri, 1959, p. 296).

L.13 *St. Barnabas Preaching*

The List of paintings sent from Naples to Spain from 1683–7, MS. Escorial IV–25 (which I know from a photocopy in the Warburg Institute) included on p. 13: 'Un S .n Blas obispo que esta predicando con no. 849 primero esbozo del quadro que esta en S .n Carlos de Lombardos de mano del Mola de Palm 2 y 1.'

L.14 *Landscape*

P. 14 of the 1683–7 List of paintings mentions: 'Un paisite Ochavado sin n.o de mano del Mola.'

L.15 *Christ*

The 1683–7 List of pictures includes on p. 15: 'Una Nuestra Senora buetta en profilo . . . con n.o 975 de mano di Francisco Mola, o del Morandi de Palm 1.'

L.16 Copy after Titian's *St. Peter Martyr*

P. 18 of the 1683–7 List included: 'Un quadro que representa San Pedro Martir con no. 182 copia da Titiano he cho por el Mola de palm 5 y 3.'

L.17 *Portrait of a Boy*

P. 20 of the 1683–7 List included: 'Un quadro en tabla que representa un Nino con una mancana en manos he cho con pasteles con n.o 960 de mano del Mola de palm 1½ y 1.'

L.18 *Portrait of a Young Boy*

P. 20 of the 1683–7 List mentioned: 'Un quadro que representa un moco con una cadena de oro, que le atraviezza a las espalles con num.o 696 sobra cuero dorado de mano del Mola de palm 1½ por todas partes.'

L.19 Copy after Titian's *St. Peter Martyr*

P. 24 of the 1683–7 List included 'Un San Pedro Martir in n.o copia de Titiano de mano del Mola'.

L.20 *Head of Medusa*

The picture was no. 138 in the 1689 inventory of the collection of Queen Christina of Sweden, but was not included in the inventory of 1721 (see Granberg, 1897, p. 44).

L.21 Pictures of unidentified subjects

Three paintings attributed to Mola were sold from the Johan de Jongen collection at the Hague, 24 March 1692 (see Hoet, 1752, Vol. I, pp. 5 and 6).

L.22 *God the Father and the Archangel Raphael*

The 1692 inventory of Cardinal Flavio Chigi's paintings in the Palace at SS. Apostoli mentioned as no. 97: 'Un Quadro tela di pmi 3 e 2½ . . . con . . . un Angelo Raffaelle, et un putto col camavero del Papa, et un altro, che tiene una fiaccola con una gloria in Cielo, con Dio padre e Cherubini, mano del Mola' (see Arslan, 1928, p. 80).

L.23 *Portrait of Virgilius Bifolcus*

No. 36 in Flavio Chigi's inventory of 1692 was: 'Un quadro in tela di pmi 4 . . . con il ritratto del poeta Virgilio Bifolco, con un libro in mano, fatto del Mola' (see Arslan, 1928, p. 80 and Voss, 1910, for a reproduction of an engraving after the portrait).

L.24 *Venus and Cupids*

No. 146 in Flavio Chigi's inventory of 1692 was: 'Due quadri compagni tela di pmi 3 e 2½ . . . in uno . . . diversi Amorini p. aria e paese, e l'altro con diverse figure con Venere a sedere, con un' altra figura che li porge un vezzo di perle, con un Amorino p. aria, che tiene due piccione legati, con paese, mano d'uno scolaro dell' Albano, chiamato il Mola' (see Arslan, 1928, p. 80).

L.25 *Four Sheep*

No. 187 in Flavio Chigi's inventory of 1692 was: 'Un quadro d'un pmo alto e = longo, . . . con quattro pecorelle, mano del Mola' (see Arslan, 1928, p. 80).

L.26 *Bacchus*

No. 168 in Flavio Chigi's inventory of 1692 was: 'Un quadro di p.mi 4 e 3, . . . con un Bacco con grappo d'uva in mano, e dall' altro il tirso, mano dell Mola' (see Arslan, 1928, p. 80). Since 1 palm is the equivalent of about 25 cm. (see *Enciclopedia Italiana*, Vol. XXVI, 1935) the dimensions fit with those of Cat. 51 whose history before 1759 is otherwise unclear.

L.27 *Portrait of a Philosopher*

No. 173 in Flavio Chigi's inventory of 1692 was: 'Un quadro di pmi 4 e 3, . . . con il ritratto d'un filosofo, mano del Mola.' The picture was probably acquired from Giovanni Conforti in 1673 (see Golzio, 1939, p. 292, no. 532, and Arslan, 1928, p. 80).

L.28 *Portrait of a Young Man*

No. 44 in Flavio Chigi's inventory of 1692 was: 'Un quadro in tavola di pmi 2½ e 1½ . . . con un ritratto d'un giovanetto, con un berrettone in testa alla polacca, mano del Mola' (see Arslan, 1928, p. 80).

L.29 *Two Female Heads*

No. 72 in Flavio Chigi's inventory of 1692 was: 'Un quadro di pmi 2½ e 2 . . . con due teste di donne, una chiara e l'altra sbattimentata . . . mano del Mola' (see Arslan, 1928, p. 80).

L.30 *Bacchus*
The 1710 inventory of the Ruffo Collection mentioned: 'Un Bacco con diversi amorini di p.mi 3 e 2 del Mola, scolaro dell' Albano' (see Ruffo, 1916, p. 190).

L.31 *Pan and Syrinx*
The inventory of Carlo Maratta, drawn up on 28 April 1712, included as no. 187: 'Siringa e Pan con Paese del Mola 1 p. 4, alto poc. piu.' (See Galli, 1928, p. 63). Battisti, 1960, p. 89 established that this was one of the 124 pictures from the artist's collection which his daughter, Faustina, sold to Spain in 1722.

L.32 *Landscape*
No. 191 of the 1712 Maratta was: 'Paese del Mola' (see Galli, 1928, p. 63). It probably passed to Madrid in 1722 when it was listed as: 'Paese del Mola' (see Battisti, 1960, p. 88).

L.33 *Landscape with a Sleeping Child*
No. 192 in the 1712 Maratta inventory was: 'Un simil quadro (paese) del Mola 2 p.mi alto 1 p. 6 largo con un amorino che dorme' (see Galli, 1928, p. 63). In spite of a discrepancy in size this was probably the picture which passed to Spain in 1722 as 'In tela di 4 palmi che e un putto con fiore del Mola' (see Battisti, 1960, p. 88).

L.34 *Head of an Angel*
No. 247 in the 1712 inventory of the Maratta collection was: 'Una testa d'un Angiolo grande al naturale del Mola, dipinta a fresco' (see Galli, 1928, p. 67).

L.35 *Landscape*
No. 336 in the 1712 Maratta was a pair of pictures: 'Altri due paesi uno del Mola, l'altro del Gasparo Pussino compagni; 2 palmi et mezzo alti largo p.mi 1 poc. piu' (see Galli, 1928, p. 73). It may be the picture listed in 1722 inventory as 'Un paesino bislungo per alto del Mola' (see Battisti, 1960, p. 89).

L.36 *Portrait of Urban VIII*
The picture is mentioned as no. 265 in the 1713 inventory of Giovanni Battista Rospigliosi's collection: 'Un quadro in tela di p. 4 Ritratto di Papa Urbano in mezza figura, opera del Mola' (see Zeri, 1959, p. 308).

L.37 *Portrait of a Young Man*
No. 397 in the 1713 Rospigliosi inventory was: 'Un quadretto di p. 1 . . . con una testina d'un Giovane, del Mola' (see Zeri, 1959, p. 314).

L.38 *St. John the Baptist*
No. 18 in the Adrien Paets Sale, Rotterdam, 26 April 1713 was: 'Een Stuk, verbeeldende St. Jan in de Woestyne, door Francisco Mola, hoog 1 voet 8 duim, breed 2 voet' (see Hoet, 1752, Vol. I, p. 156).

L.39 *Venus and Adonis*

L.40 *Diana and Endymion*
These pictures are catalogued as being in the Dal Pozzo Palace, Verona, by Pozzo, 1718, p. 307.

L.41 *Susannah with the Elders*
No. 17 in the Quiryn van Biesum Sale, Rotterdam, 18 October 1719 was: 'Suzanna met de Boeven door Mola, h. 1 v. 5d., br. IV 2d.' (See Hoet, 1752, Vol. I, p. 227.)

L.42 Two unidentified paintings
Nos. 18 and 19 in the Quiryn van Biesum Sale were: 'Een dito, Vissertjes, van denzelven, h.1 en een half v. dbr. IV. 1d and 'Een dito, von denselven, zynde een weerga' (see Hoet, 1752, Vol. I, p. 227).

L.43 *Virgin and Child*
No. 20 in the Quiryn van Biesum Sale was: 'Maria met het Kindje van denzelven (Mola)' (see Hoet, 1752, Vol. I, p. 227).

L.44 *Landscape*
No. 47 in the De Amory Sale, Amsterdam, 23 June 1722 was: 'Een konstig Landschap van Mola, h. 2v. 2 d., br. IV 8d' (see Hoet, 1752, Vol. I, p. 263).

L.45 *A Hermit*
No. 39 in the D. Potter Sale, The Hague, 19 May 1723 was: 'Een Heremiet, door Mola, zynde Ovael' (see Hoet, 1752, Vol. I, p. 293).

L.46 *St. John the Baptist preaching*
Mariette, in his *Abecedario*, 1851–60, Vol. IV, p. 4, noted the now lost version of Cat. 35 engraved by Coelemans in the Cabinet Boyer d'Aguilles.

L.47 *Judith and Holofernes*

The picture is mentioned by Pascoli, 1730–36, Vol. I, p. 125, in Palazzo Costaguti.

L.48 *Lot with his Daughters*

The picture is mentioned by Pascoli, 1730–36, Vol. I, p. 125, as having been painted for the High Constable. The reference may be mistaken, since Pascoli in the same passage refers to the *Rebecca and Eliezer* painted for the High Constable, see Cat. 41. No *Lot with his Daughters* by Mola, is mentioned in the 1782 Catalogue of the Colonna Gallery and Pascoli appears to have in mind the *Angel Appearing to Hagar*, the companion of the *Rebecca*, see Cat. 42. There was a version of this theme in the Pallavicini Collection, see Cat. L.12.

L.49 *Portrait of Alexander VII*

The picture, which is mentioned by Pascoli, 1730–36, Vol. I, p. 124, is recorded by Masucci in a drawing now at Stockholm, see Cat. R.47.

L.50 *Diana and Endymion*

The picture, whose dimensions were 7 palms by 5, is mentioned by Pascoli, 1730–36, Vol. I, p. 125 in the collection of Bonaventura Argenti.

L.51 *Voyage of Jacob*

The picture, according to Pascoli, 1730–36, Vol. I, p. 127, was painted for the otherwise unidentified Alvarese, and impressed Louis XIV. It may have been the picture later in the Pierre Crozat Collection, Cat. 11.

L.52 *Birth of the Virgin*

The picture, whose subject Pascoli, 1730–36, Vol. I, p. 127, does not specify, was left unfinished at Mola's death. It was mentioned in the Vatican by Taja, 1750, p. 192, who identified the subject. This part of the decoration of S. Maria della Pace was completed by Vanni, see Waterhouse, 1937, p. 98.

L.53 *St. John the Baptist*

No. 100 in the Willem Six Sale, Amsterdam, 12 May 1734, was 'Een St. Jan, door Francisco Mola' (see Hoet, 1752, Vol. I, p. 416).

L.54 *Battle Scene*

No. 152 in the Willem Six Sale, Amsterdam, 12 May 1734, was 'Soldaatjes in een Rots, door Francisco Mola' (see Hoet, 1752, Vol. I, p. 416).

L.55 *St. Peter Baptizing in Prison*

No. 53 in the catalogue of paintings sold Amsterdam, 21 October 1739, was 'Petrus in de Gevankenis, kragtig geschildert, door Francisco Molla, h. 4v 1d., br. 3v. 3d.' (see Hoet, 1752, Vol. I, p. 612). This must be a version of Cat. 53.

L.56 and L.57 *Narcissus,* and *Erminia with the Shepherds*

This pair of pictures were first mentioned in the 1740 inventory of Pierre Crozat's collection: '76, Deux petits tableaux faisant aussi pendant sous le même numero, peints sur toile de sept pouces et demi de haut sur dix pouces et demi de large représentant l'un le sujet de Narcisse que se mire dans l'eau avec des chiens dans un fond de paysage, l'autre un paysage avec des figures assises par le Mola.' (See Stuffman, 1968, p. 61.) Subsequently the pictures passed to Louis François Crozat, and thence to his younger brother Louis Antoine Crozat, Baron de Thiers, in whose collection they were catalogued in 1755, pp. 35 and 36. The pictures are now lost, and although Stuffman may be right in identifying them with nos. 957 and 961 of the 1774 Hermitage Catalogue (see Lacroix, 1862, p. 213), which are attributed to Giovanni Battista Bagnacavallo, there is now no trace of them in the Hermitage. Two similar pictures are mentioned under Cat. L.63. The designs of another version, Cat. 31, is reflected in one of a pair of tondi at Hanover (see Hanover, *Katalog,* 1954, nos. 22 and 23). The second of the pictures is an *Erminia with the Shepherds*. The two Hanover pictures came to the Gallery from the A. Kestner Collection (1777–1853). Since Kestner formed his collection in Rome after 1817 (see Hanover, . . . *Katalog,* 1954, pp. 22–3) the pictures are likely to be no. 315 of the 1782 Catalogue of the Colonna Gallery: 'Due tondini in tavola rappresentanti una Erminia col Pastore, l'altro narciso al Fonte = Francisco Mola.' The old attribution is, however, incorrect since the feeble quality points to an attribution to Francesco Giovane, see Cat. R.1.

L.58 *Portrait of a Woman*

No. 4 in the Pieter de Klok Sale, Amsterdam, 1744, was 'Een Lesende Vrouw, door Francisco Molo, zeer schoon en kragtig, h. 2v. 6d, br. 2 voet' (see Hoet, 1752, Vol. II, p. 128).

L.59 *Landscape*

No. 109 in the Maria Beukelaar Sale, The Hague, 19 April 1752, was: 'Een Landschap met Stoffagie

door Mola, h. 2v. 1 en een half d., br. 3 v. 11d.'
(See Hoet, 1752, Vol. II, p. 321.)

L.60 *Rest on the Flight*
The picture was included in the Coypel Sale,
Paris, 1753 (see Mireur, 1901–12, Vol. V, p. 237).

L.61 *Head of an Apostle*
The picture was included in the Coypel Sale,
Paris, 1753 (see Mireur, 1901–12, Vol. V, p. 237).

L.62 *Departure of the Daughters of Jethro*
No. 30 in the Duc de Tallard Sale, Rémy & Globy,
Paris, 22 March – 13 May 1756, was: 'Le Départ
des Filles de Jetro, Tableau sur toile, de vingt-six
pouces de haut, sur trente-cinq pouces de large.'
The picture was bought by Perier (see Rémy,
1756, p. 24).

L.63 *Narcissus*, and *Erminia and the Shepherds*
No. 20 in the J. B. de Troy Sale, Rémy, Paris
1764, was: 'Deux très beaux tableaux de ce Maître;
l'un représente une Pastorale, composée de deux
figures de belle proportion; l'autre, Narcis qui se
regarde dans l'eau; ils sont peints sur toile et portent
chacun 3 pieds 9 pouces de haut, sur 2 pieds
9 pouces de large' (I am grateful to Dr. A. Baarts
for this reference, see further L.56 and 57). Although
the subject of the second picture is not identified
Cats. L.56 and 57 suggest that it was *Erminia and
the Shepherds*.

L.64 *Rape of Europa*
No. 21 in the J. B. de Troy Sale, Rémy, Paris,
1764, was: 'L'Enlèvement d'Europe, peint sur
toile, de 2 pieds 3 pouces de haut, sur 2 pieds 11
pouces' (I am grateful to Dr. A. Baarts for this
reference). The dimensions fit with those of Cat.
27 whose earlier history is unknown.

L.65 *Portrait of Giovanni Battista Pamphili*
The picture was mentioned at Villa Belrispiro
by Venuti, 1766, Vol. II, p. 423.

L.66 *Suicide of Ajax*
The painting is known through the engraving
of Fr. Spierre (1639–81). The motto of the engrav-
ing 'Fortisque Viri tulit arma disertus' derives (as
Mr. Robin Cormack noted) from Ovid, *Meta-
morphoses*, Book 13, line 383. There is a preliminary
drawing for the design at Düsseldorf, F.P. 836.

L.67 *St. Bruno in Ecstasy*
The picture is known through the engraving by
A. E. Rousselet (fl. 1726–57). A preliminary draw-
ing for the design is at the Louvre, no. 8433. See
also Cat. 71.

L.68 *Trinity*
The design is known through an engraving by
C. Bloemart (*c.* 1603–84) and a painting in S.
Marco, Cortona, which is a school picture,
probably by Bancuore. Two drawings can be
related to the engraving: D. 762 in the National
Gallery of Scotland (see Rowlands, 1964, p. 274)
and no. 570/1863 in Stockholm, a study for the
head of God the Father. The composition appears
to have influenced Guglielmo Cortese's *Trinity
Appearing to St. Hilarion* in S. Giovanni in Laterano
of *c.* 1660–5 (see Salvagnini, 1937, Pl. 54 and
Waterhouse, 1937, p. 57). Cortese, who had
worked with Mola at Valmontone, gave evidence
on his behalf in 1662. A drawing in the Farnesina,
Rome, F.C. 127122, which is attributed to Mola,
is probably a sketch by Cortese for this fresco.

L.69 *Penitent Magdalene*
The picture was engraved by B. Picart (1673–
1733). A drawing for this design in Berlin-Dahlem,
no. K.d.Z 1238 was brought to my attention by
Mr. John Gere. Another drawing was engraved by
Rogers in his *Imitations of Drawings* of 1778. The
picture appears to have influenced the artist respon-
sible for R.40.

L.70 *Portrait of Volumnius Bandinellus*
The engraving after Mola's portrait was issued
by Clouet in 1658, the year in which Bandinellus
was appointed a Cardinal.

Bibliography

Catalogues are generally listed under the location of the collection or exhibition, but in some cases under the name of the compiler.

ACHIARDI, P. D', *La Pinacoteca Vaticana*, Bergamo, 1914.

AMBROSE, G. E., *Catalogue of the . . . Pictures . . . at Lansdowne House, London, and Bowood, Wilts,* London, 1897.

ARMELLINI, M., *Le Chiese di Roma,* 2 Vols., Rome, 1887, reprinted 1941.

ARSLAN, E., 'Opere del Grechetto a Genova, a Milano e a Firenze', *Arte Lombarda,* Vol. X, supplement, 1965, pp. 169 ff.

ARSLAN, E., 'Disegni del Mola a Stoccolma', *Essays in the History of Art Presented to Rudolf Wittkower,* London, 1967.

ARSLAN, W., 'Opere Romane di P. F. Mola', *Bollettino d'Arte,* 1928, pp. 55 ff.

ARSLAN, W., 'Considerazioni su Francesco Zuccarelli', *Bollettino d'Arte,* 1934, pp. 507 ff.

BAGLIONE, G., *Le Vite de' Pittori, Scultori, ed Architetti. Dal pontificato di Gregorio XIII del 1572. In fino a' tempi di Papa Urbano Ottavo nel 1642,* Rome, 1642.

BAILLY, N., *Inventaire des Tableaux du Roy redigé en 1709 et 1710,* ed. F. Engerand, Paris, 1899.

BALDINUCCI, F., *Notizie dei Professori del Disegno da Cimabue in qua,* 6 Vols., Florence, 1681–1728, reprinted 1847.

BASAN, P. F., *Catalogue Raisonné . . . du Cabinet de feu Mr. Mariette,* Paris, 1775.

BATTISTI, E., 'Postille documentarie su artisti italiani a Madrid e sulla Collezione Maratta', *Arte Antica e Moderna,* 1960, pp. 77 ff.

BEAN, J., *Catalogue of the Italian Drawings in the Art Museum, Princeton University,* Princeton, 1966.

BEAN, J., and STAMPFLE, F., *Drawings from the New York Collections, II: The Seventeenth Century in Italy,* New York, 1967.

BEAN, J., and VITZTHUM, W., 'Disegni del Lanfranco e del Benaschi', *Bollettino d'Arte,* 1961, pp. 106 ff.

BERENSON, B., *Italian Pictures of the Renaissance, Venetian School,* 2 Vols., London, 1957.

BERTHIER, J. J., *Chroniques du Monastère de San Sisto et de San Domenico à Rome,* 2 Vols., Levanto, 1919–1920.

BERTINI, A., *I Disegni Italiani della Biblioteca Reale di Torino,* Rome, 1958.

BERTOLOTTI, A., 'Testamenti ed Inventarii di Gaspare Mola Incisore', *Rivista Europea,* Vol. III, Florence, 1877, pp. 256 ff.

BERTOLOTTI, A., *Artisti Lombardi a Roma nei Secoli XV, XVI e XVII,* Milan, 1881.

BIRMINGHAM, CITY ART GALLERY, *Exhibition of Works by Sir Joshua Reynolds,* 1961.

BLUNT, A. F., 'The Heroic and the Ideal Landscape in the Work of Nicolas Poussin', *Journal of the Warburg and Courtauld Institutes,* Vol. VII, 1944, pp. 154 ff.

BLUNT, A. F., *The French Drawings at Windsor Castle,* London, 1945.

BLUNT, A. F., *The Drawings of Castiglione and Stefano della Bella . . . at Windsor Castle,* London, 1954.

BLUNT, A. F., *Art and Architecture in France, 1500–1700,* Harmondsworth, 1957.

BLUNT, A. F., 'Poussin Studies XIII: Early Falsifications of Poussin', *Burlington Magazine,* Vol. CIV, 1962, pp. 486 ff.

BLUNT, A. F., *The Paintings of Poussin: A Critical Catalogue,* London, 1966.

BLUNT, A. F., and COOKE, H. L., *Roman Drawings of the XVII and XVIII Centuries . . . at Windsor Castle,* London, 1960.

BLUNT, A. F., and CROFT-MURRAY, E., *Venetian Drawings of the XVII and XVIII Centuries . . . at Windsor Castle,* London, 1937.

BLUNT, A. F., see FRIEDLAENDER, W., 1939, 1949, 1953 and 1963.

BOASE, T. S. R., 'A Seventeenth Century Carmelite Legend Based on Tacitus', *Journal of the Warburg and Courtauld Institutes,* Vol. III, 1939–40, pp. 107 ff.

BIBLIOGRAPHY

BOCCAZZI, F., *La Basilica dei Santi Giovanni e Paolo in Venezia*, Venice, 1965.

BOCCHIUS, A., *Symbolicarum quæstionum de universo genere . . . libri quinque*, Bologna, 1574.

BOCCONI, S., *Collezioni Capitoline*, Rome, 1950.

BODMER, H., *Ludovico Carracci*, Burg, 1939.

BOECK, W., 'Die Bolognesischen Meister des Karikaturenbandes der Münchner Graphischen Sammlung', *Münchner Jahrbuch der bildenden Kunst*, Vol. V, 1954, pp. 154 ff.

BOLOGNA, PALAZZO DELL' ARCHIGINNASIO, *Mostra dei Carracci*, 1956.

BOLOGNA, PALAZZO DELL' ARCHIGINNASIO, *L'Ideale Classico del Seicento in Italia e la Pittura di Paesaggio*, 1962.

BOLOGNA, PALAZZO DELL' ARCHIGINNASIO, *Il Guercino*, Catalogo a cura di Denis Mahon, 1968.

BONNAFFÉ, E., *Dictionnaire des Amateurs Français au XVII ème Siècle*, Paris, 1884.

BOREA, E., *Domenichino*, Milan, 1965.

BOSCHETTO, A., 'Per la Conoscenza di Francesco Albani, Pittore', *Proporzioni*, 1948, pp. 109 ff.

BOSCHINI, M., *La Carta del Navegar Pitoresco*, Venice, 1660.

BOTTARI, G., *Raccolta di lettere sulla Pittura, Scultura ed Architettura scritte da' più Celebri Personaggi dei Secoli XV, XVI, e XVII, pubblicata da M. Gio. Bottari, e continuata fino ai nostri giorni da Stefano Ticozzi*, 8 Vols., Milan, 1822–5.

BOWOOD HOUSE, *see* AMBROSE, G. E., 1897.

BRANCA S., *Il Collezionismo Veneziano nel '600*, Padua, 1965.

BRAUER, H., and WITTKOWER, R., *Die Zeichnungen des Gianlorenzo Bernini*, Berlin, 1931.

BRENTANI, L., *Antichi Maestri d'Arte e di Scuola delle Terre Ticinesi. Notizie e documenti*, 7 Vols., Como and Lugano, 1937–63.

BRIGANTI, G., 'The Mahon Collection of Seicento Paintings', *Connoisseur*, Vol. CXXXII, 1953, pp. 4 ff.

BRIGANTI, G., *Pietro da Cortona*, Florence, 1962.

BRUNSWICK, *see* FLECHSIG, E., 1922.

BUCHANAN, W., *Memoirs of Painting*, 2 Vols., London, 1824.

BUCHOWIECKI, W., *Handbuch der Kirchen Roms*, Vienna, 1967.

BUDDE, I., *Beschreibender Katalog der Handzeichnungen in der Staatlichen Kunstakademie Düsseldorf*, Düsseldorf, 1930.

BUENEMANN, H., 'Zur Spätzeit des Benedetto Luti', *Pantheon*, 1965, pp. 47 ff.

BURDON, G., 'Sir Thomas Isham. An English Collector in Rome in 1677–8', *Italian Studies*, Vol. XV, 1960, pp. 1 ff.

BURGHLEY HOUSE, *see* EXETER, MARCHIONESS of, 1954.

BUSCAROLI, R., *La Pittura di Paesaggio in Italia*, Bologna, 1935.

BUSCOT PARK, *Catalogue of the Faringdon Collection*, National Trust, London, 1966.

BUSIRI-VICI, A., 'Pier Francesco Mola's Archimedes', *Apollo*, Vol. LXXXII, 1965, pp. 32 ff.

BYAM SHAW, J., *Paintings by Old Masters at Christ Church, Oxford*, London, 1967.

CAMPORI, G., *Raccolta di Cataloghi ed Inventarii inediti . . .*, Modena, 1870.

CARDELLA, L., *Memorie Storiche de' Cardinali della Santa Romana Chiesa*, 9 Vols., Rome, 1792–7.

CENTO, PINACOTECA COMUNALE, *Omaggio al Guercino*, 1967.

CIACCONIUS, A., *Vitæ, et Res Gestæ Pontificum Romanorum et S. R. E. Cardinalium . . .*, 4 Vols., Rome, 1677.

CICOGNA, E. A., *Delle Inscrizioni Veneziane Raccolte ed Illustrate*, 6 Vols. in 7, Venice, 1824–53.

CITTADELLA, C., *Catalogo Istorico de' Pittori e Scultori Ferraresi e delle opere loro*, 4 Vols., Ferrara, 1782–3.

CLARK, A. M., 'The Portraits of Artists drawn for Nicola Pio', *Master Drawings*, Vol. V, 1967, pp. 3 ff.

COCKE, R., 'Mola's Designs for the Stanza dell' Aria at Valmontone', *Burlington Magazine*, Vol. CX, 1968, pp. 558 ff.

COLONNA, P., *I Colonna*, Rome, 1927.

COOKE, H. L., *see* BLUNT, A. F., 1960.

COPENHAGEN, *Catalogue of Old Foreign Paintings, Royal Museum of Fine Arts*, Copenhagen, 1951.

COUCHÉ, J., DE FONTENAI and CROZE-MAGNAN, *Galerie du Palais Royal gravée d'après les tableaux des différentes écoles qui la composent: avec . . . une description historique de chaque tableau par Mr. l'abbé de Fontenai*, 3 Vols., Paris, 1786–1808.

CRESCIMBENI, G. M., *L'Istoria della Basilica di S. Anastasia*, Rome, 1722.

CROFT-MURRAY, E., *see* BLUNT, A. F., 1937.

CZOBOR, A., 'On some Late Works by Pier Francesco Mola', *Burlington Magazine*, Vol. CX, 1968, pp. 565 ff.

BIBLIOGRAPHY

DENGEL, I. P., *Palast und Basilica San Marco in Rom*, Rome, 1913.

DETROIT, THE INSTITUTE OF ARTS, *Art in Italy, 1600–1700*, 1965.

DOBROKLONSKIJ, M., *The Drawings of the Italian School, 17th–18th Centuries in the Hermitage*, Leningrad, 1961.

DONATI, U., *Artisti Ticinesi a Roma*, Bellinzona, 1942.

DOWLEY, F. H., 'Some Drawings by Benedetto Luti', *Art Bulletin*, Vol. XLIV, 1962, pp. 219 ff.

DOWLEY, F. H., 'Carlo Maratti, Carlo Fontana, and the Baptismal Chapel in Saint Peter's', *Art Bulletin*, Vol. XLVII, 1965, pp. 57 ff.

DRESDEN, STAATLICHE GEMÄLDEGALERIE, *Verzeichnis der älteren (Gemälde) ... I, Die romanischen Länder*, Dresden, 1929.

DUBOIS DE SAINT-GELAIS, L. F., *Description des tableaux du Palais Royal*, Paris, 1727.

DÜSSELDORF, *Catalogue Raisonné des Tableaux de la Galerie Electorale de Düsseldorf Rédigé d'après le Catalogue Raisonné de Mr. N. de Pigage*, Düsseldorf, 1805.

DÜSSELDORF, STAATLICHES KUNSTMUSEUM, *Italienische Handzeichnungen des Barock; Katalog von E. Schaar*, Düsseldorf, 1964.

DÜSSELDORF, *see* SCHAAR, E., 1967, and BUDDE, I., 1930.

DUSSLER, L., *Sebastiano del Piombo*, Basle, 1942.

EDINBURGH, *Catalogue of the Paintings and Sculpture, National Gallery of Scotland*, Edinburgh, 1957.

ELLER, I., *The History of Belvoir Castle*, London, 1841.

EMILIANI, A., *Disegni del Seicento Emiliano nella Pinacoteca di Brera*, Milan, 1959.

ENGERAND, F., *Inventaire des Tableaux Commandés et Achetés par la Direction des Bâtiments du Roi 1709–1792*, Paris, 1901.

ENGERAND, *see also* BAILLY, N., 1899.

ENGGASS, R., *The Paintings of Baciccio*, University Park, Pennsylvania, 1964.

EWALD, G., *Johann Carl Loth*, Amsterdam, 1965.

EXETER, MARCHIONESS OF, *Catalogue of Pictures at Burghley House*, Stamford, 1954.

FALDI, I., *La Quadreria della Cassa Depositi e Prestiti*, Rome, 1956.

FALDI, I., 'I Dipinti Chigiani di Michele e Giovanni Battista Pace', *Arte Antica e Moderna*, 1966, pp. 144 ff.

FAULKNER, T., *An Historical and Topographical Description of Chelsea and its Environs*, 2 Vols., Chelsea, 1829.

FERRI, P. N., *Catalogo Riassuntivo della Raccolta dei Disegni Antichi e Moderni posseduta dalla R. Galleria degli Uffizi*, Rome, 1890.

FILHOL, A. M., and LAVALLÉE, J., *Galerie du Musée Napoléon*, Paris, 10 Vols., 1804–15.

FLECHSIG, E., *Verzeichnis der Gemäldesammlung im Landesmuseum zu Braunschweig*, Brunswick, 1922.

FLORENCE, UFFIZI, GABINETTO DEI DISEGNI, *Mostra dei Disegni di Pietro da Cortona*, 1965.

FLORENCE, PALAZZO PITTI, *Pittura Italiana del Seicento e del Settecento*, 1922.

FLORENCE *see also* NUGENT, 1930.

FOGOLARI, G., *Le R. R. Gallerie dell'Accademia di Venezia*, Venice, 1934.

FORCELLA, V., *Iscrizioni delle Chiese e d'Altri Edifici di Roma*, 14 Vols., Rome, 1869–84.

FRANCIA, E., *Pinacoteca Vaticana*, Milan, 1960.

FRIEDLAENDER, W., *Nicolas Poussin*, Munich, 1914.

FRIEDLAENDER, W., *Caravaggio Studies*, Princeton, 1955.

FRIEDLAENDER, W., and BLUNT, A. F., *The Drawings of Nicolas Poussin, Part I. Biblical Subjects*, London, 1939.

FRIEDLAENDER, W., and BLUNT, A. F., *The Drawings of Nicolas Poussin, Part II. History, Romance, Allegory*, London, 1949.

FRIEDLAENDER, W., and BLUNT, A. F., *The Drawings of Nicolas Poussin, Part III. Mythological Subjects*, London, 1953.

FRIEDLAENDER, W., and BLUNT, A. F., *The Drawings of Nicolas Poussin, Part IV. Studies for the Long Gallery. Decorative Drawings. Leonardo's Treatise. Landscape Drawings*, London, 1963.

GALLI, R., 'I Tesori d'Arte di un Pittore dal Seicento (Carlo Maratta), *Archiginnasio*, 1927, pp. 217 ff., 1928, pp. 59 ff.

GAMBARINI, C., *A Description of the Earl of Pembroke's Pictures*, Westminster, 1731.

GARAS, K., 'The Ludovisi Collection of Pictures in 1633', *Burlington Magazine*, Vol. CIX, 1967, pp. 287 ff.

GEISENHEIMER, H., *Pietro da Cortona e gli Affreschi nel Palazzo Pitti*, Florence, 1909.

GENTY, J., *Pier Francesco Mola in Patria*, Bellinzona, 1968.

GNUDI, G., and CAVALLI, G. C., *Guido Reni*, Florence, 1955.

GOLDSCHEIDER, L., *Rembrandt*, London, 1960.

GOLZIO, V., *Documenti Artistici sul Seicento nell' Archivio Chigi*, Rome, 1939.

GOLZIO, V., *La Galleria e le Collezioni dell'* *Accademia di San Luca in Roma,* Rome, 1964.

GOMBOSI, G., *Palma Vecchio,* Stuttgart and Berlin, 1937.

GRANBERG, O., *Galerie des Tableaux de la Reine Christine de Suède,* Stockholm, 1897.

GRASSI, L., *La Storia del Disegno,* Rome, 1947.

GRAUTOFF, H., *Nicolas Poussin sein Werk und sein Leben,* 2 Vols., Munich, 1914.

GRONAU, G., *Raffael,* Stuttgart and Berlin, 1936.

GRONAU, H. D., *Giovanni Bellini,* Stuttgart and Berlin, 1930.

GUARNACCI, M., *Vitæ et Res Gestæ Pontificum Romanorum et . . . Cardinalium . . . ,* 2 Vols., Rome, 1751.

GUIFFREY, J. J., *Comptes des Bâtiments du Roi sous le Règne de Louis XIV,* 5 Vols., Paris, 1881–1901.

HAMBURG, KUNSTHALLE, *Zeichnungen alter Meister aus deutschem Privatbesitz,* 1965.

HANOVER, LANDESMUSEUM, *Katalog der Gemälde alter Meister in der Niedersächsischen Landesgalerie,* Hanover, 1954.

HASKELL, F. J. H., *Patrons and Painters,* London, 1963.

HEIDEMANN, J., 'The Decoration of San Martino ai Monti', letter to *Burlington Magazine,* Vol. CVI, 1964, p. 377.

HEIKAMP, D., 'Federigo Zuccari a Firenze', *Paragone,* 1967, 205 pp. 44 ff., and 207 pp. 3 ff.

HELD, J. S., *Rubens, Selected Drawings,* 2 Vols., London, 1959.

HERMANIN, F., *San Marco,* Rome, 1932.

HERMANN, L., 'The Drawings of Sir Joshua Reynolds in the Herschel Album', *Burlington Magazine,* Vol. CX, 1968, pp. 650 ff.

HIBBARD, H., 'The Date of the Aldobrandini Lunettes', *Burlington Magazine,* Vol. CVI, 1964, pp. 183 ff.

HOET, G., *Catalogus of Naamlyst van Schilderyen met derzelver pryzen, zedert een langen reeks van Jaaren zoo in Holland als op andere Plaazen in het openbaar verkogt,* 3 Vols., The Hague, 1752–70.

HUGFORD, I. E., *Raccolta di cento Pensieri Diversi di A. D. Gabbiani fatti intagliare in rame,* Florence, 1762.

INGHIRAMI, F., *L'Imp. e Reale Palazzo Pitti descritto,* Fiesole, 1828.

JAFFÉ, M., 'The Carracci at Newcastle', *Burlington Magazine,* Vol. CIV, 1962, pp. 26 ff.

JUYNBOLL, W. R., *Het Komische Genre in de Italiaansche Schilderkunst Gedurende de Zeventiende en de Achttiende Eeuw,* Leyden, 1934.

KARLSRUHE, *Katalog Alter Meister, Staatliche Kunsthalle, Karlsruhe,* by J. Lauts, Karlsruhe, 1966.

KURZ, O., *Bolognese Drawings of the 17th and 18th Centuries . . . at Windsor Castle,* London, 1955.

LACROIX, P., 'Catalogue des Tableaux qui se trouvent dans les Galeries et les Cabinets du Palais Imperial à Saint-Petersbourg, selon un Catalogue de 1774', *Revue Universelle des Arts,* XIII, XIV, XV, 1861–2.

LAVIN, I., 'Pietro da Cortona and the Frame', *Art Quarterly,* Vol. XIX, 1956, pp. 55 ff.

LEE, R. W., '*Ut Pictura Poesis:* The Humanistic Theory of Painting', *Art Bulletin,* Vol. XXII, 1940, pp. 197 ff.

LEE, R. W., 'Mola and Tasso', *Studies in Renaissance and Baroque Art presented to Sir Anthony Blunt,* London, 1967, pp. 136 ff.

LÉPICIÉ, M., *Catalogue Raisonné des Tableaux du Roy,* 2 Vols., Paris, 1752–4.

LEVEY, M., *Later Italian Pictures in the Royal Collection,* London, 1964.

LIMENTANI, U., 'Salvator Rosa, Nuovi Studi e Ricerche', II, *Italian Studies,* Vol. IX, 1954, pp. 46 ff.

LIMENTANI, U., *Poesie e Lettere Inedite di Salvator Rosa,* London, 1964.

Listas de Cuadros y Objetos Artisticos Remitidos desde Italia a Espana por el Puerto da Napoles en los Anos 1683–1687, MS. E. Escorial IV, 25.

LONDON, AGNEW & SONS, *Sir Anthony Van Dyck,* 1968.

LONDON, KENWOOD HOUSE, *An American University Collection,* 1962.

LONDON, MAGNASCO SOCIETY, *Loan Exhibition of Drawings of the XVII & XVIII centuries,* Warren Gallery, 1927.

LONDON, *Catalogue of the National Gallery,* London, 1929.

LONDON, *National Gallery Catalogues. The 16th Century Venetian School,* by C. Gould, London, 1959.

LONDON, ROYAL ACADEMY OF ARTS, *Seventeenth Century Art in Europe,* 1938.

LONDON, ROYAL ACADEMY OF ARTS, *Italian Art and Britain,* 1960.

LONDON, ROYAL ACADEMY OF ARTS, *Treasures of the Royal Academy,* 1963.

LONDON, WILDENSTEIN, *Artists in Seventeenth Century Rome,* 1955.

LONDON, see also AMBROSE, G. E., 1897.

LONGHI, R., *Giovanni Serodine,* Florence, 1955.

LONGHI, R., *Scritti Giovanili,* Florence, 1961.

BIBLIOGRAPHY

LOPRESTI, L., 'Pietro Testa, Incisore e Pittore', *L'Arte*, 1921, pp. 10 ff.

MADRID, *Catalogo de los Cuadros del Museo del Prado, por P. de Madrazo*, Madrid, 1920.

MAHON, D., *Studies in Seicento Art and Theory*, London, 1947.

MAHON, D., 'Stock-taking in *Seicento* Studies', *Apollo*, Vol. LXXXII, 1965, pp. 378 ff.

MAHON, D., see BOLOGNA, Palazzo dell' Archiginnasio, 1968.

MÂLE, E., *L'Art Religieux de la fin du XVIe siècle, du XVIIe siècle, et du XVIII siècle*, Paris, 1951.

MALVASIA, C. C., *Felsina Pittrice*, 2 Vols., Bologna, 1678, reprinted 1841.

MARABOTTINI A., 'Novità sul Lucchesino', and 'Il Trattato di Pittura e i Disegni del Lucchesino', *Commentari*, 1954, pp. 116 ff. and pp. 217 ff.

MARABOTTINI, A., Catalogue of the Exhibition *Pietro da Cortona*, Rome, 1956.

MARIETTE, P. J., *Description sommaire des desseins des grands maistres . . du Cabinet de feu M. Crozat*, Paris, 1741.

MARIETTE, P. J., *Abecedario . . . et autres notes inédites de cet amateur sur les arts et les artistes . . . Ouvrage publié par Ph. de Chennevières et A. de Montaiglon*, 6 Vols., Paris, 1851–60.

MARTIN, J. R., *The Farnese Gallery*, Princeton, 1965.

MARTINELLI, V., 'Le Pitture del Bernini', *Commentari*, 1950, pp. 95 ff.

MARTINELLI, V., 'Nuovi Ritratti di Guidobaldo Abbatini e di Pierfrancesco Mola', *Commentari*, 1958, pp. 99 ff.

MARTINELLI, V., 'Altre Opere di P. F. Mola a Roma', *Arte Europea: Scritti di Storia dell'Arte in Onore di E. Arslan*, 2 Vols., Milan, 1966, pp. 713 ff.

MEZZETTI, A., 'La Pittura di Antonio Gherardi', *Bollettino d'Arte*, 1948, pp. 157 ff.

MEZZETTI, A., 'Contributi a Carlo Maratti', *Rivista dell' Istituto Nazionale d'Archeologia e Storia dell'Arte*, 1955, pp. 253 ff.

MEZZETTI, A., *Il Dosso e Battista Ferraresi*, Milan, 1965.

MILAN, see EMILIANI, A., 1959.

MIREUR, H., *Dictionnaire des Ventes d'Art*, 7 Vols., Paris, 1901–12.

MITCHELL, C., 'Poussin's *Flight into Egypt*', *Journal of the Warburg and Courtauld Institutes*, Vol. I, 1937–8, pp. 340 ff.

MOIR, A., *The Italian Followers of Caravaggio*, 2 Vols., Cambridge, Mass, 1967.

MOLA, G. B., *Roma l'Anno 1663*, ed. K. Noehles, Berlin, 1967.

MOLAJOLI, B., *Notizie su Capodimonte*, Naples. 1958.

MONGAN, A., and SACHS, P. J., *Drawings in the Fogg Museum of Art*, Cambridge, Mass., 1940.

MONTALTO, L., 'Gli Affreschi del Palazzo Pamphili in Valmontone', *Commentari*, 1955, pp. 267 ff.

MONTALTO, L., 'Francesco Cozza nella Libreria Pamphili a Piazza Navona', *Commentari*, 1956, pp. 41 ff.

MORGAN, (LADY) S., *The Life and Times of Salvator Rosa*, 2 Vols., London, 1824.

MOSCHETTI, A., *Il Museo Civico di Padova*, Padua, 1938.

MROZINSKA, M., *I Disegni del Codice Bonola del Museo di Varsovia*, Venice, 1959.

NASH, E., *Pictorial Dictionary of Ancient Rome*, 2 Vols., London, 1961–2.

NEPPI, A., *Gli Affreschi del Domenichino a Roma*, Rome, 1958.

NEW YORK, see BEAN, J., and STAMPFLE, F., 1967.

NIBBY, A., *Analisi storico-topografico-antiquaria de' dintorni di Roma*, 3 Vols., Rome, 1848–9.

NICOLSON, B., *Hendrick Terbrugghen*, London, 1958.

NOEHLES, K., 'L'Architetto Giovanni Battista Mola e la sua Guida Romana del 1663', *Atti del Convegno . . . della Valle Intelvi, Arte Lombarda*, 1966, pp. 192 ff.

NOEHLES, K., see MOLA, G. B., 1663.

NUGENT, M., *Mostra della Pittura Italiana del '600 e '700*, Florence, 1930.

OBERLIN, *Catalogue of European and American Paintings and Sculpture in the Allen Memorial Art Museum, Oberlin College*, by W. Stechow, Oberlin, 1967.

OESTERREICH, M., *Description de tout l'intérieur des deux palais de Sans Souci, de ceux de Potsdam, et de Charlottenbourg*, Potsdam, 1773.

OLSEN, H., *Italian Painting in Denmark*, Copenhagen, 1961.

ORLANDI, P. A., *Abecedario Pittorico*, Bologna, 1704.

OTTLEY, W. Y., *Engravings of the Most Noble the Marquis of Stafford's Collection of Pictures*, 4 Vols. in 2, London, 1818.

OXFORD, *Catalogue of Paintings in the Ashmolean Museum*, Oxford, 1961.

OXFORD, see also BYAM SHAW, J., 1967, and PARKER, K.T., 1956.

PAGLIUCCHI, P., *I Castellani del Castel S. Angelo*, 2 Vols., Rome, 1906–28.

BIBLIOGRAPHY

PALLUCCHINI, R., *Gli Affreschi di Paolo Veronese a Maser,* Venice, 1939.

PANOFSKY, E., *Studies in Iconology,* New York, 1939.

PANOFSKY, E., 'Et in Arcadia Ego', *Philosophy and History. Essays Presented to E. Cassirer,* Oxford, 1936.

PARIS, *Actes du Colloque International Nicolas Poussin,* 2 Vols., Paris, 1960.

PARIS, *Catalogue des Tableaux du Cabinet de M. Crozat, Baron de Thiers,* Paris, 1775.

PARIS, LOUVRE, *Exposition Nicolas Poussin,* 1960.

PARIS, LOUVRE, *Exposition de 700 Tableaux de Toutes les Écoles Tirés des Réserves,* 1960.

PARIS, *Recueil d'Estampes d'après les plus beaux Tableaux et d'après les plus beaux Desseins qui sont en France, dans le Cabinet du Roi, dans celuy de Monseigneur le Duc d'Orléans, et dans d'autres Cabinets,* 2 Vols., Paris, 1729–1742.

PARKER, K. T., 'Pierfrancesco Mola', *Old Master Drawings,* Vol. II, 1927, p. 23.

PARKER, K. T., *Catalogue of the Collection of Drawings in the Ashmolean Museum, Vol. II, Italian Schools,* Oxford, 1956.

PASCOLI, L., *Vite de' Pittori, Scultori, Architetti Moderni,* 2 Vols., Rome, 1730–6, facsimile edition, Rome, 1933.

PASSERI, G. B., *Vite de' Pittori, Scultori ed Architetti dall'anno 1641 sino all'anno 1673,* ed. Jacob Hess, Leipzig and Vienna, 1934.

PASTOR, L. VON, *History of the Popes,* English Translation, 32 Vols., London, 1891–1953.

PEMBROKE, SIDNEY, 16th EARL OF, *Paintings and Drawings at Wilton House,* London, 1968.

PERCY, A., 'Castiglione's Chronology: Some Documentary Notes', *Burlington Magazine,* Vol. CIX, 1967, pp. 672 ff.

PERCY, A., 'A Castiglione *Album*', *Master Drawings,* Vol. VI, 1968, pp. 144 ff.

PÉREZ SÁNCHEZ, A. E., *Veintiseis Dibujos Boloñeses y Romanos del Siglo XVII,* Madrid, 1965.

PÉREZ SÁNCHEZ, A. E., *Pintura Italiana del Siglo XVII en España,* Madrid, 1965.

PERGOLA, P. DELLA, *Galleria Borghese: I Dipinti,* 2 Vols., Rome, 1955–9.

PERGOLA, P. DELLA, 'Gli Inventari Aldobrandini: L'Inventario del 1682', *Arte Antica e Moderna,* Vol. V, 1962, pp. 316 ff. and Vol. VI, 1963, pp. 61 ff.

PIETRANGELI, C., *Bollettino dei Musei Comunali di Roma,* Vol. I, 1954, p. 59.

PIGLER, A., *Barockthemen,* 2 Vols., Budapest, 1956.

PIO, N., 'Vita di P. F. Mola', MS. Vatican Capponiano 257, 1724, reprinted in 'L'Arte alla Corte di Alessandro VII' by L. Ozzola, *Archivio della Società Romana di Storia Patria,* 1908.

POPE-HENNESSY, J., *The Drawings of Domenichino . . . at Windsor Castle,* London, 1948.

POPHAM, A. E., *Catalogue of the Drawings in the Collection formed by Sir Thomas Phillipps Bart F.R.S. Now in the possession of his Grandson, T. Fitzroy Phillipps Fenwick of Thirlestane House, Cheltenham,* Privately printed, 1935.

POPHAM, A. E., and WILDE, J., *Italian Drawings of the XV and XVI Centuries . . . at Windsor Castle,* London, 1949.

PORTOGHESI, P., 'An Unknown Portrait of Borromini', *Burlington Magazine,* Vol. CIX, 1967, p. 709.

POSSE, H., *Der Römische Maler Andrea Sacchi,* Leipzig, 1925.

POZZO, B. DAL, *Le Vite de' Pittori, degli Scultori et Architetti Veronesi,* Verona, 1718.

PRINCETON, see BEAN, J., 1966.

REGTEREN ALTENA, J. Q. VAN, *Les Desseins Italiens de la Reine Christine de Suède,* Stockholm, 1966.

RÉMY, P., *Catalogue raisonné des tableaux, sculptures . . . qui composent le cabinet de feu Monsieur le Duc de Tallard,* Paris, 1756.

RÉMY, P., *Catalogue raisonné des tableaux, desseins et estampes et autres effets curieux après le décès de M. de Jullienne,* Paris, 1767.

REYNOLDS, G., *Nineteenth Century Drawings, 1850–1900,* London, 1949.

RICHTER, J. P., and WEALE, W. H., *A Descriptive Catalogue of the Collection of Pictures belonging to the Earl of Northbrook,* London, 1899.

RIDOLFI, C., *Le Maraviglie dell'Arte,* 2 Vols., Venice, 1648, ed. Von Hadeln, Berlin, 1914.

RIPA, C., *Iconologia,* Padua, 1611.

RIS, CLÉMENT DE, *Les Amateurs d'autrefois,* Paris, 1877.

ROME, PALAZZO BARBERINI, *Mostra di Cortoneschi a Roma,* 1956.

ROME, GALLERIE CAPITOLINE, MS. Inventory of Pio Collection, 1750.

ROME, *Catalogo dei Quadri e Pitture Esistenti nel Palazzo dell'Eccellentissima casa Colonna in Roma,* Rome, 1782.

ROME, PALAZZO DELL' ESPOSIZIONE, *Il Seicento Europeo,* 1956.

ROME, FARNESINA, *Mostra di Disegni Fiorentini del Museo del Louvre,* 1959.

ROME, Inventory of the Massimi Collection, 11 October 1677; Vatican MS. Cappon. 260.

ROME, see also MARABOTTINI, A., 1956; and SESTIERI, E., 1942.

RONCI, G., Disegni Italiani nella Biblioteca Nazionale di Rio de Janeiro', *Bollettino d'Arte*, 1957, pp. 135 ff.

ROSENBERG, J., 'Rembrandt and Guercino', *Art Quarterly*, 1944, pp. 129 ff.

RÖTHLISBERGER, M., *Claude Lorrain, The Paintings*, 2 Vols., London, 1961.

ROUEN, MUSÉE DES BEAUX-ARTS, *Exposition Nicolas Poussin et Son Temps*, 1961.

ROWLANDS, J., 'Mola's Preparatory Drawings and Some Additions to his *Oeuvre*', *Master Drawings*, Vol. II, 1964, pp. 271 ff.

RUFFO, V., 'Galleria Ruffo nel Secolo XVII in Messina', *Bollettino d'Arte*, 1916, pp. 21 ff.

SALERNO, L., 'The Picture Gallery of Vincenzo Giustiniani', *Burlington Magazine*, Vol. CII, 1960, pp. 21 ff., 93 ff., 135 ff.

SALERNO, L., *Salvator Rosa*, Milan, 1963.

SALVAGNINI, F. A., 'Le Pitture di Guglielmo Courtois Borgognone in S. Marco di Roma', *Bollettino d'Arte*, 1935, pp. 167 ff.

SALVAGNINI, F. A., *I Pittori Borgognoni Cortese*, Rome, 1937.

SANDRART, J. VON, *T. A. der edlen Bau...*, Nuremberg, 1675–9.

SARASOTA, *see also* SUIDA, W., 1949.

SAXL, F., 'Veritas Filia Temporis', *Philosophy and History. Essays Presented to E. Cassirer*, Oxford, 1936.

SCHAACK, E. VAN, 'Un' Opera tarda di Francesco Albani', *Arte Antica e Moderna*, Vol. VI, 1963, pp. 49 ff.

SCHAAR, E., 'Eine Poussin-Mola-Frage', *Zeitschrift für Kunstgeschichte*, Vol. XXIII, 1961, pp. 184 ff.

SCHAAR, E., and SUTHERLAND HARRIS, A., *Die Handzeichnungen von Andrea Sacchi und Carlo Maratti: Kataloge, Kunstmuseum, Düsseldorf, Handzeichnungen*, Vol. I, Düsseldorf, 1967.

SCHARF, G., *Catalogue of the Collection of Pictures at Woburn Abbey and 81 Eaton Sq., London*, London, 1877.

SCHLEIER, E., 'Lanfranco's *Notte* for the Marchese Sannesi and some Early Drawings', *Burlington Magazine*, Vol. CIV, 1962, pp. 246 ff.

SCHLEISSHEIM, *Katalog der Kgl. Gemäldegalerie*, Schleissheim, 1914.

SCHLOSSER, J. VON, *Die Kunstliteratur*, Vienna, 1924.

SCHOLZ, J., 'Italian Drawings in the Art Museum of Princeton University', *Burlington Magazine*, Vol. CIX, p. 295.

SESTIERI, E., *Catalogo della Galleria ex-Fidecommissaria Doria-Pamphili*, Rome, 1942.

SILOS, J. M., *Pinacotheca sive Romana Pictura et Sculptura*, 2 Vols., Rome, 1673.

SPEAR, R. E., 'Review of *Domenichino* by Evelina Borea', *Art Bulletin*, Vol. XLIX, 1967, pp. 360 ff.

STAMPFLE, E., *see* BEAN, J., 1967.

STECHOW, W., 'Shooting at Father's Corpse', *Art Bulletin*, Vol. XXIV, 1942, pp. 213 ff.

STECHOW, W., 'The Samuel H. Kress Study Collection, Catalogue', *Allen Memorial Art Museum Bulletin*, XIX, 1961–62, p. 1 ff.

STERLING, C., 'Au Département des Peintures: *Guerrier Oriental*, par Pierfrancesco Mola', *Musées de France*, 1950, pp. 33 ff.

STOCKHOLM, NATIONALMUSEUM, *Italienska Barockteckningar*, 1965.

STOCKHOLM, NATIONALMUSEUM, *Christina, Queen of Sweden*, 1966.

STRYIENSKI, C., *La Galerie du Régent Philippe, Duc d'Orléans*, Paris, 1913.

STRYIENSKI, C., 'La Galerie des Tableaux du Régent', *Revue Archéologique*, Vol. XIX, 1912, pp. 130 ff.

STUFFMAN, M., 'Les Tableaux de la Collection de Pierre Crozat', *Gazette des Beaux-Arts*, Vol. LXXII, 1968, pp. 11 ff.

SUIDA, W., *Catalogue of the Ringling Museum*, Sarasota, 1949.

SUTHERLAND, A., 'The Decoration of S. Martino ai Monti', *Burlington Magazine*, Vol. CVI, 1964, pp. 58 ff.

SUTHERLAND, A., 'P. F. Mola – His Visits to North Italy and His Residence in Rome', *Burlington Magazine*, Vol. CVI, 1964, pp. 363 ff.

SUTHERLAND HARRIS, A., 'Notes on the Chronology and Death of Pietro Testa', *Paragone*, 213, 1967, pp. 35 ff.

SUTHERLAND HARRIS, A., *see* SCHAAR, E., 1967.

SUTTON, D., 'Gaspard Dughet: some aspects of his art', *Gazette des Beaux-Arts*, Vol. LX, 1962, pp. 269 ff.

TAJA, A., ed. Pagliarini, M. and N., *Descrizione del Palazzo Apostolico Vaticano*, Rome, 1750.

TIETZE, H., *Titian*, London, 1937, and 1950.

TIETZE, H., *European Master Drawings in the United States*, New York, 1947.

TITI, F., *Studio di pittura, scoltura et architettura, nelle Chiese di Roma*, 1674.

TITI, F., *Ammaestramento utile, e curioso di pittura, scoltura, et architettura nelle Chiese di Roma*, Rome, 1686.

TITI, F., *Nuovo studio di pitture, scoltura, ed Architettura nelle chiese di Roma*, Rome, 1721.

BIBLIOGRAPHY

TITI, F., *Descrizione delle Pitture, Sculture e architettura esposte al pubblico in Roma,* Rome, 1763.

TORRE, F., *Ritratto di Milano,* Milan, 1674.

VALCANOVER, F., *Museo Civico da Feltre,* Venice, 1954.

(VASSALLI, A.), *Ricordo Festeggiamenti,* Coldrerio, 1947.

VENICE, CA' GIUSTINIANI, *Mostra di Paolo Veronese,* 1939.

VENICE, CA' PESARO, *La Pittura del Seicento a Venezia,* 1959.

VENTURI, A., *La Galleria Estense in Modena,* Modena, 1883.

VENUTI, R., *Accurata e succinta descrizione topografica e istorica di Roma,* 2 Vols., Rome, 1766.

VEY, H., 'Some European Drawings at Worcester', *Worcester Art Museum Annual Report,* 1958, pp. 30 ff.

VIENNA, *Albertina Katalog, Vol. VI. Die Schulen von Ferrara, Bologna, Parma, Modena, der Lombardei u.s.w.,* by Stix, A., and Spitzmueller, A., Vienna, 1941.

VIENNA, *Katalog der Gemäldegalerie, Kunsthistorisches Museum,* 2 Vols., Vienna, 1963–5.

VILLOT, F., *Notice des Tableaux du Musée National du Louvre,* Paris, 1873.

VITZTHUM, W., 'Review of *Roman Drawings at Windsor Castle', Burlington Magazine,* Vol. CIII, 1961, pp. 513 ff.

VITZTHUM, W., *see* BEAN, J., 1961.

VITZTHUM, W., 'Entwurf und Ausführung', *Master Drawings,* Vol. II, 1964, pp. 296 ff.

VITZTHUM, W., 'M. V. Dobroklonski, *Catalogue of Drawings of the Italian Schools of the 17th and 18th Centuries at the Hermitage', Master Drawings,* Vol. II, 1964, pp. 174 ff.

VITZTHUM, W., 'Zuschreibungen an François Perrier', *Walter Friedlaender zum 90 Geburtstag,* Berlin, 1965, pp. 211 ff.

VORAGINE, JACOPO DEL, *Legenda Aurea,* ed, Levasti, Florence, 1925.

VOSS, H., 'Di Pierfrancesco Mola, Pittore et Incisore Comasco', *Rivista Archeologica della Provincia di Como,* 1910, pp. 177 ff.

VOSS, H., *Die Malerei des Barock in Rom,* Berlin, 1924.

VOSS, H., 'P. F. Mola', in Thieme-Becker, *Allgemeines Lexikon der bildenden Künstler,* Leipzig, Vol. 25, 1931, pp. 28 ff.

VOSS, H., 'Die Flucht nach Aegypten', *Saggi e Memorie,* Vol. I, 1957, pp. 25 ff.

WAAGEN, G., *Treasures of Art in Great Britain,* 4 Vols., London, 1854–7.

WALLACE, R. W., 'The Genius of Salvator Rosa', *Art Bulletin,* Vol. XLVII, 1965, pp. 471 ff.

WATERHOUSE, E. K., *Baroque Painting in Rome,* London, 1937.

WATERHOUSE, E. K., 'Paintings from Venice for 17th Century England', *Italian Studies,* Vol. XII, 1952, pp. 1 ff.

WATERHOUSE, E. K., *Italian Baroque Painting,* London, 1962.

WENGSTRÖM, G., *Collection du Musée National, II, Nicolas Poussin,* Malmöe, 1936.

WETHEY, H., *El Greco and his School,* 2 Vols., Princeton, 1962.

WIBIRAL, N., 'Contributi alle Ricerche sul Cortonismo in Roma – I Pittori della Galleria di Alessandro VII nel Palazzo del Quirinale', *Bollettino d'Arte,* 1960, pp. 123 ff.

WILD, D., 'Charles Mellin ou N. Poussin', *Gazette des Beaux-Arts,* Vol. LXVIII, 1966, pp. 177 ff., and Vol. LXIX, 1967, pp. 3 ff.

WILDE, J., *see* POPHAM, A. E., 1949.

WILKINSON, N. R., *Wilton House Pictures,* London, 1907.

WILTON HOUSE, *see* PEMBROKE, SYDNEY, 16th EARL OF, 1968.

WIND, E., 'Hercules and Orpheus: Two mock-heroic designs by Dürer', *Journal of the Warburg and Courtauld Institutes,* Vol. II, 1938–9, pp. 206 ff.

WITTKOWER, R., *The Drawings of the Caracci . . . at Windsor Castle,* London, 1952.

WITTKOWER, R., *Art and Architecture in Italy, 1600–1750,* Harmondsworth, 1958.

WÖLFFLIN, H., *Die klassische Kunst,* 1899, English translation, London, 1952.

ZERI, F., *La Galleria Spada in Roma,* Florence, 1954.

ZERI, F., *La Galleria Pallavicini in Roma,* Florence, 1959.

ZIFF, J., '"Backgrounds, Introduction of Architecture and Landscape": A Lecture by J. M. W. Turner', *Journal of the Warburg and Courtauld Institutes,* Vol. XXVI, 1963, pp. 124 ff.

ZIPPEL, G., 'Paolo II e l'Arte', *L'Arte,* 1911, pp. 13 ff.

Index

INDEX

INDEX

INDEX

INDEX

INDEX

1. P. F. Mola, *God the Father Blessing,* (Cat. 7)

2. P. F. Mola, *SS. Sebastian and Roch,* (Cat. 7)

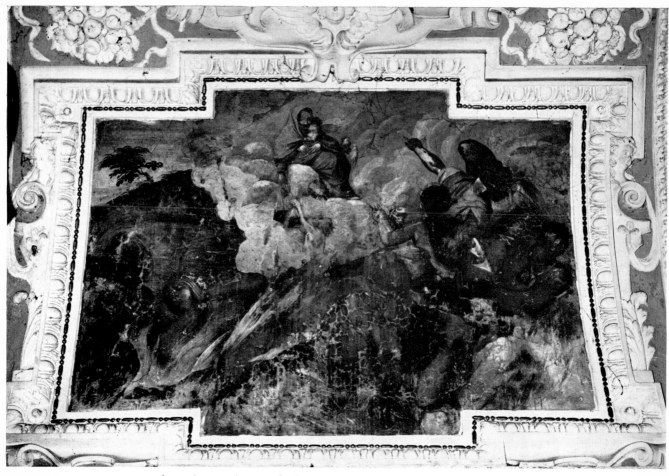

3. P. F. Mola, *The Madonna of The Rosary Saving Souls from Purgatory*, (Cat. 7)

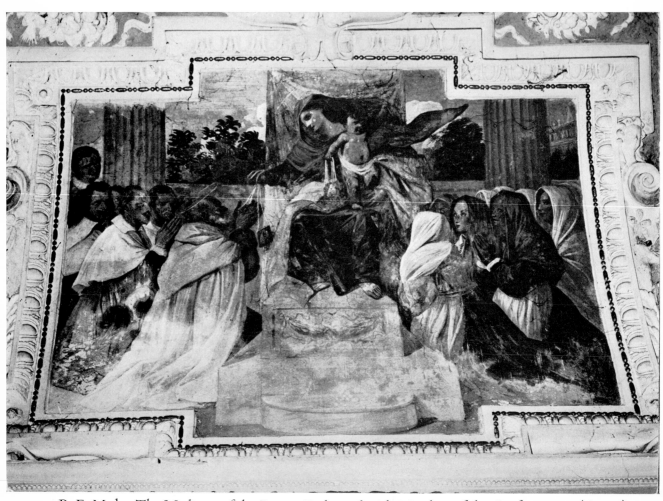

4. P. F. Mola, *The Madonna of the Rosary Enthroned with Members of the Confraternity*, (Cat. 7)

5. P. F. Mola, *The Virgin and Child with Two Kneeling Figures,* (Cat. 7)

6. P. F. Mola, *The Virgin and Child with Two Angels,* (Cat. 7)

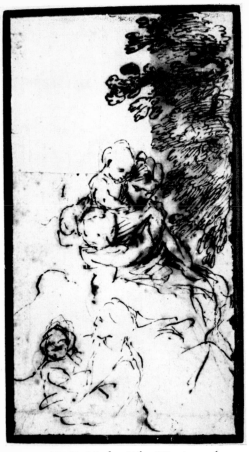

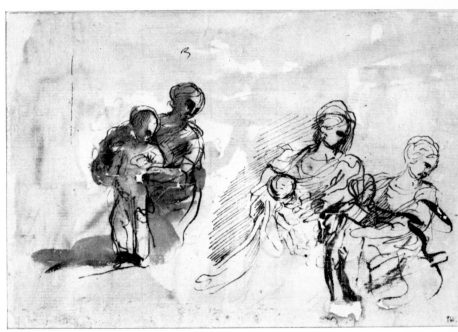

7. P. F. Mola, *The Virgin and Child*, (Cat. 7)

8. P. F. Mola, *Studies of the Virgin and Child*, (Cat. 7)

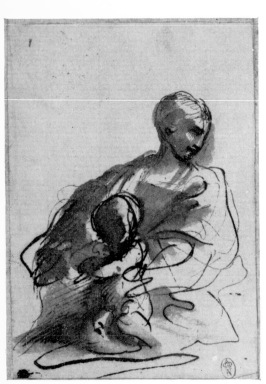

9. P. F. Mola, *The Virgin and Child*, (Cat. 7)

10. P. F. Mola, *God the Father Blessing*, (Cat. 7)

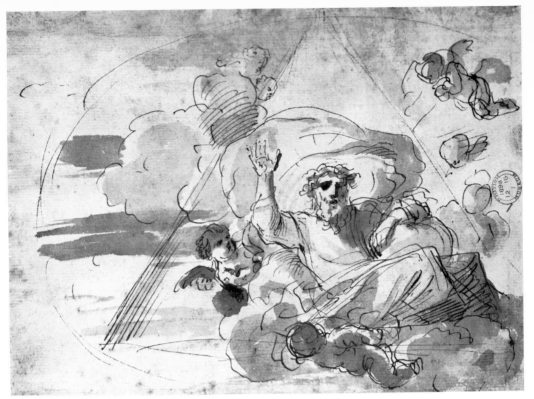

11. P. F. Mola, *God the Father Blessing,* (Cat. 7)

12. P. F. Mola, *Landscape with a View of Brusada,* (Cat. 7)

13. P. F. Mola, *Adoration of the Shepherds*, (Cat. 66)

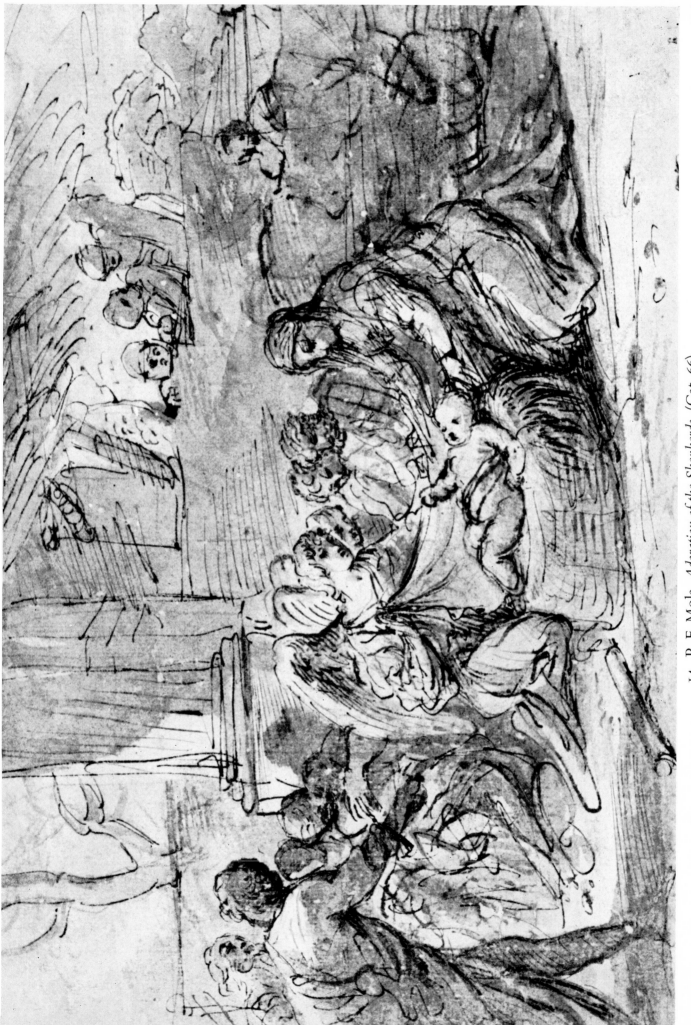

14. P. F. Mola, *Adoration of the Shepherds*, (Cat. 66)

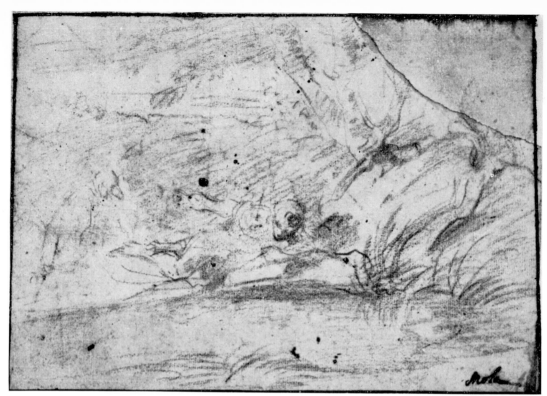

15. P. F. Mola, *Narcissus,* (Cat. 31)

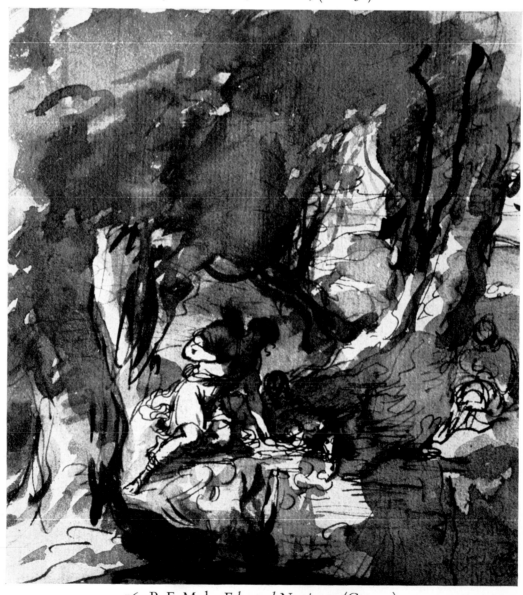

16. P. F. Mola, *Echo and Narcissus,* (Cat. 31)

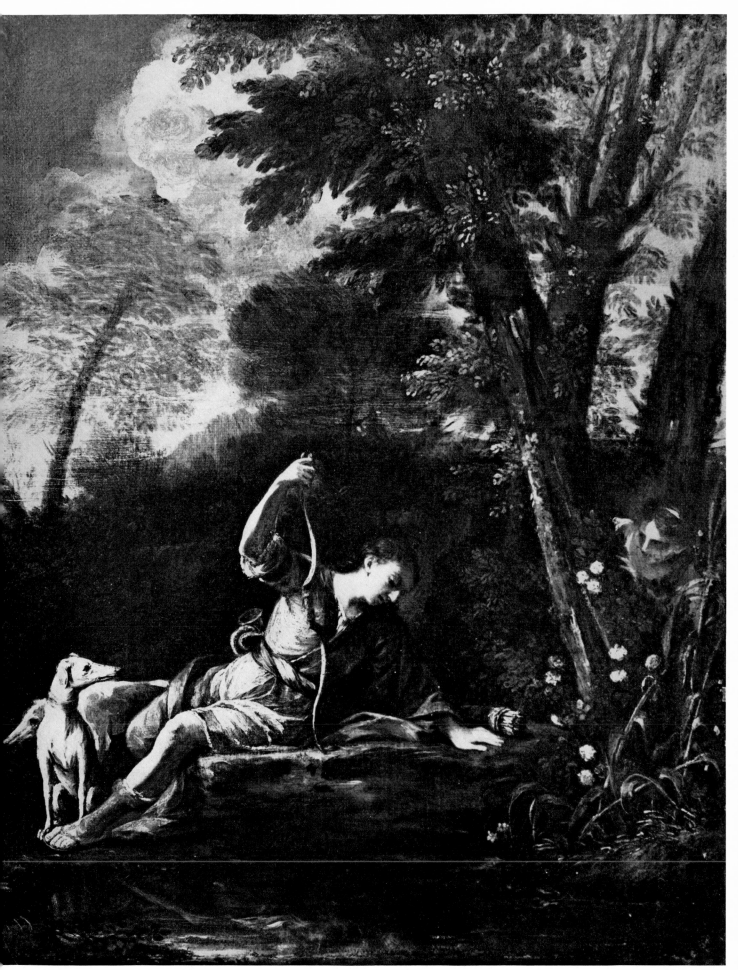

17. P. F. Mola, *Echo and Narcissus,* (Cat. 31)

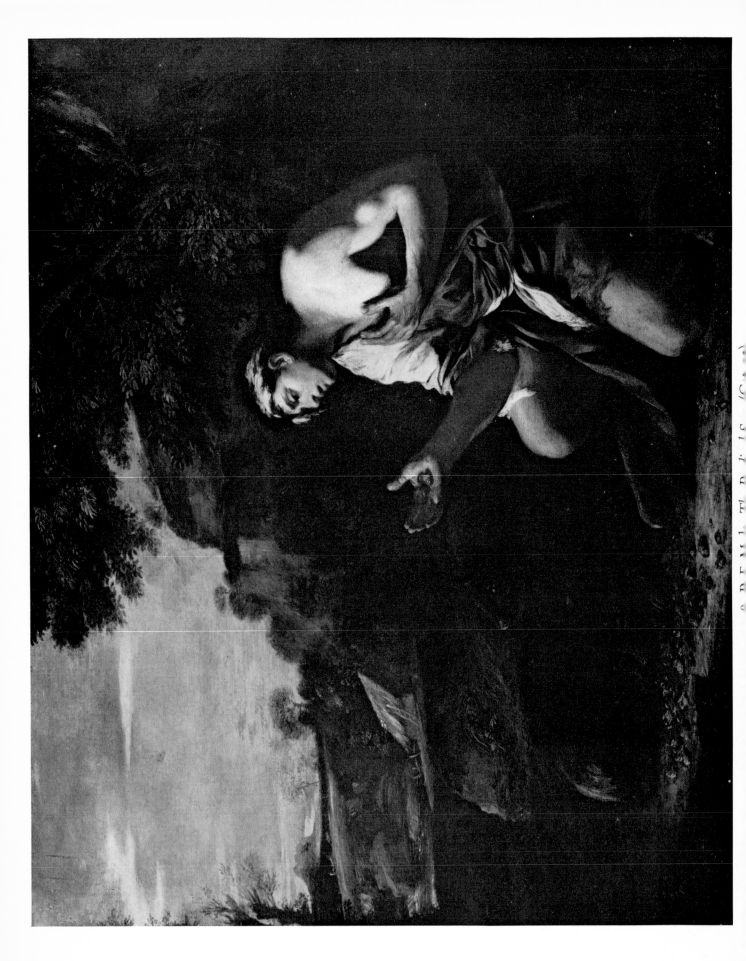

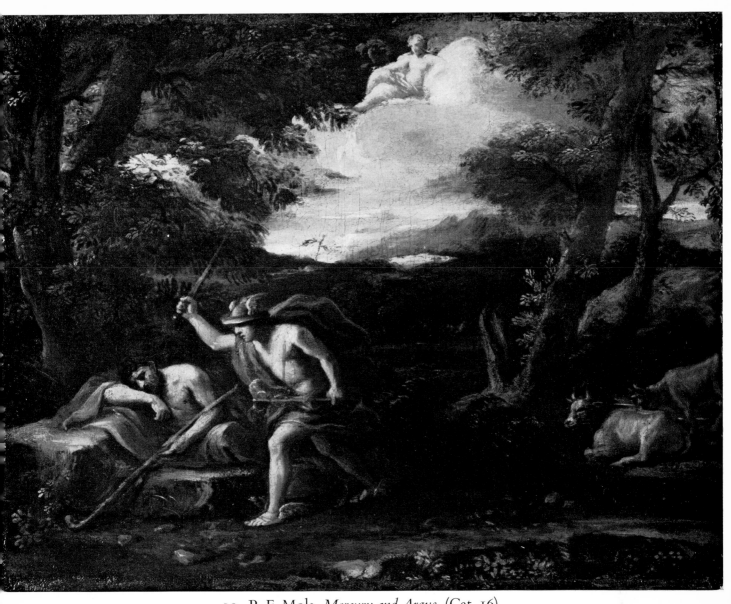

19. P. F. Mola, *Mercury and Argus*, (Cat. 16)

20. P. F. Mola, *Study of Sheep and a Man's Head*, (Cat. 21)

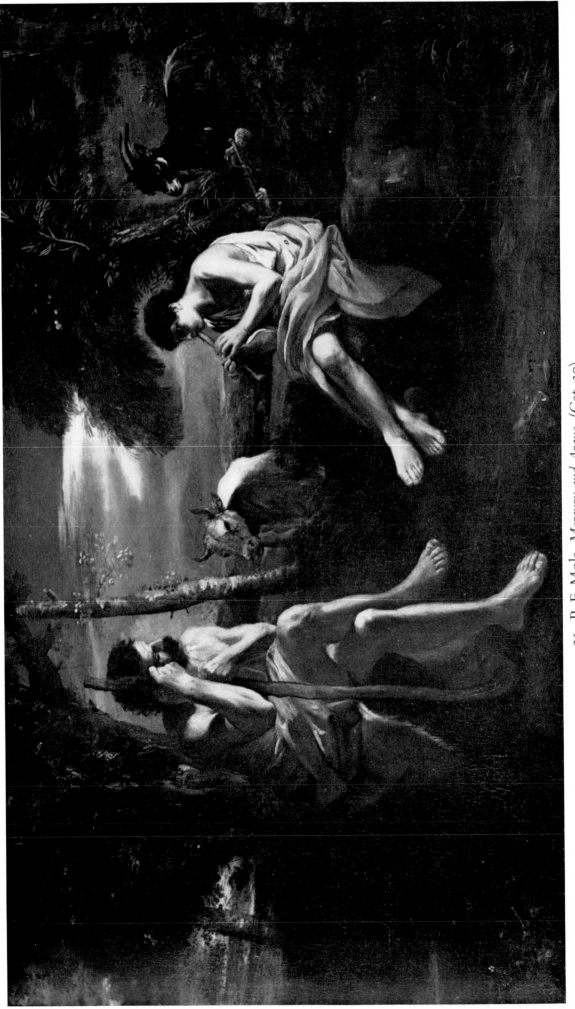

21. P. F. Mola, *Mercury and Argus*, (Cat. 30)

22. P. F. Mola, *Mercury and Argus*, (B. XIX 6), (Cat. 30)

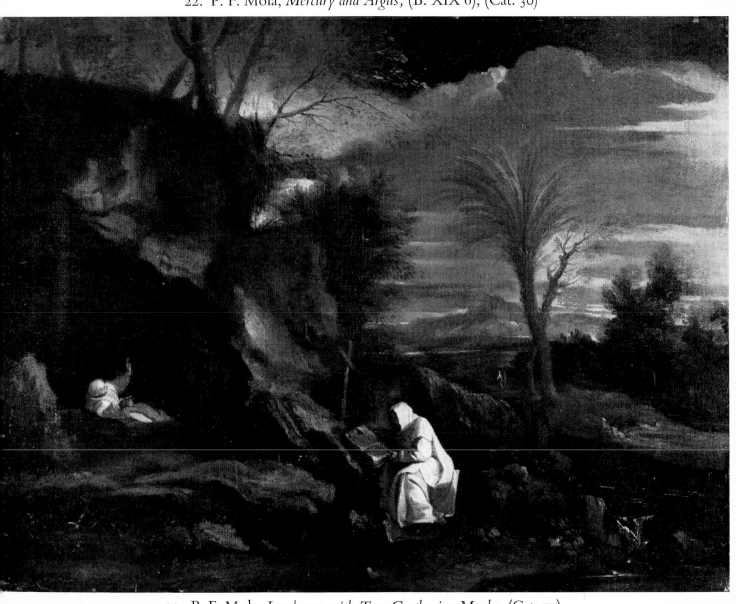

23. P. F. Mola, *Landscape with Two Carthusian Monks*, (Cat. 17)

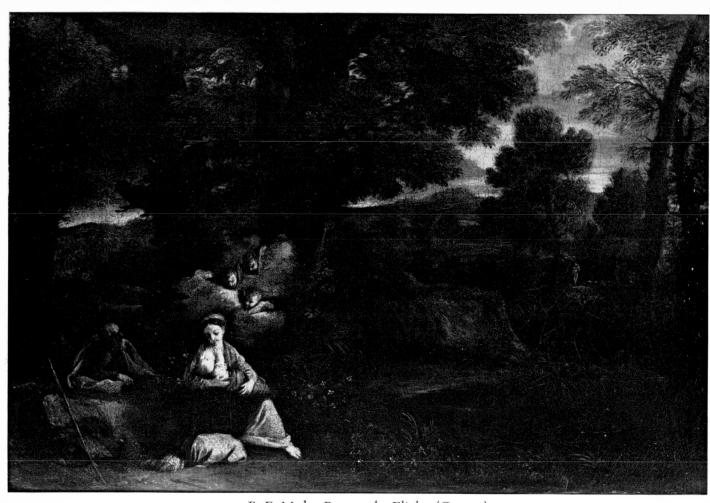

24. P. F. Mola, *Rest on the Flight,* (Cat. 18)

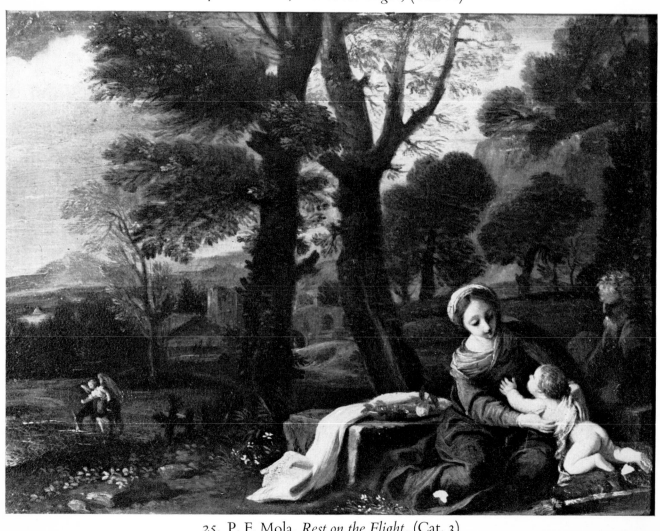

25. P. F. Mola, *Rest on the Flight,* (Cat. 3)

26. P. F. Mola, *Rest on the Flight*, (Cat. 25)

27. P. F. Mola. *Erminia Guarding her Flock*. (Cat. 26)

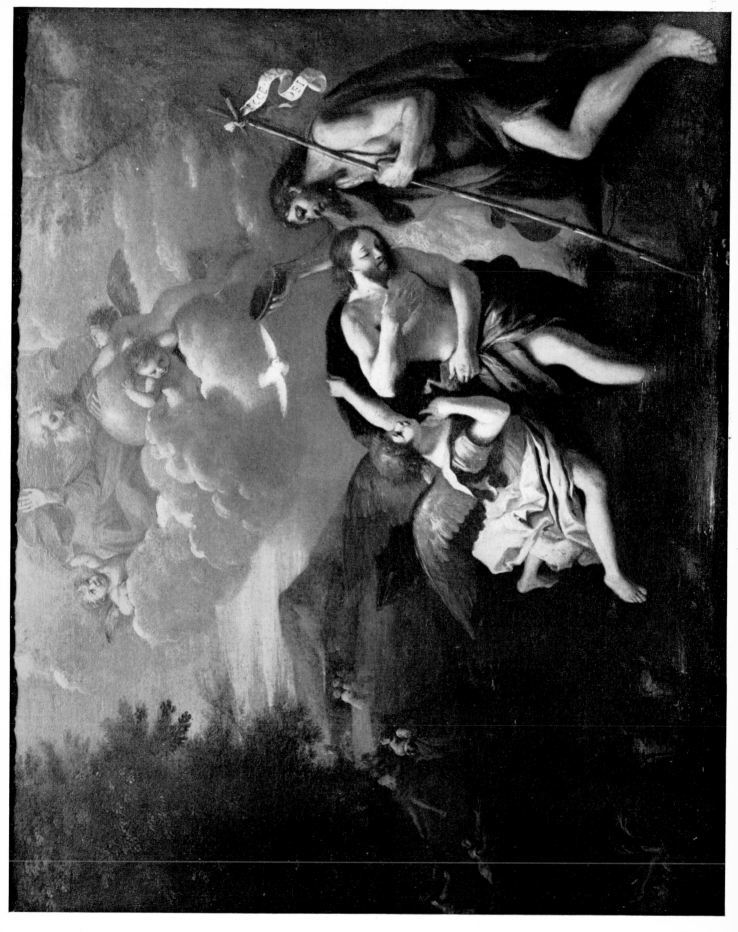

28. P. F. Mola,
*The Baptism
of Christ*,
(Cat. 20)

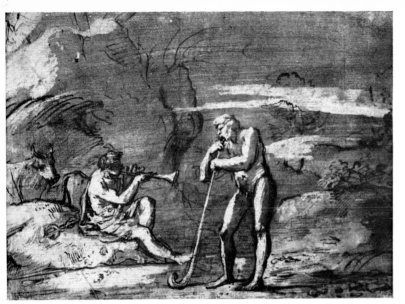

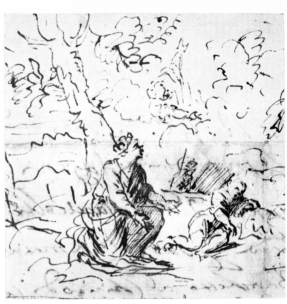

29. P. F. Mola, *Mercury and Argus,* (Cat. 2)

30. P. F. Mola, *Hagar and Ishmael,* (Cat. 28)

31. P. F. Mola, *Mercury and Argus,* (Cat. 2)

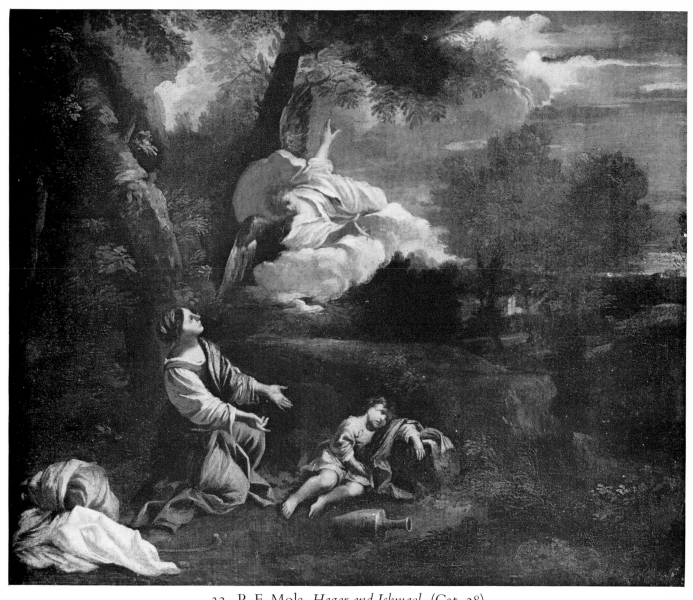

32. P. F. Mola, *Hagar and Ishmael*, (Cat. 28)

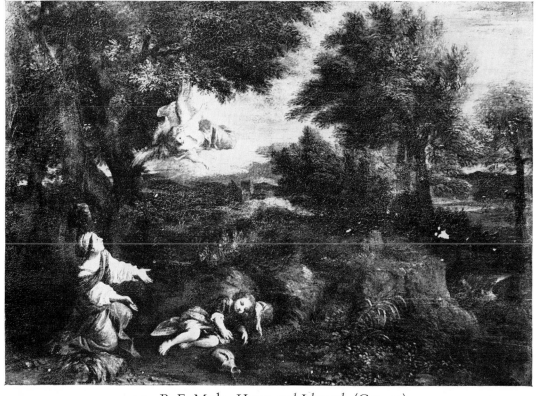

33. P. F. Mola, *Hagar and Ishmael*, (Cat. 32)

34. P. F. Mola, *The Image of St. Dominic Carried to Soriano by the Virgin, St. Catherine and St. Mary Magdalene.* (Cat. 56)

35. P. F. Mola, *The Image of St. Dominic Carried to Soriano by the Virgin, St. Catherine and St. Mary Magdalene.* (Cat. 56)

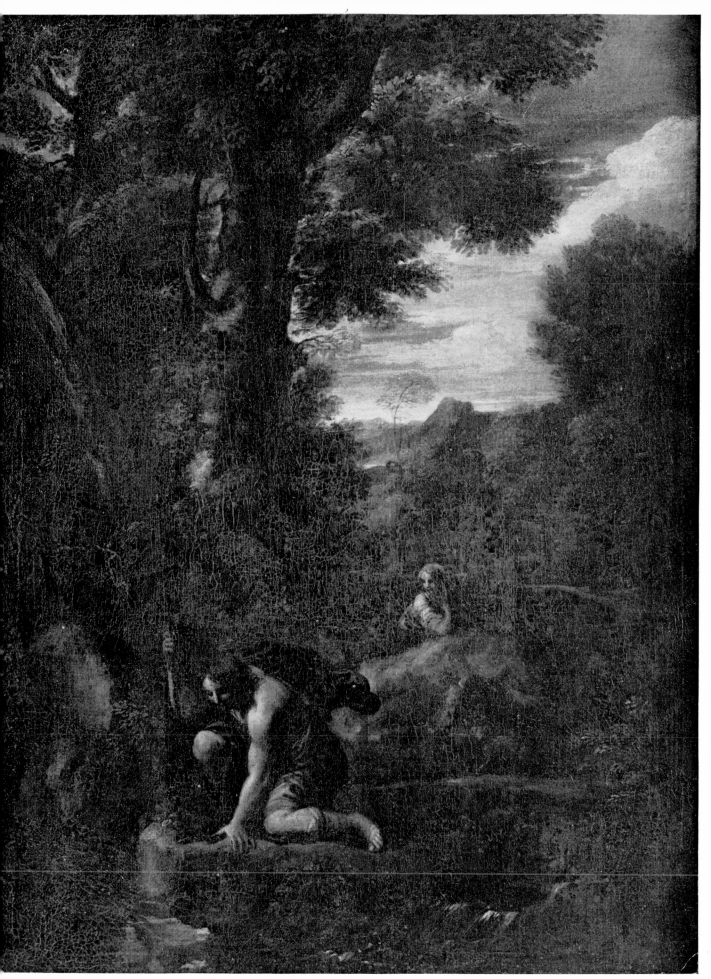

36. P. F. Mola, *Echo and Narcissus,* (Cat. 8)

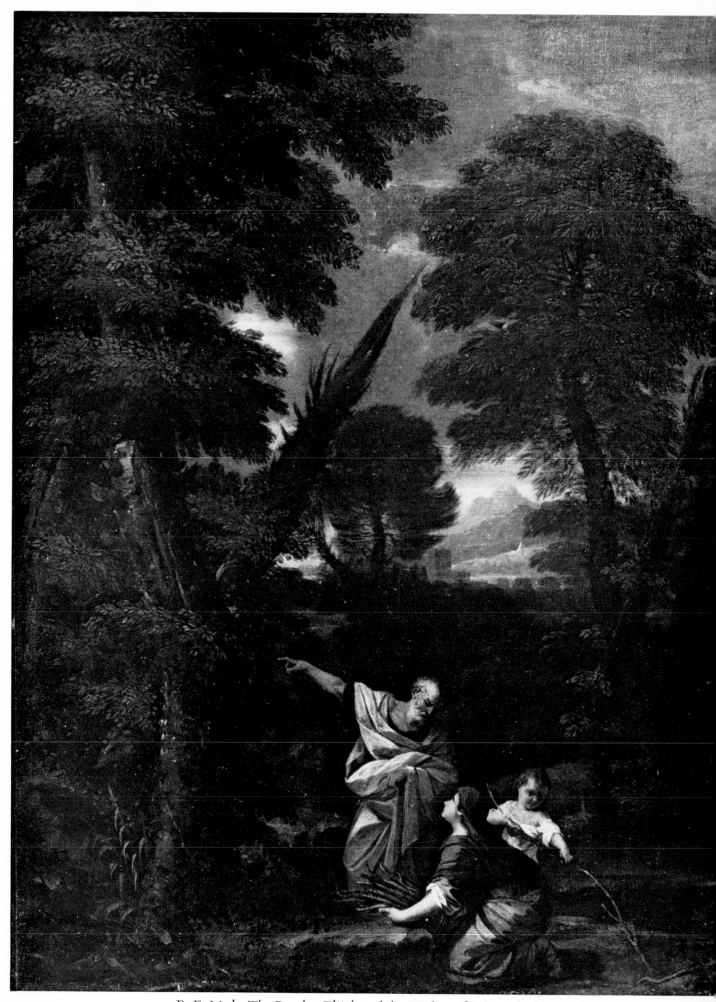

37. P. F. Mola, *The Prophet Elijah and the Widow of Zarepath*, (Cat. 62)

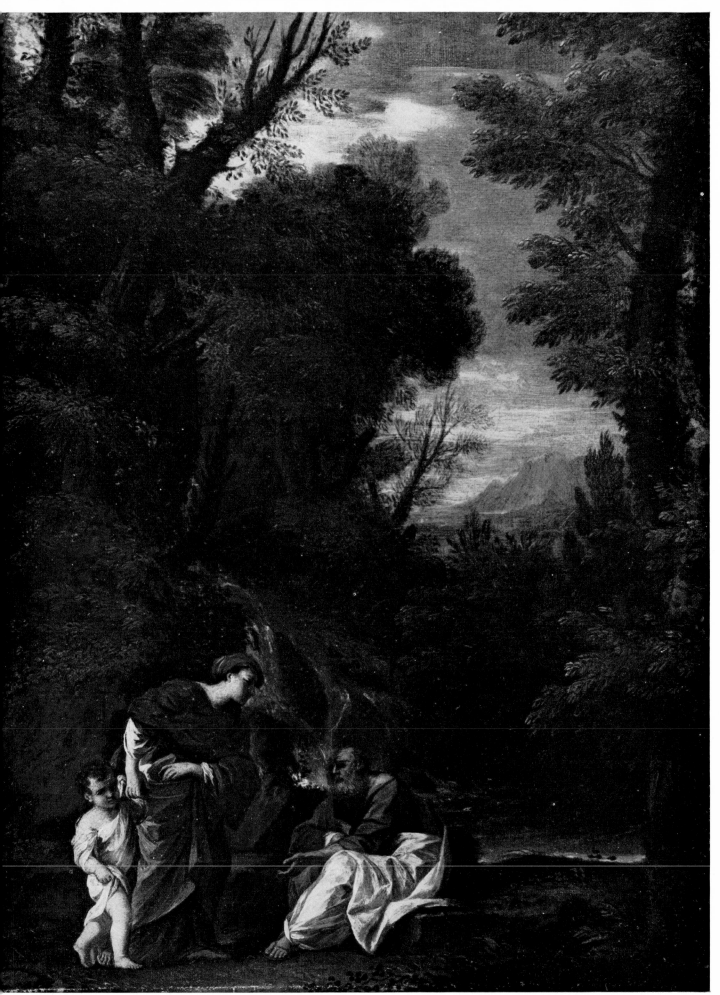

38. P. F. Mola, *The Prophet Elisha and the Rich Woman of Shunem*, (Cat. 61)

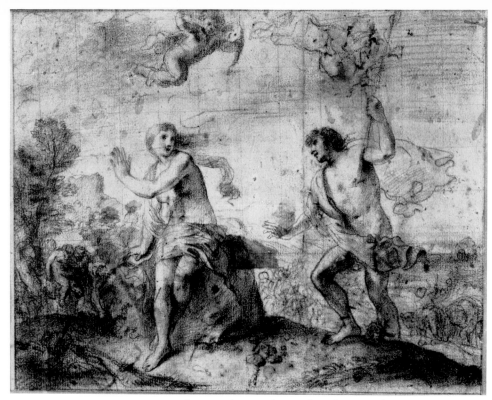

39. P. F. Mola, *Bacchus and Ariadne,* (Cat. 46)

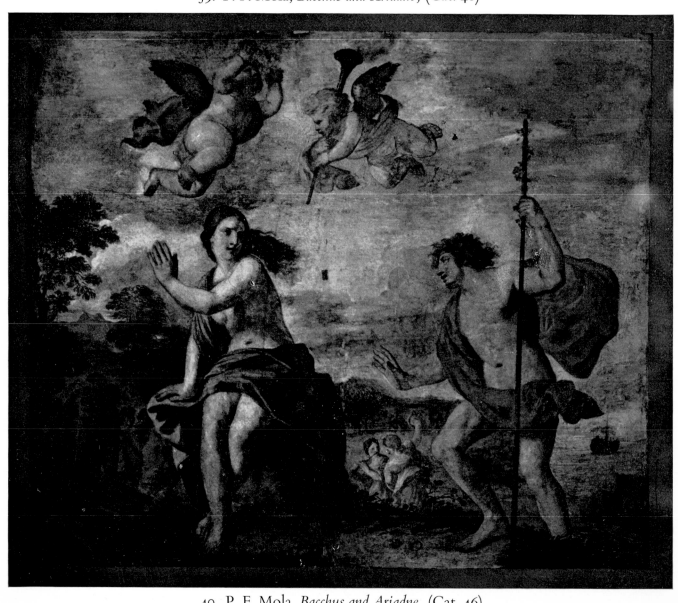

40. P. F. Mola, *Bacchus and Ariadne,* (Cat. 46)

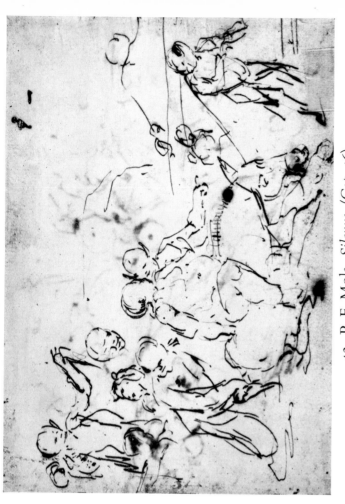

41. P. F. Mola, *Bacchus and Ariadne*, (Cat. 46)

42. P. F. Mola, *Silenus*, (Cat. 46)

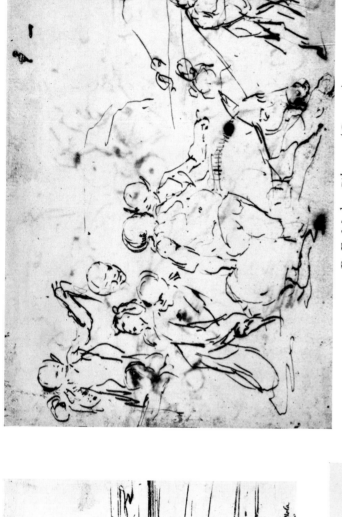

43. P. F. Mola, *Bacchus and Ariadne*, (Cat. 46)

44. P. F. Mola, *Studies of Putti and Ariadne*, (Cat. 46)

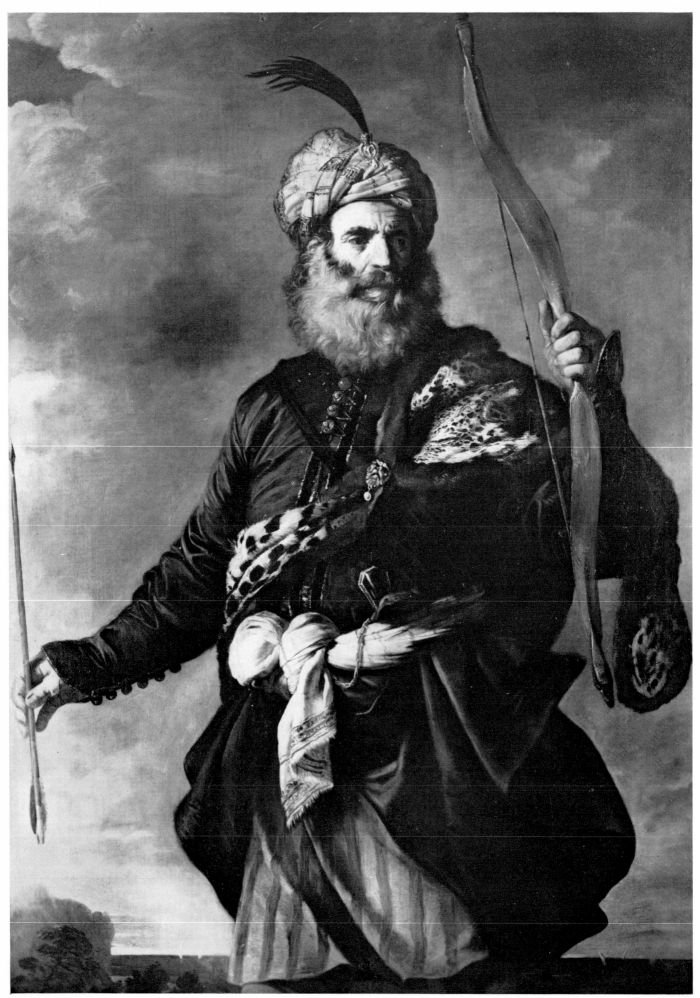

45. P. F. Mola, *Barbary Pirate,* (Cat. 36)

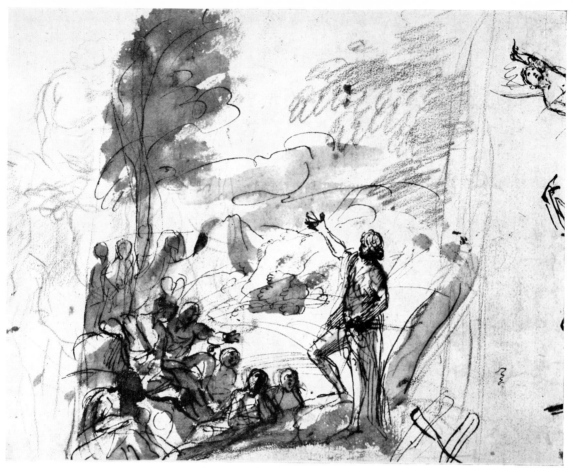

46. P. F. Mola, *St. John the Baptist Preaching,* (Cat. 9)

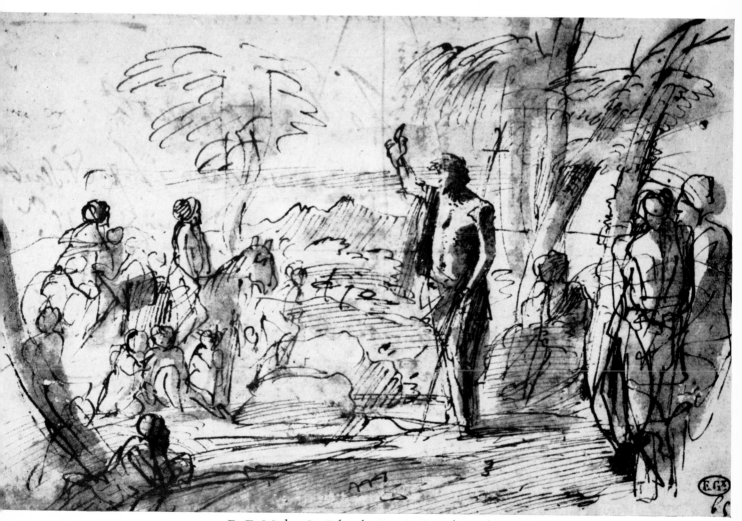

47. P. F. Mola, *St. John the Baptist Preaching,* (Cat. 9)

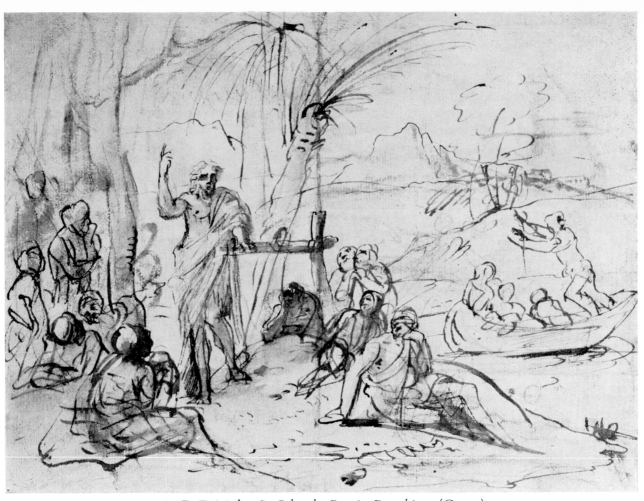

48. P. F. Mola, *St. John the Baptist Preaching,* (Cat. 9)

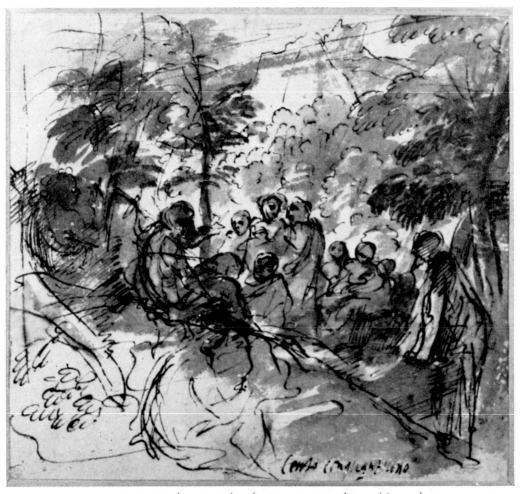

49. P. F. Mola, *St. John the Baptist Preaching,* (Cat. 9)

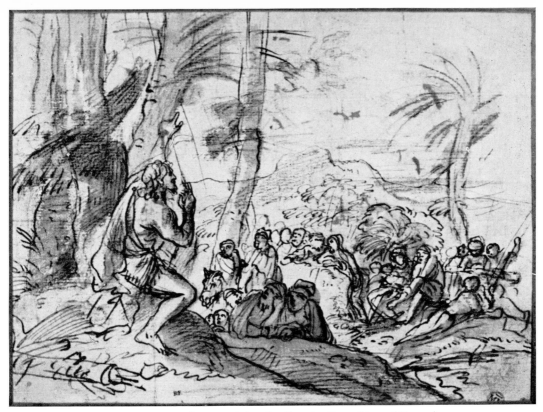

50. P. F. Mola, *St. John the Baptist Preaching*, (Cat. 9)

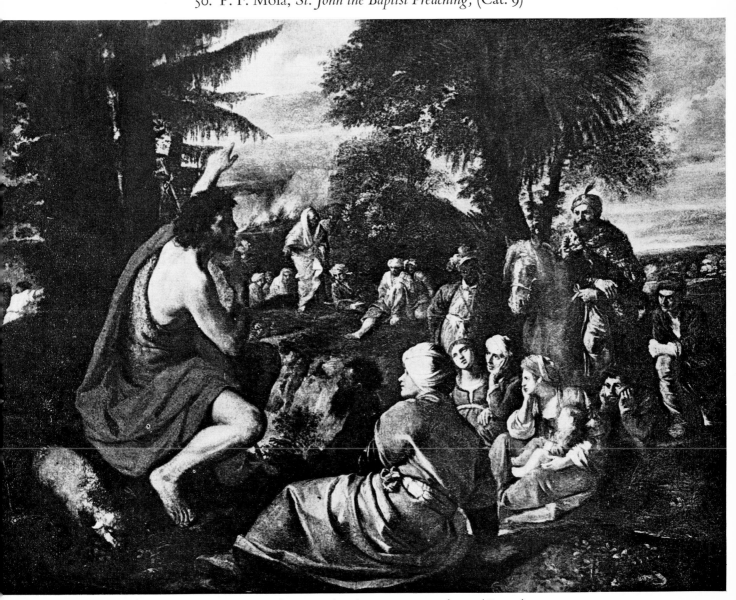

51. P. F. Mola, *St. John the Baptist Preaching*, (Cat. 9)

52. P. F. Mola, *Studies of St. Barnabas and Tancred and Erminia,* (Cat. 55)

54. P. F. Mola, *St. Barnabas Preaching,* (Cat. 55)

53. P. F. Mola, *St. Barnabas Preaching,* (Cat. 55)

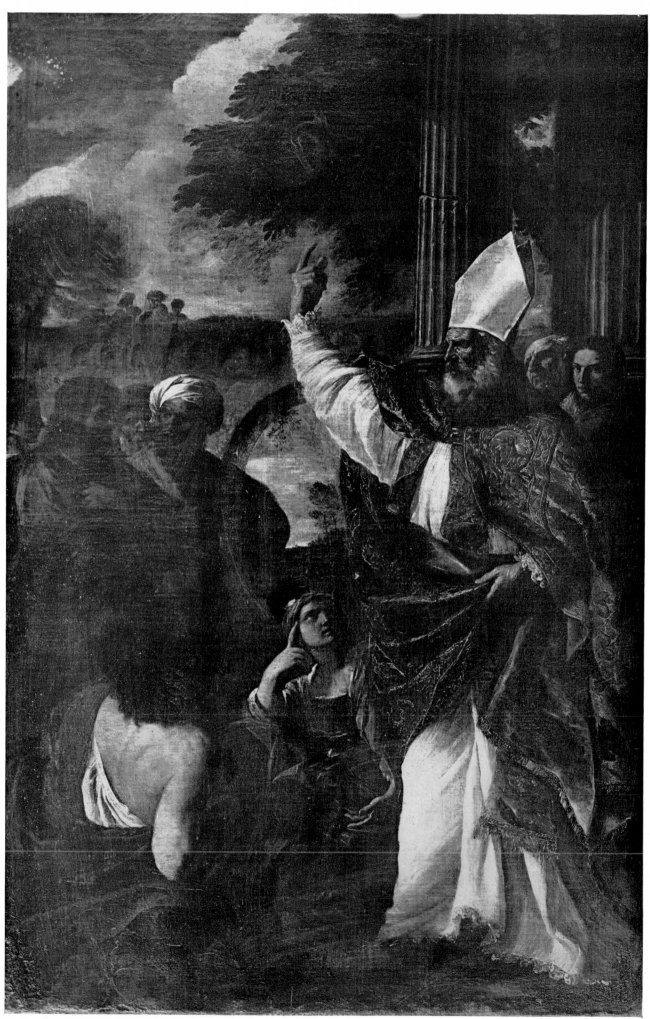

55. P. F. Mola, *St. Barnabas Preaching,* (Cat. 55)

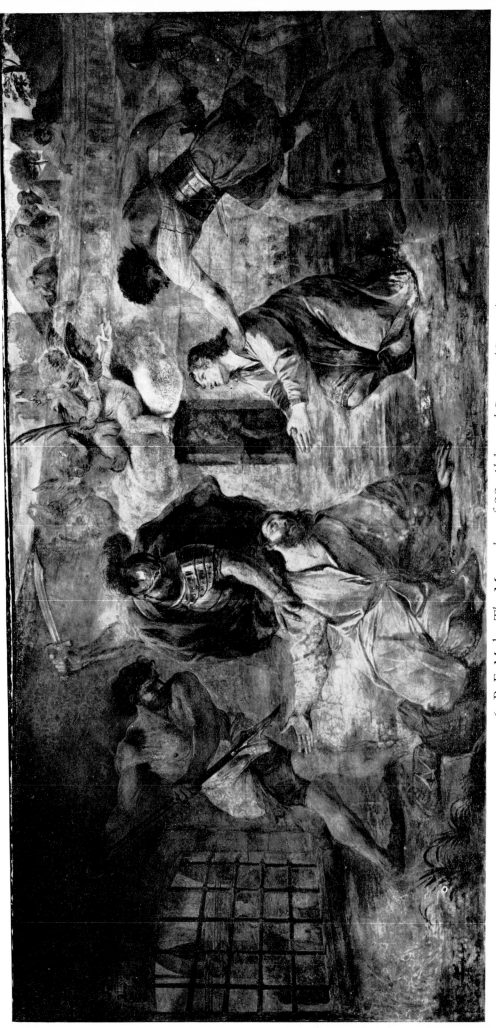

56. P. F. Mola, *The Martyrdom of SS. Abdon and Sennon*, (Cat. 57)

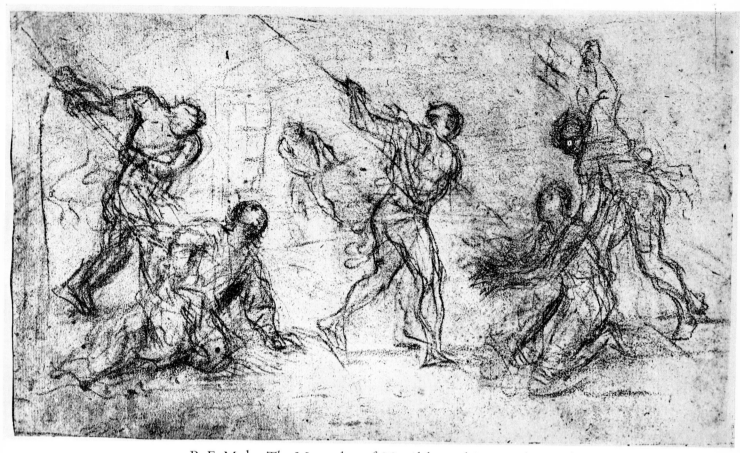

57. P. F. Mola, *The Martyrdom of SS. Abdon and Sennon,* (Cat. 57)

58. P. F. Mola, *Studies of Legs,* (Cat. 57)

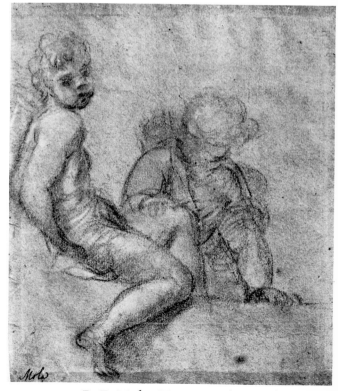

59. P. F. Mola, *Two Putti,* (Cat. 57)

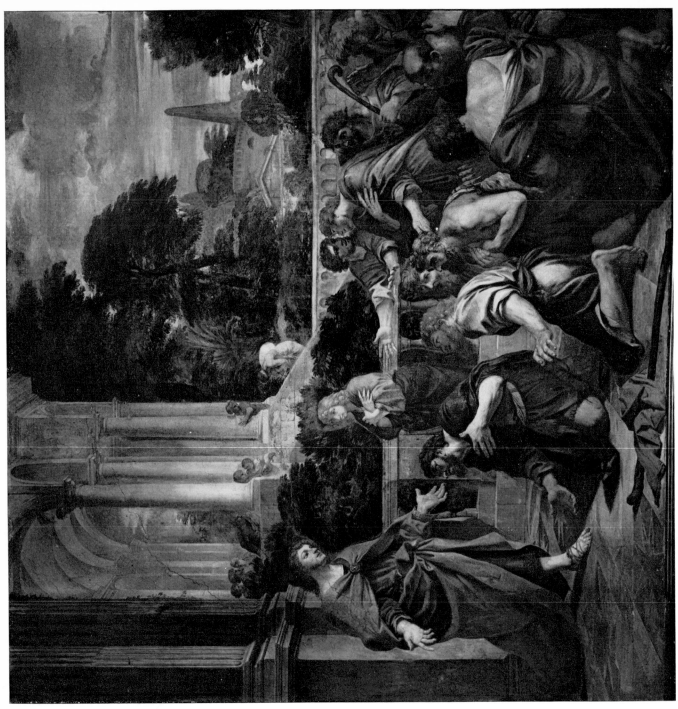

60. P. F. Mola, *Joseph Greeting his Brothers*, (Cat. 49)

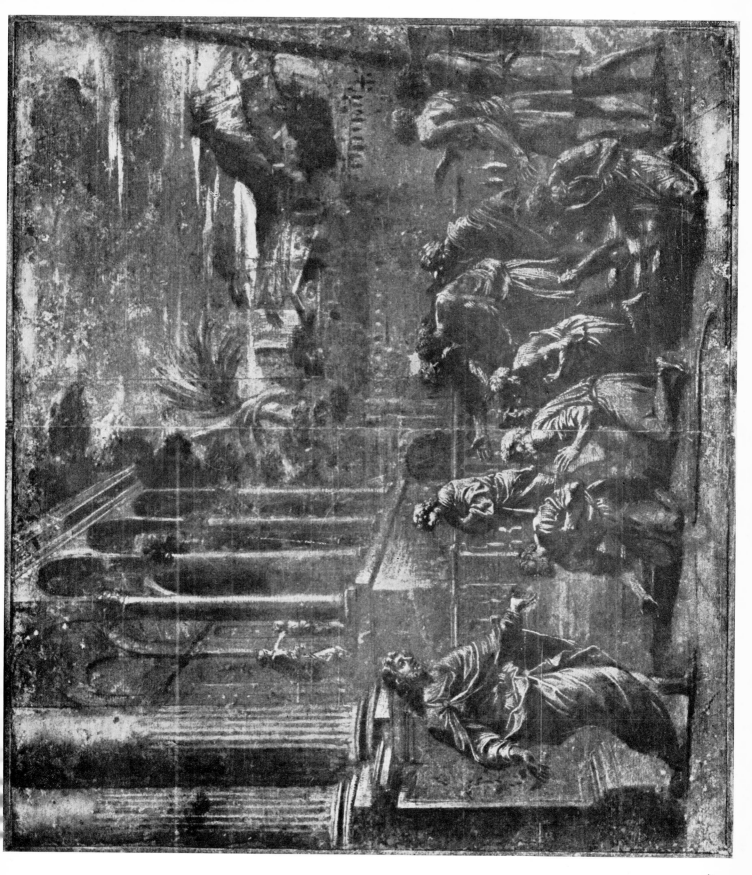

61. P. F. Mola,
Joseph Greeting his
Brothers, (Cat. 49)

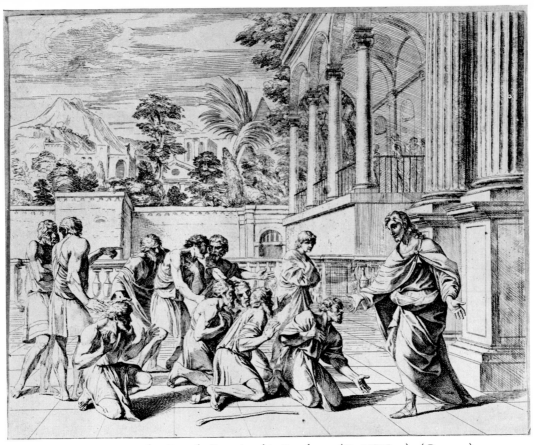

62. P. F. Mola, *Joseph Greeting his Brothers,* (B. XIX. I), (Cat. 49)

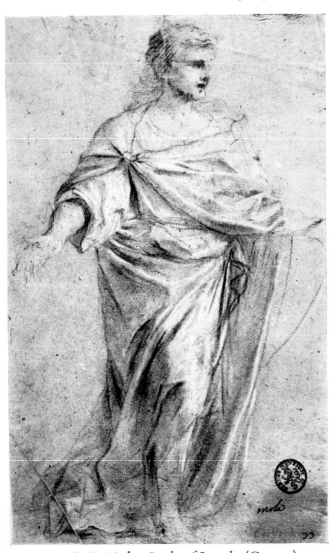

63. P. F. Mola, *Study of Joseph,* (Cat. 49)

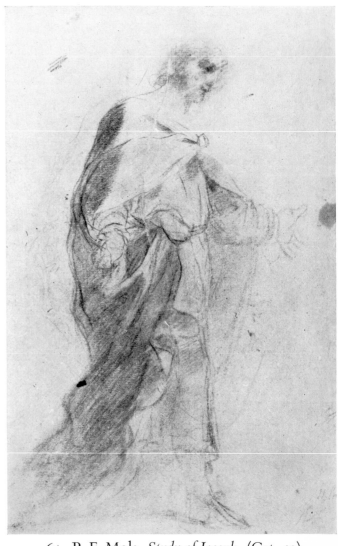

64. P. F. Mola, *Study of Joseph,* (Cat. 49)

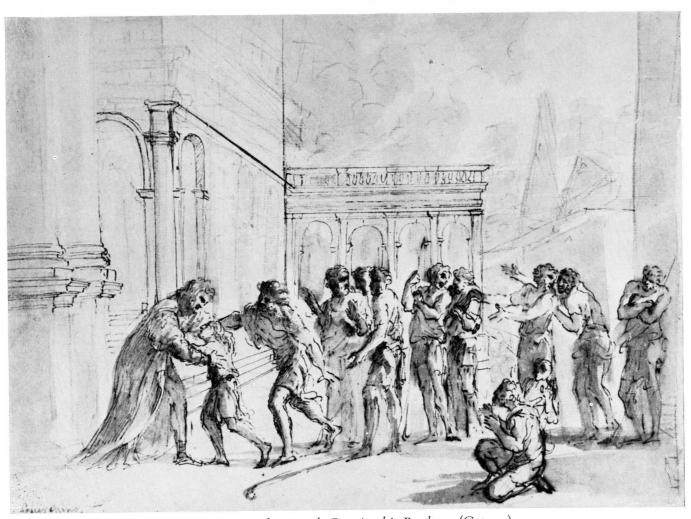

65. P. F. Mola, *Joseph Greeting his Brothers*, (Cat. 49)

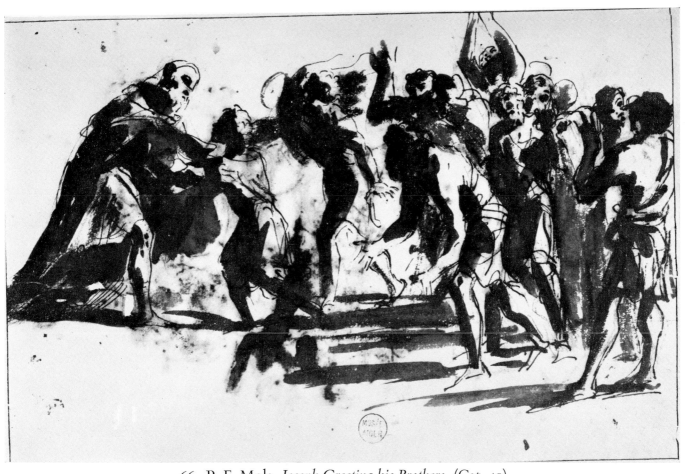

66. P. F. Mola, *Joseph Greeting his Brothers*, (Cat. 49)

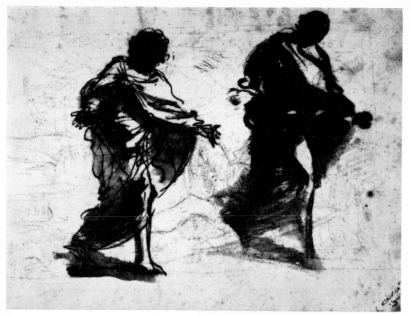

67. P. F. Mola, *Studies of Joseph,* (Cat. 49)

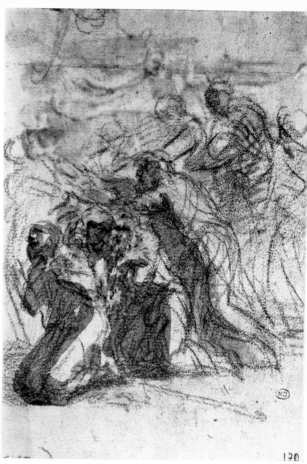

69. P. F. Mola, *Study of Joseph's Brothers,*
(Cat. 49)

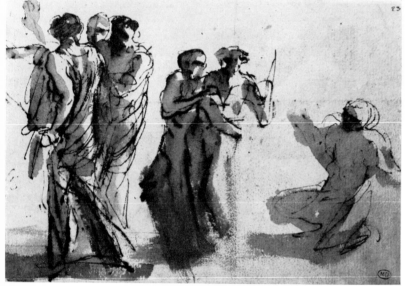

68. P. F. Mola, *Study of Joseph's Brothers,* (Cat. 49)

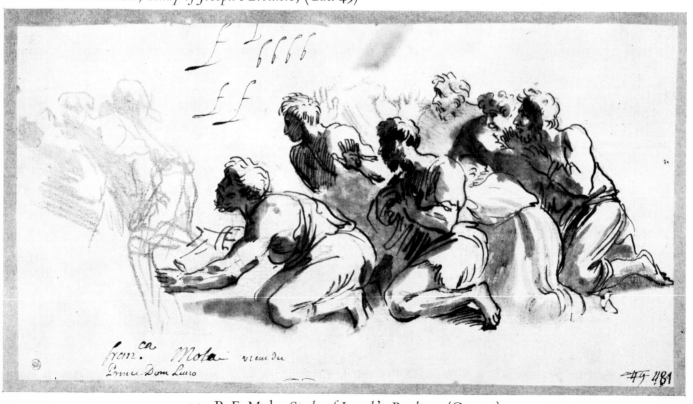

70. P. F. Mola, *Study of Joseph's Brothers,* (Cat. 49)

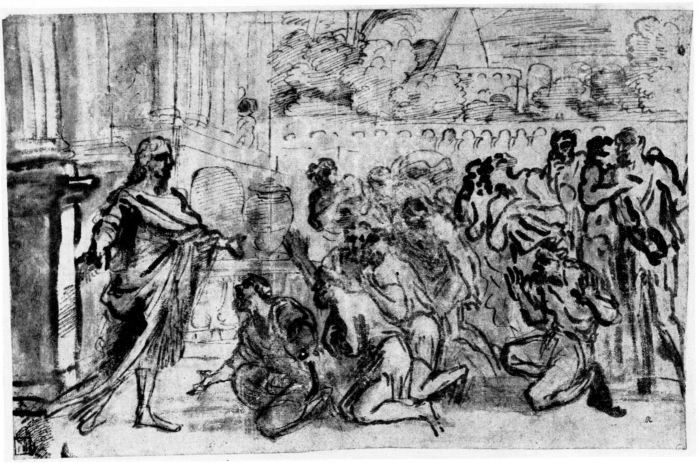

71. P. F. Mola, *Joseph Greeting his Brothers,* (Cat. 49)

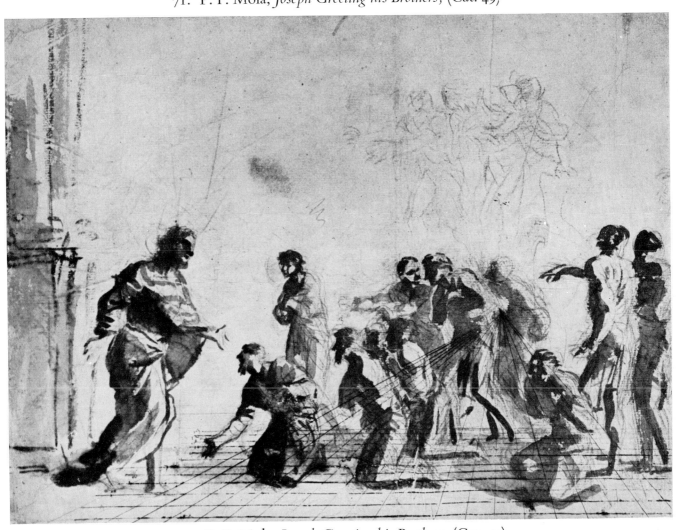

72. P. F. Mola, *Joseph Greeting his Brothers,* (Cat. 49)

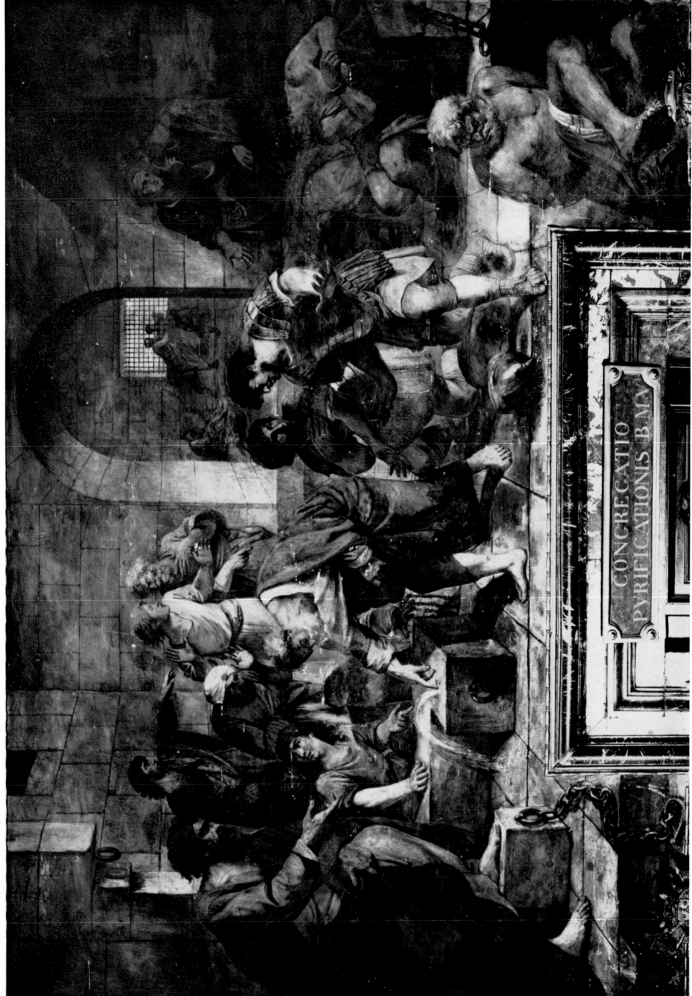

73. P. F. Mola, *St. Peter Baptizing in Prison*, (Cat. 53)

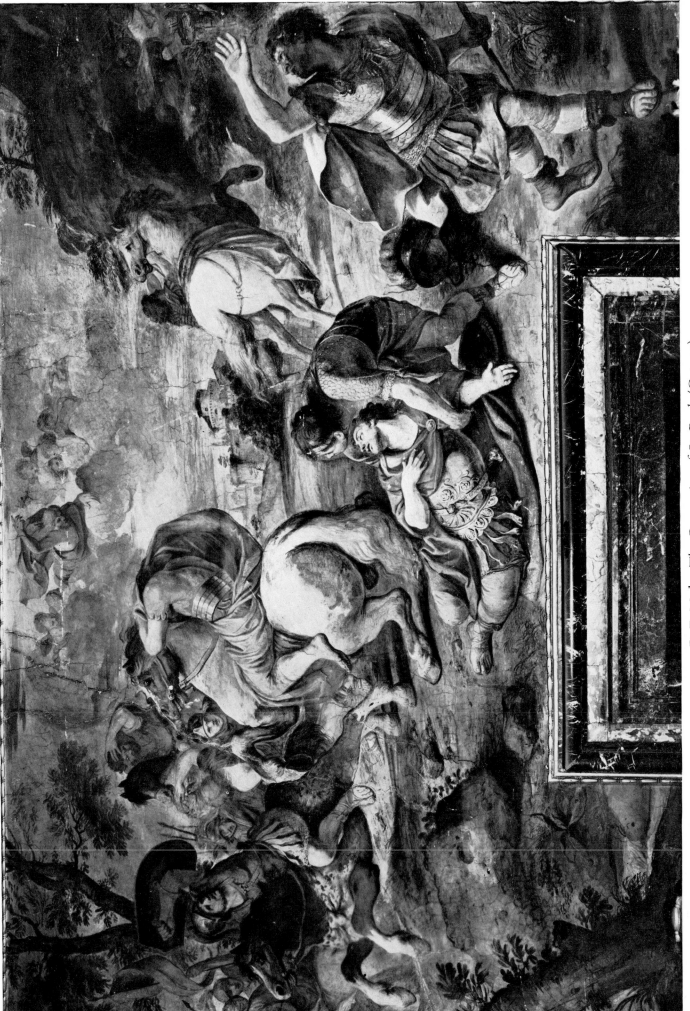

74. P. F. Mola, *The Conversion of St. Paul*, (Cat. 52)

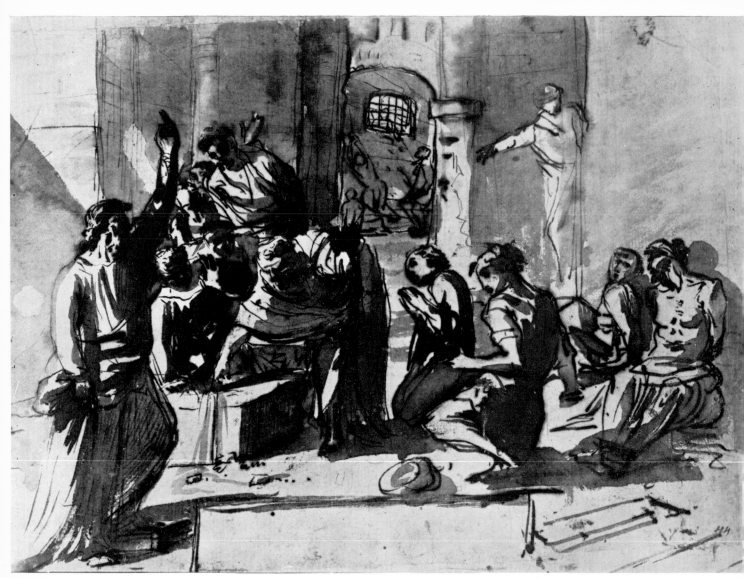

75. P. F. Mola, *St. Peter Baptizing in Prison*, (Cat. 53)

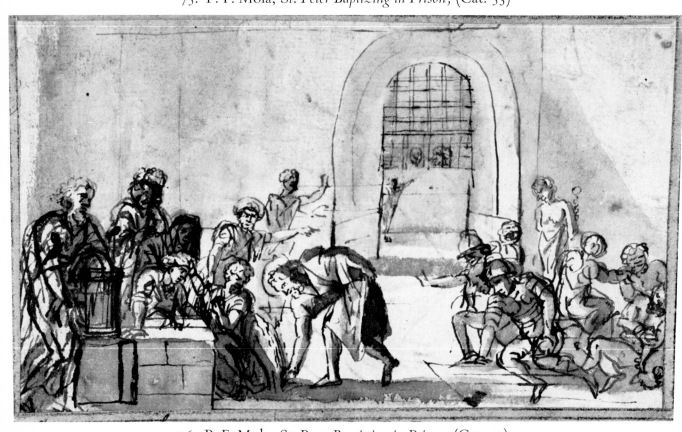

76. P. F. Mola, *St. Peter Baptizing in Prison*, (Cat. 53)

77. P. F. Mola, *The Prodigal Son,* (Cat. 53)

78. P. F. Mola, *Study of a Prisoner,* (Cat. 53)

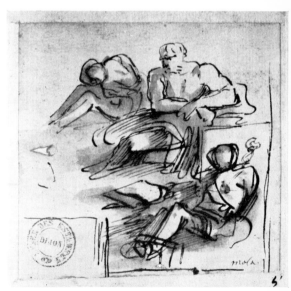

79. P. F. Mola, *Study of Three Prisoners,*
(Cat. 53)

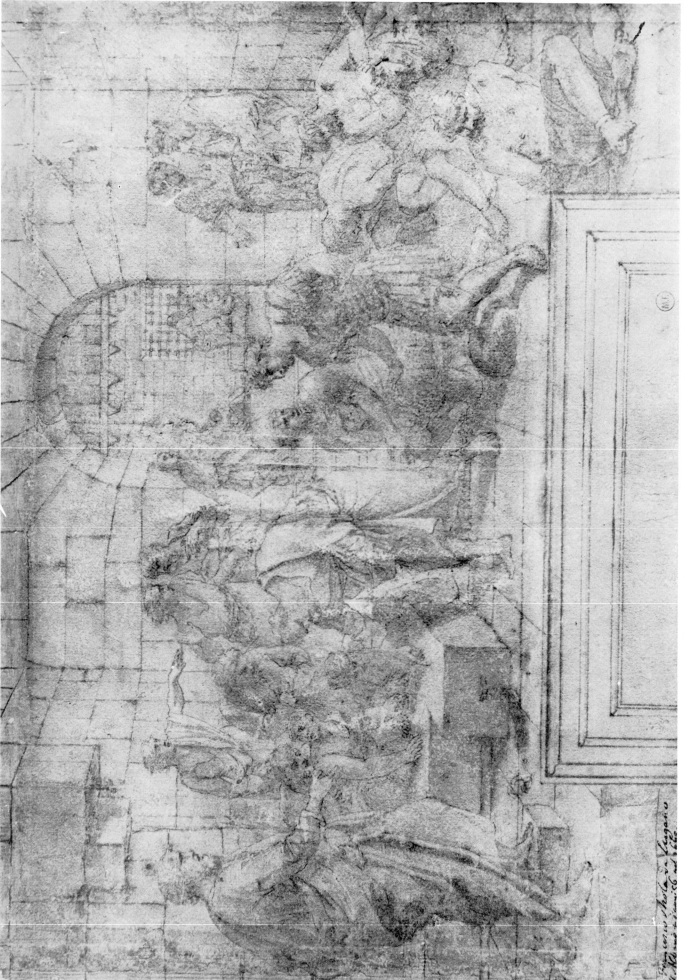

80. P. F. Mola, *St. Peter Baptizing in Prison*, (Cat. 53)

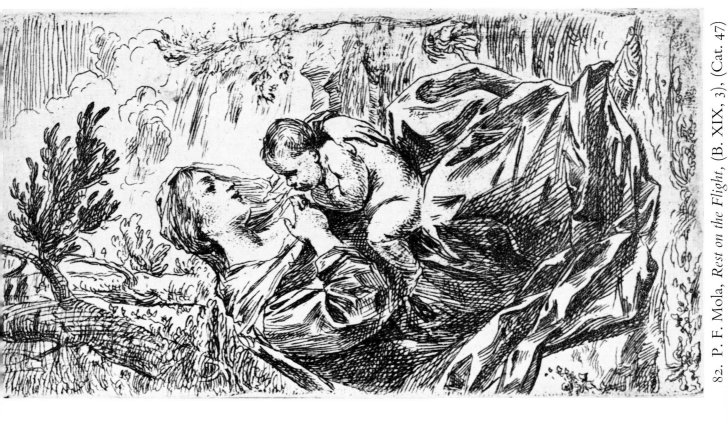

82. P. F. Mola, *Rest on the Flight*, (B. XIX, 3), (Cat. 47)

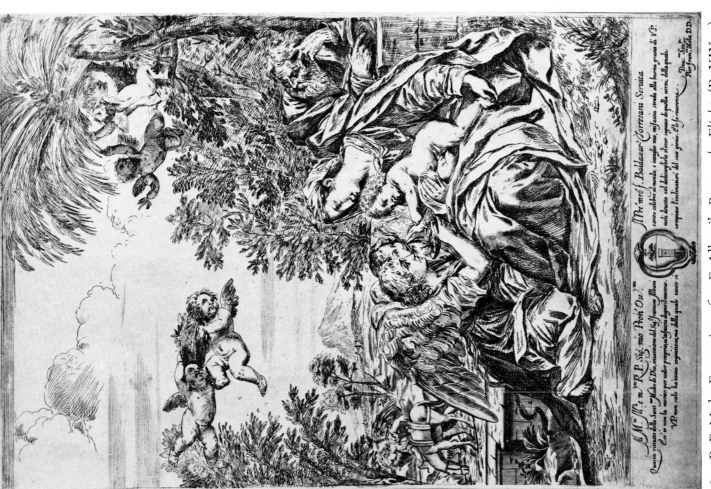

81. P. F. Mola, Engraving after F. Albani's *Rest on the Flight*, (B. XIX. 4), (Cat. 47)

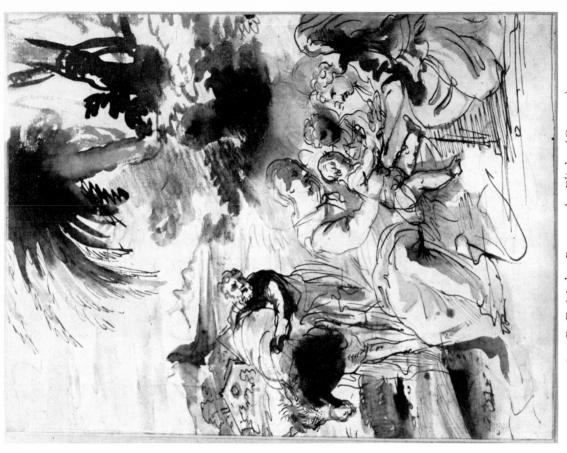

84. P. F. Mola, *Rest on the Flight*, (Cat. 47)

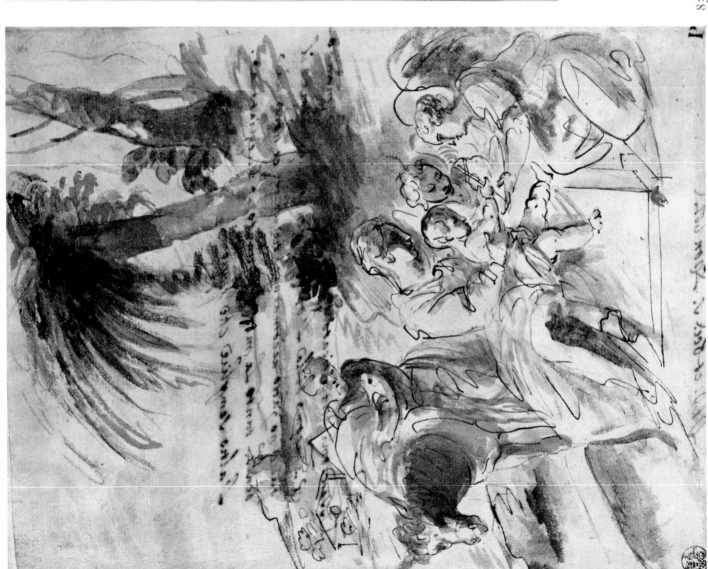

83. P. F. Mola, *Rest on the Flight*, (Cat. 47)

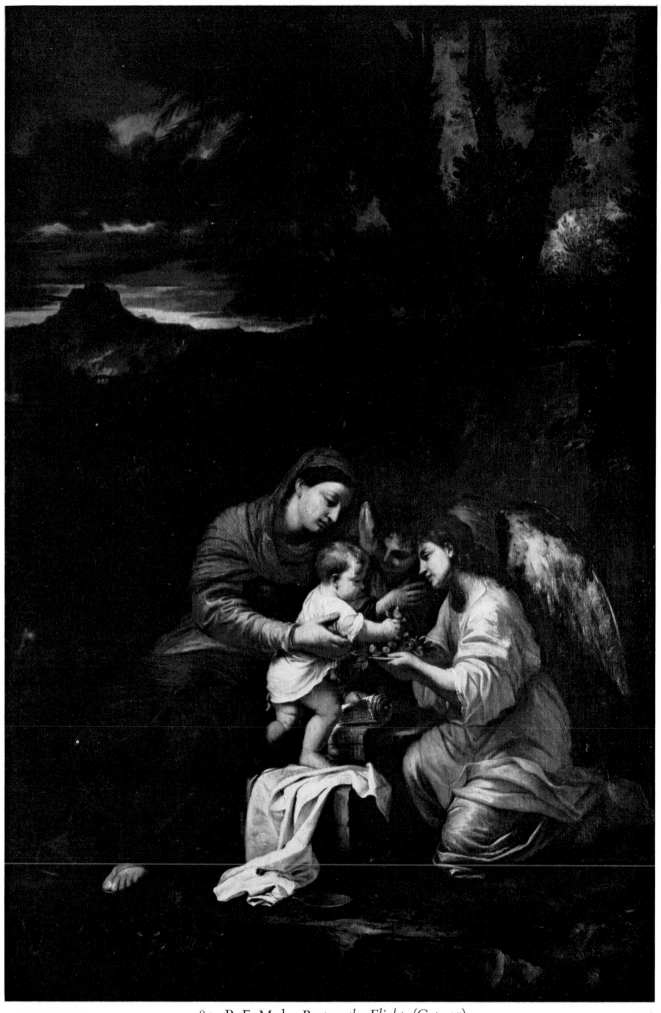

85. P. F. Mola, *Rest on the Flight*, (Cat. 47)

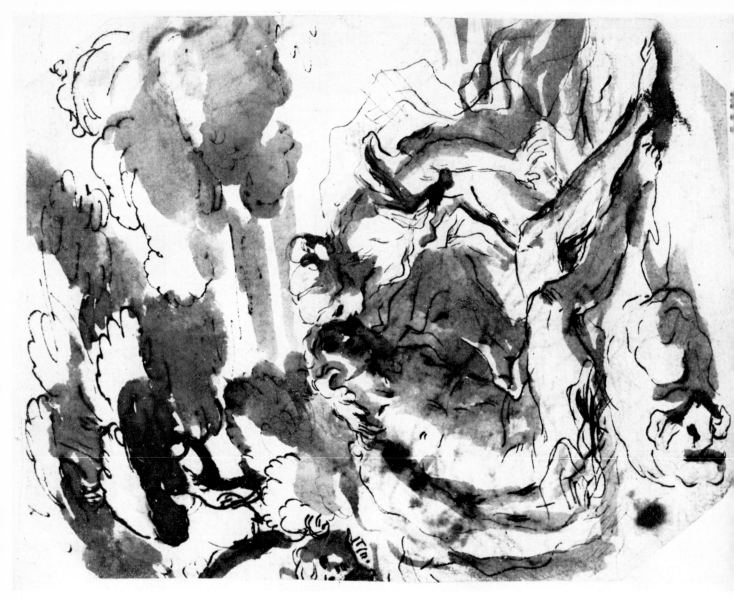

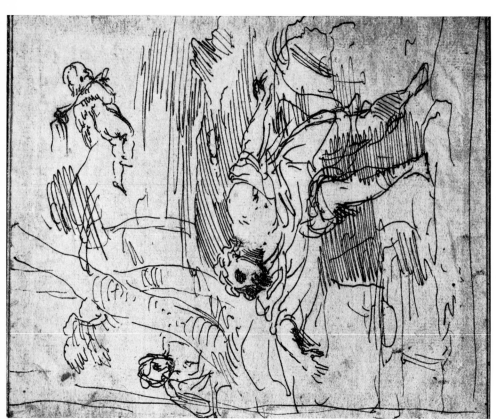

86. P. F. Mola, *Diana and Endymion*, (Cat. 40)

88. P. F. Mola, *Diana and Endymion,* (Cat. 40)

89. P. F. Mola, *Boy with a Dove*, (Cat. 63)

90. P. F. Mola, *Death of Archimedes,* (Cat. 38)

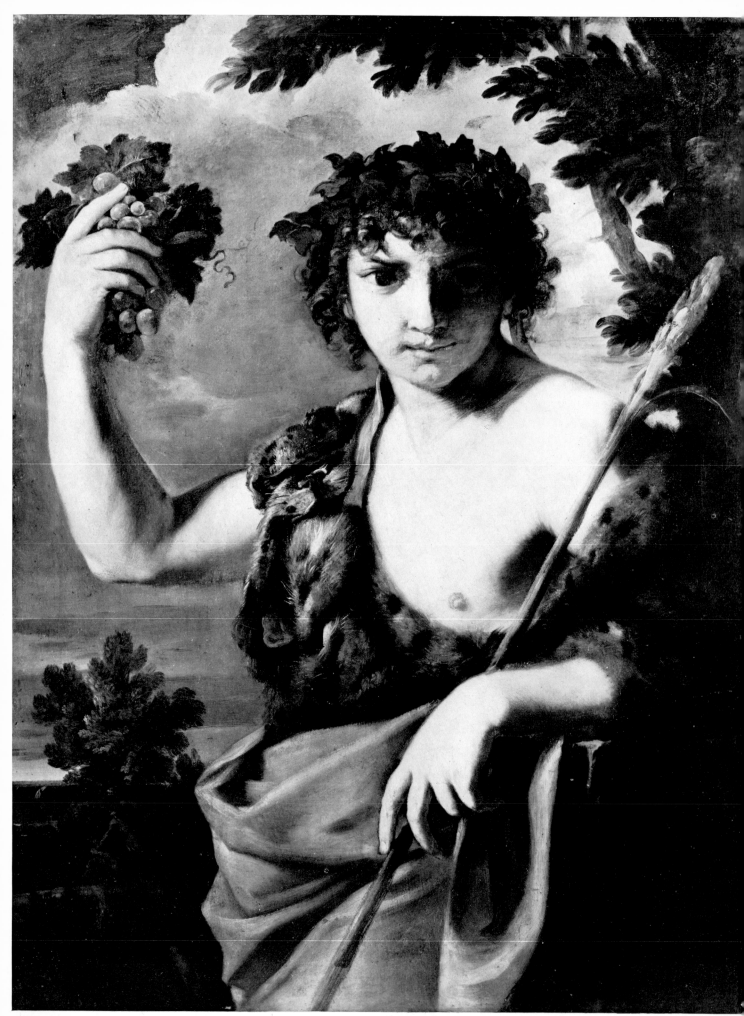

91. P. F. Mola, *Bacchus,* (Cat. 51)

92. P. F. Mola, *Expulsion of Hagar and Ishmael*, (Cat. 39)

93. P. F. Mola, *The Angel Appearing to Hagar and Ishmael*, (Cat. 42)

95. P. F. Mola, *Hagar and the Angel*, (Cat. 42)

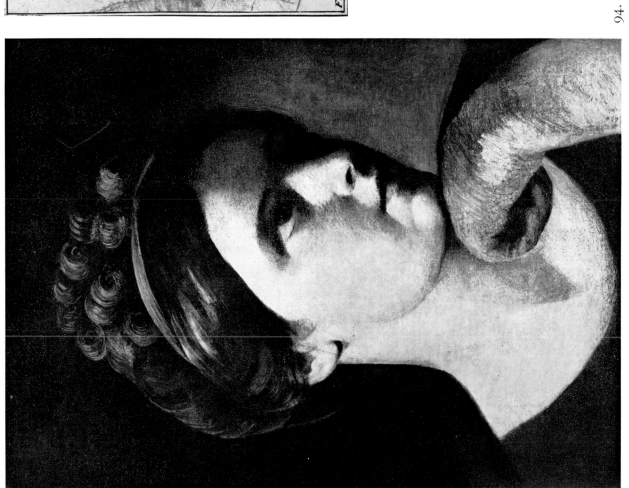

94. P. F. Mola, *Head of a Young Woman*, (Cat. 48)

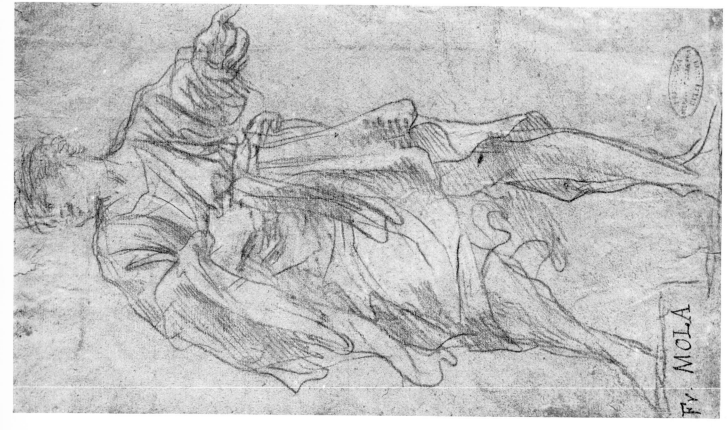

Fr. MOLA

97. P. F. Mola, *Study of Eliezer* (?), (Cat. 41)

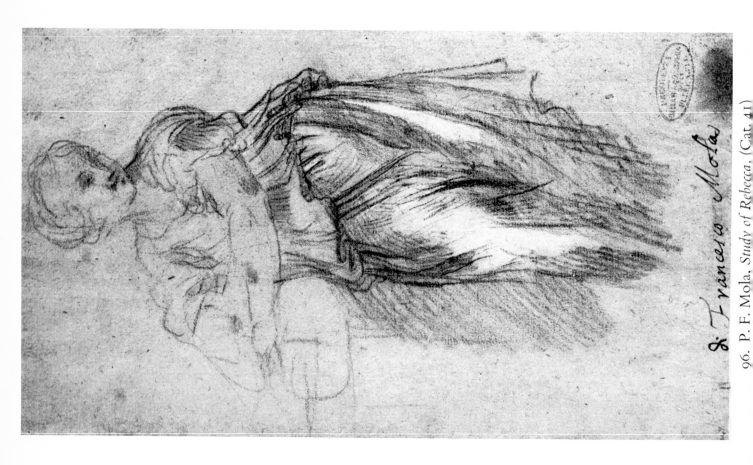

S. Francesco Mola

96. P. F. Mola, *Study of Rebecca*, (Cat. 41)

98. P. F. Mola, *Landscape with St. Bruno in Ecstasy*, (Cat. 15)

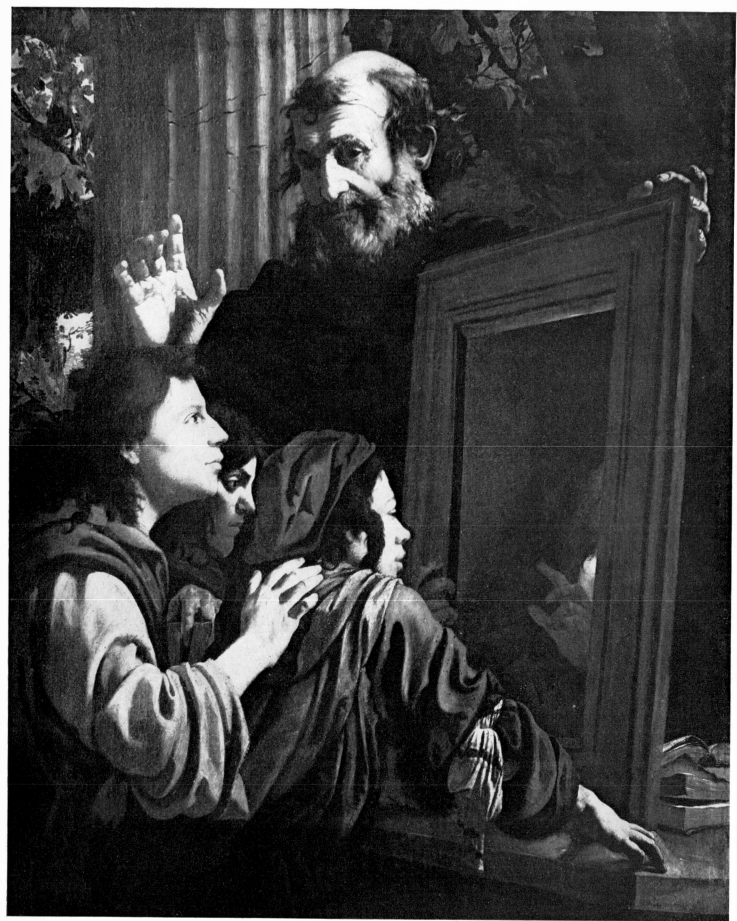

99. P. F. Mola, *Philosopher Teaching* (?), (Cat. 22)

101. P. F. Mola, *St. John the Baptist in the Wilderness*, (Cat. 54)

100. P. F. Mola, *St. Michael Confounding Lucifer*, (Cat. 59)

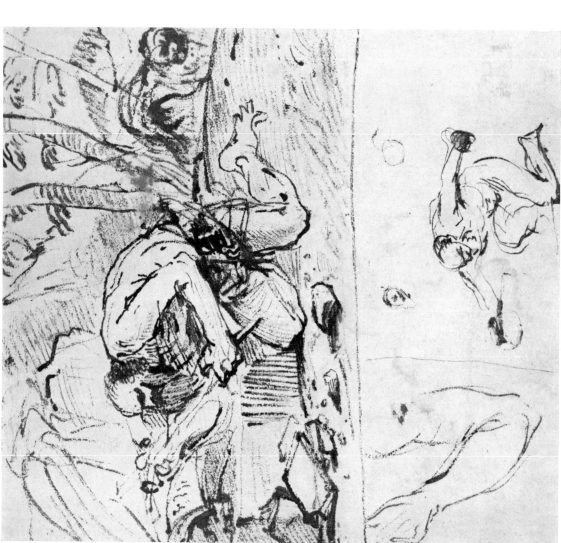

102. P. F. Mola, *Studies of St. Jerome*, (Cat. 1)

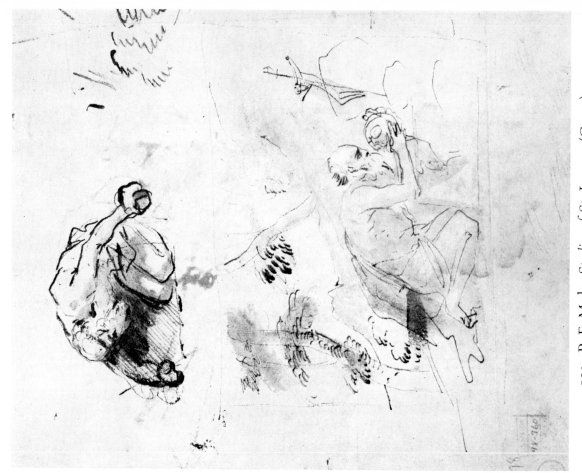

103. P. F. Mola, *Studies of St. Jerome*, (Cat. 1)

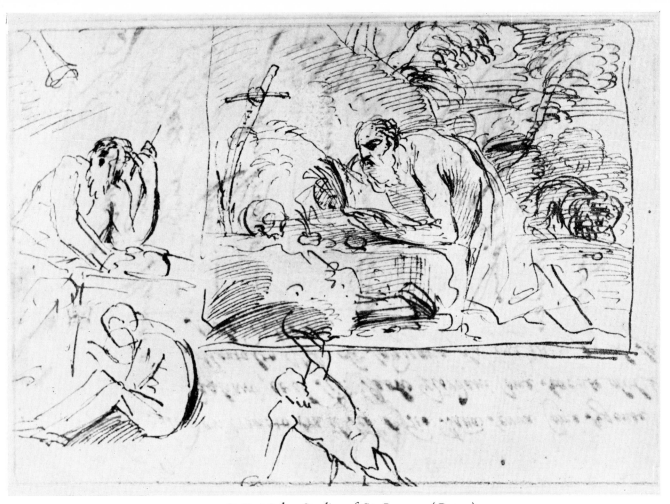

104. P. F. Mola, *Studies of St. Jerome*, (Cat. 1)

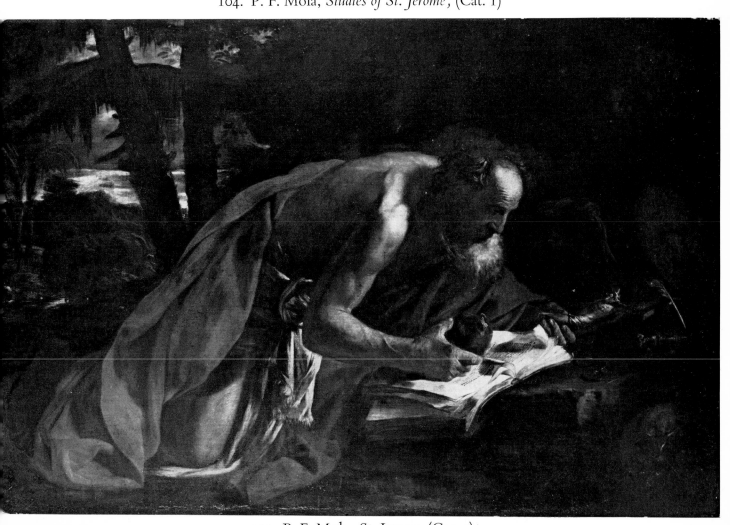

105. P. F. Mola, *St. Jerome*, (Cat. 1)

106. P. F. Mola and G. Dughet, *Sala del Principe*, (Cat. 65)

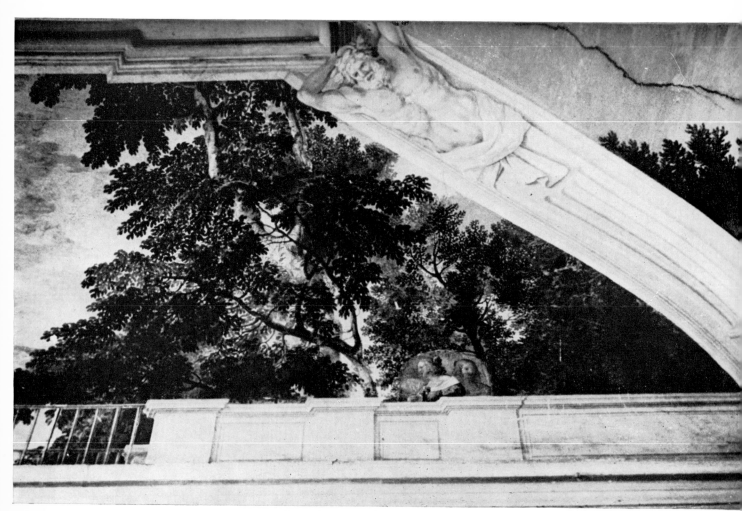

107. P. F. Mola and G. Dughet, *Sala del Principe*, (Cat. 65)

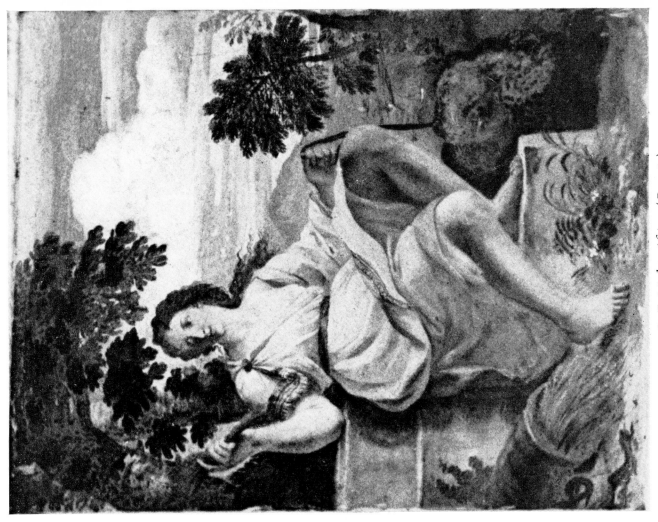

109. P. F. Mola, *Africa*, (Cat. 64)

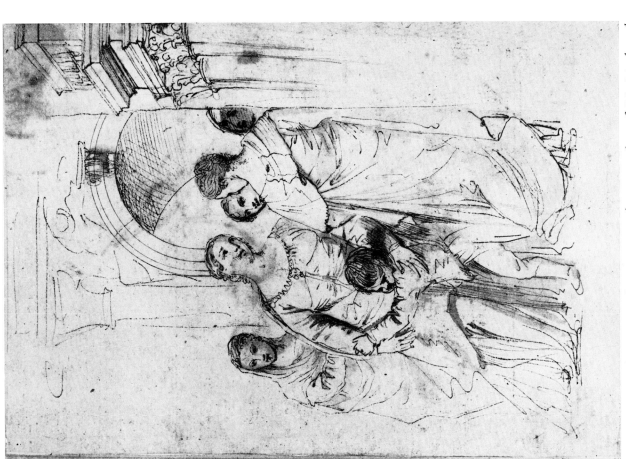

108. P. F. Mola, Copy after Veronese's *Martyrdom of SS. Mark and Marcellinus*, (Cat. 65)

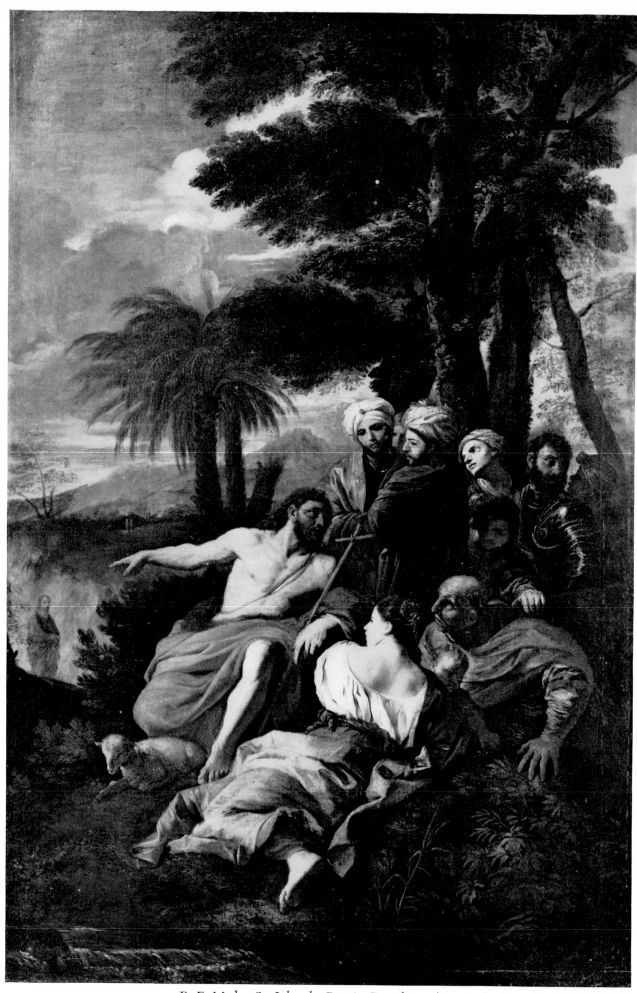

110. P. F. Mola, *St. John the Baptist Preaching,* (Cat. 35)

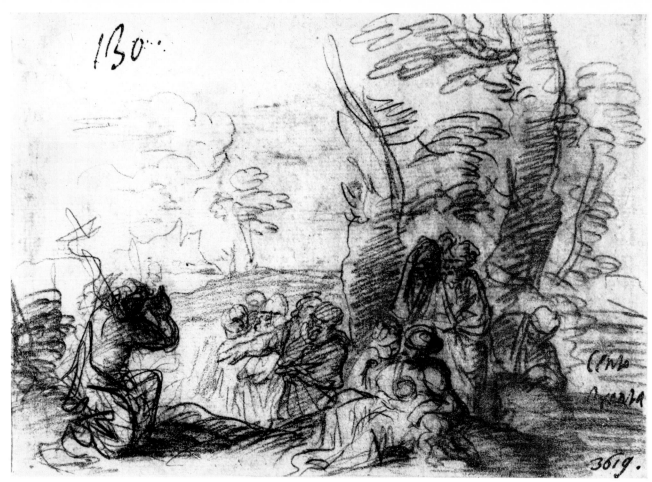

111. P. F. Mola, *St. John the Baptist Preaching*, (Cat. 35)

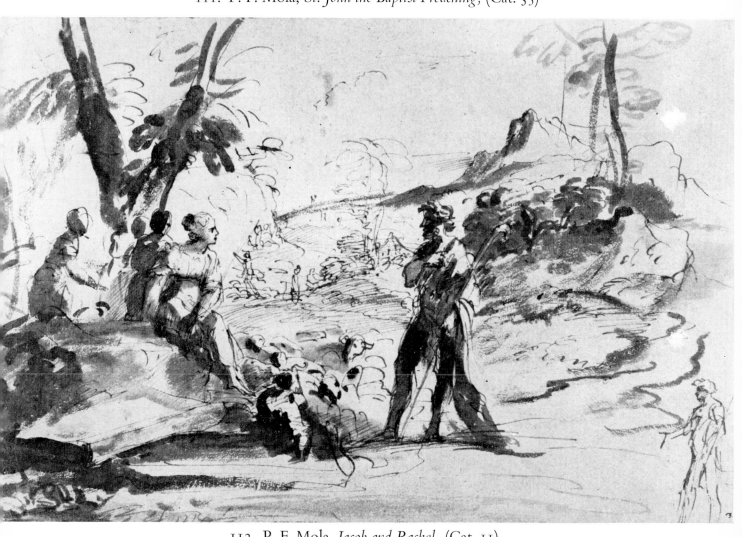

112. P. F. Mola, *Jacob and Rachel*, (Cat. 11)

113. P. F. Mola, *Jacob and Rachel*, (Cat. 11)

114. P. F. Mola, *Rest on the Flight*, (Cat. 12)

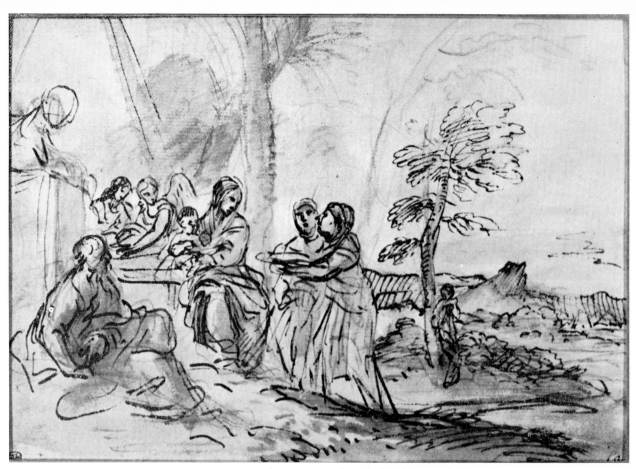

115. P. F. Mola, *Rest on the Flight,* (Cat. 12)

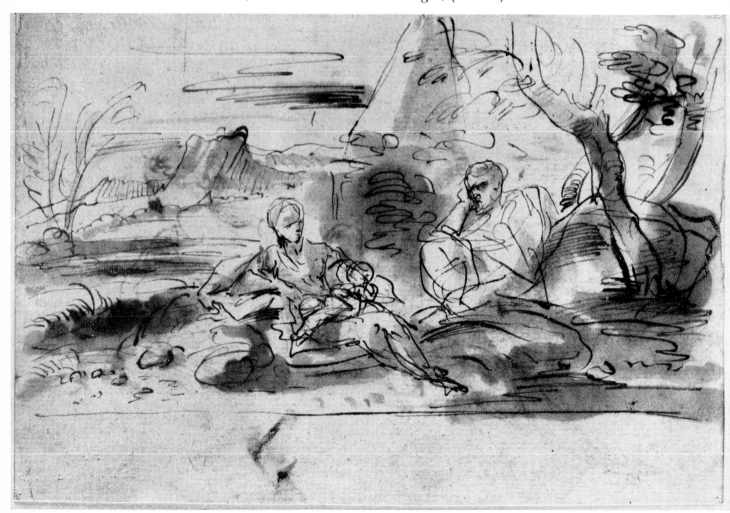

116. P. F. Mola, *Rest on the Flight,* (Cat. 12)

117. P. F. Mola, *Studies for A Rest on the Flight and The Vision of St. Joseph*, (Cat. 12)

118. P. F. Mola, *Studies of St. Joseph*, (Cat. 12)

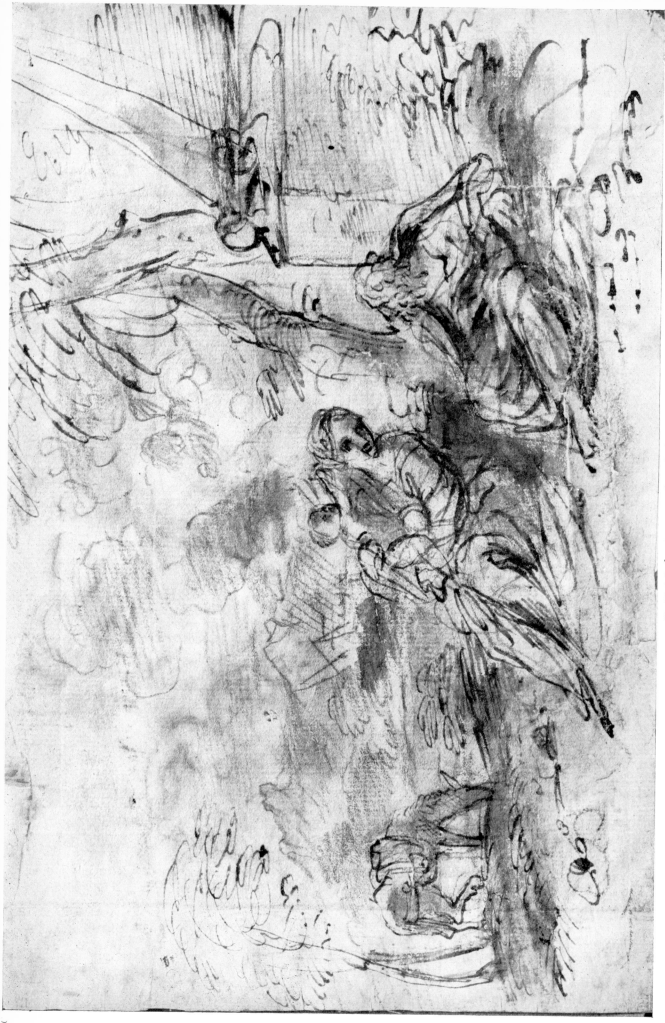

119. P. F. Mola, *Rest on the Flight*, (Cat. 12)

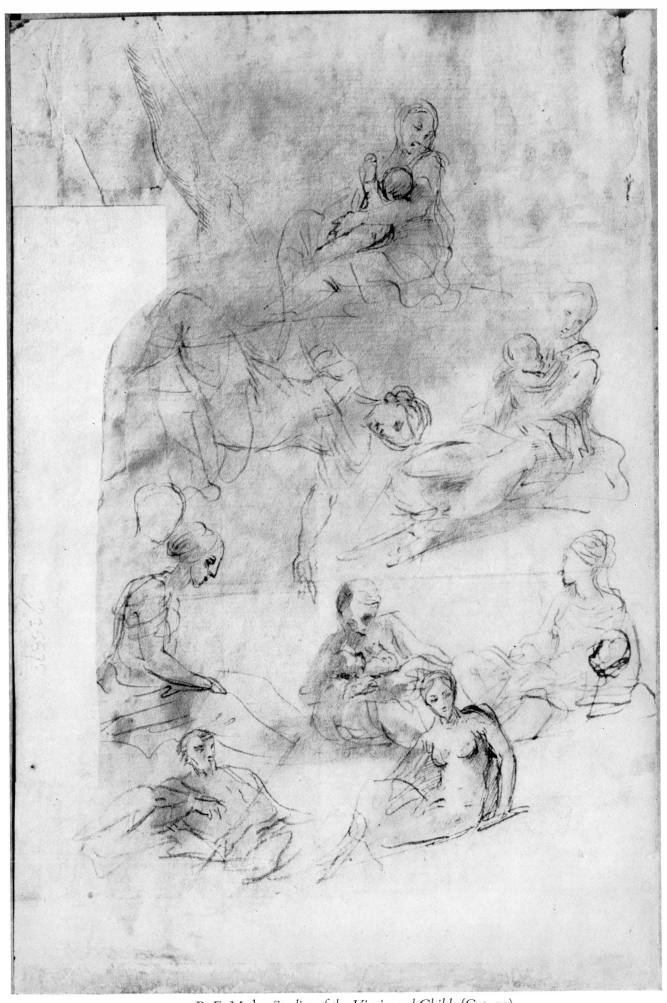

120. P. F. Mola, *Studies of the Virgin and Child,* (Cat. 12)

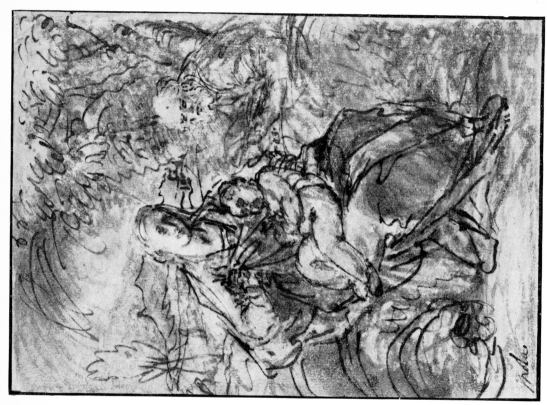

122. P. F. Mola, *Rest on the Flight*, (Cat. 29)

121. P. F. Mola, *Rest on the Flight*, (Cat. 29)

123. P. F. Mola, *Erminia Guarding her Flock*, (Cat. 33)

124. P. F. Mola, Copy after Titian's *Three Ages of Man*, (Cat. 4)

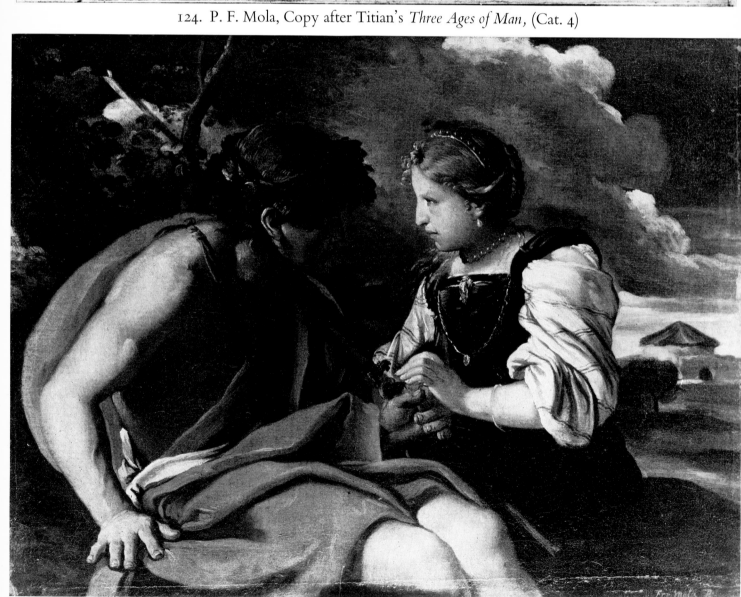

125. P. F. Mola, *Bacchus and Ariadne*, (Cat. 67)

126. P. F. Mola, *Bacchus and Ariadne*, (Cat. 4)

127. P. F. Mola and G. Dughet, *St. John the Baptist in the Wilderness*, (Cat. 24)

128. P. F. Mola, *St. John the Baptist Preaching,* (Cat. 19)

29. P. F. Mola, *St. John the Baptist Preaching,* (Cat. 19)

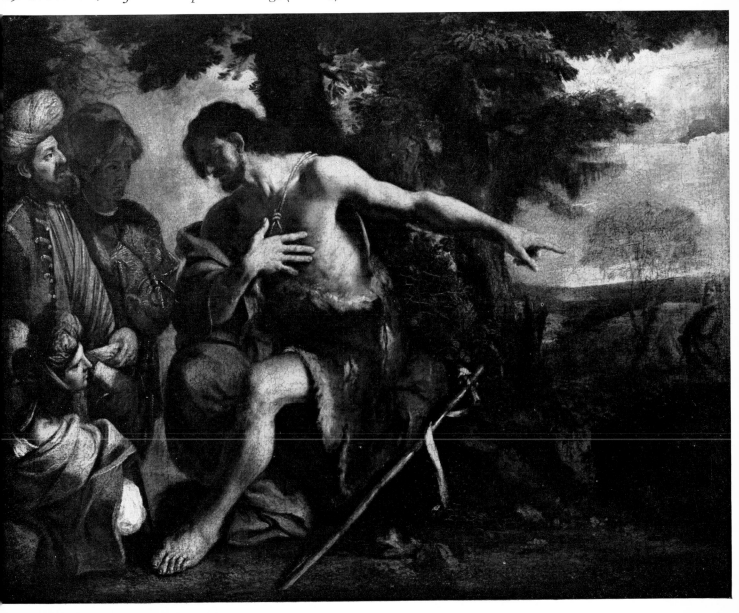

130. P. F. Mola, *Rape of Europa*. (Cat. 27)

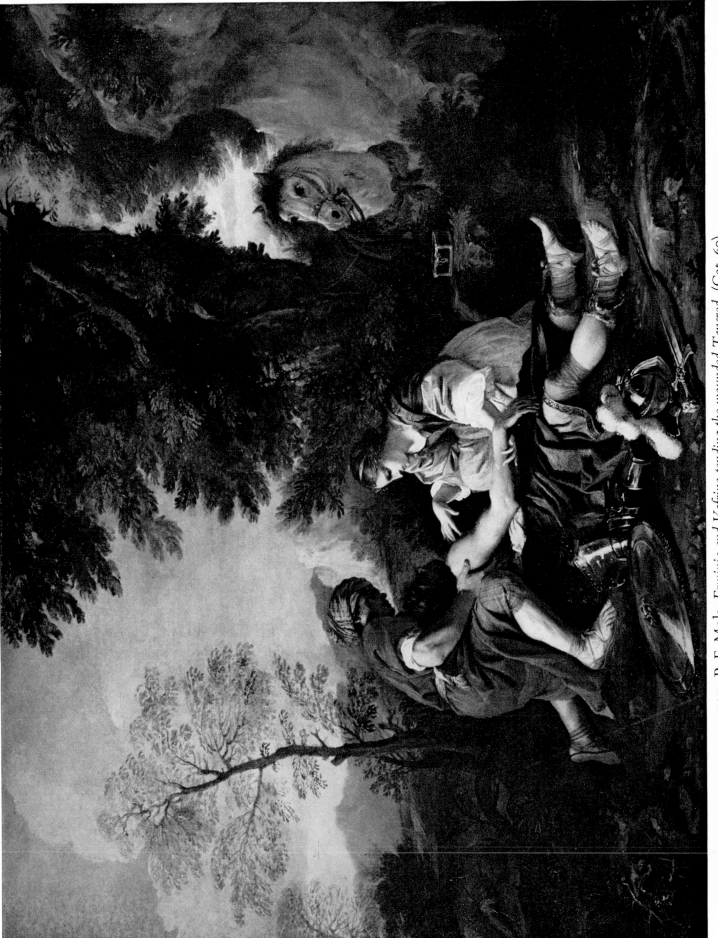

131. P. F. Mola, *Erminia and Vafrino tending the wounded Tancred*, (Cat. 60)

133. P. F. Mola, *Vision of St. Bruno*, (Cat. 45)

132. P. F. Mola, *Vision of St. Bruno*, (Cat. 45)

135. P. F. Mola, *Vision of St. Bruno*, (Cat. 45)

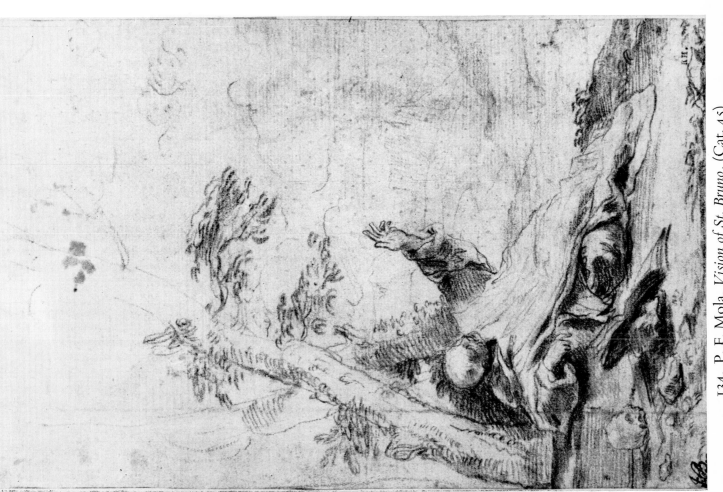

134. P. F. Mola, *Vision of St. Bruno*, (Cat. 45)

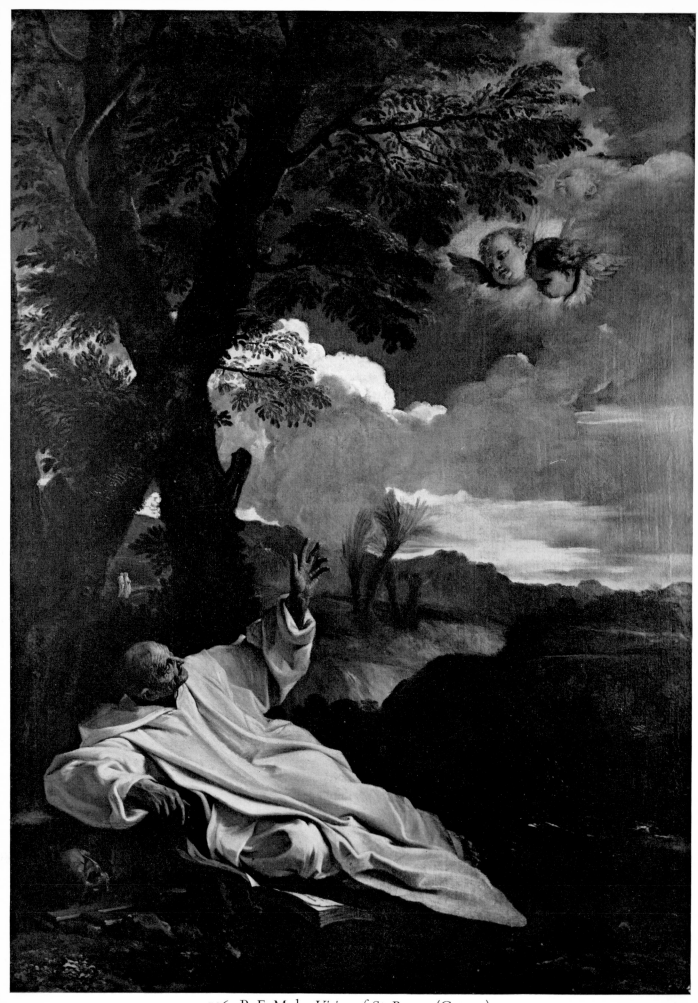

136. P. F. Mola, *Vision of St. Bruno*, (Cat. 45)

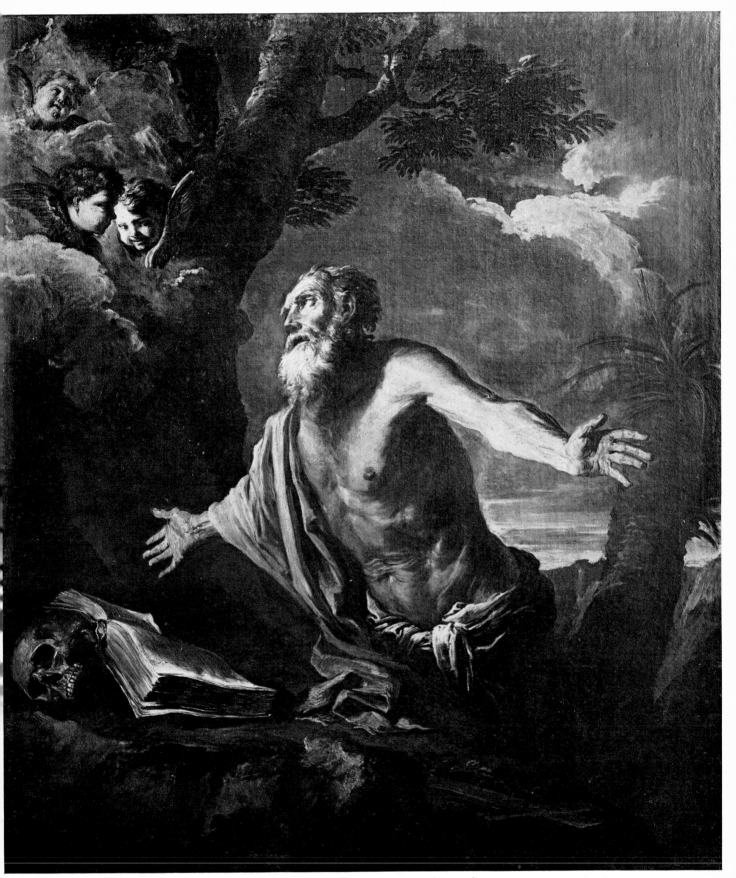

137. P. F. Mola, *St. Jerome*, (Cat. 6)

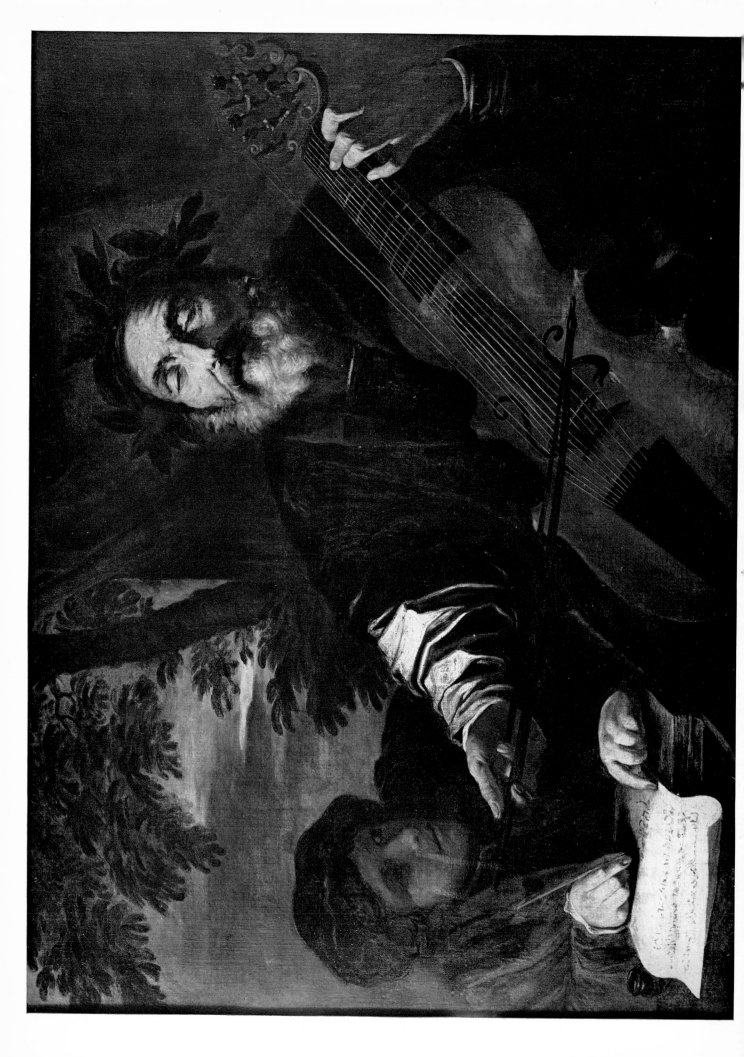

140. P. F. Mola, *Homer Dictating*, (Cat. 43)

139. P. F. Mola, *Portrait of a Woman*, (Cat. 50)

142. P. F. Mola, *Woman Spinning*, (Cat. 37)

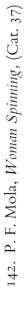

141. P. F. Mola, *Portrait of a Woman*, (Cat. 44)

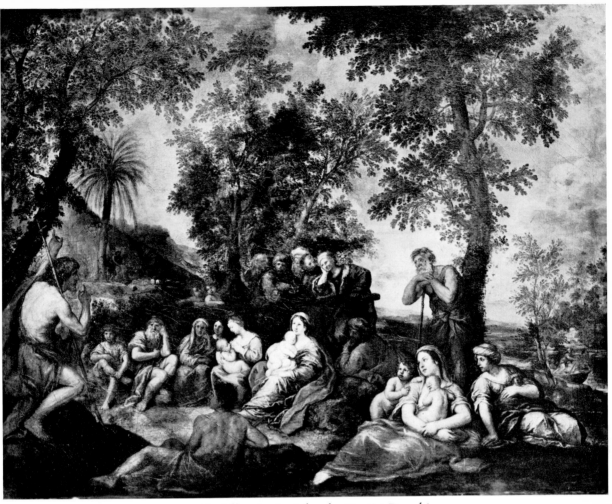

143. F. Albani, *St. John the Baptist Preaching*

144. F. Albani, *Baptism of Christ*

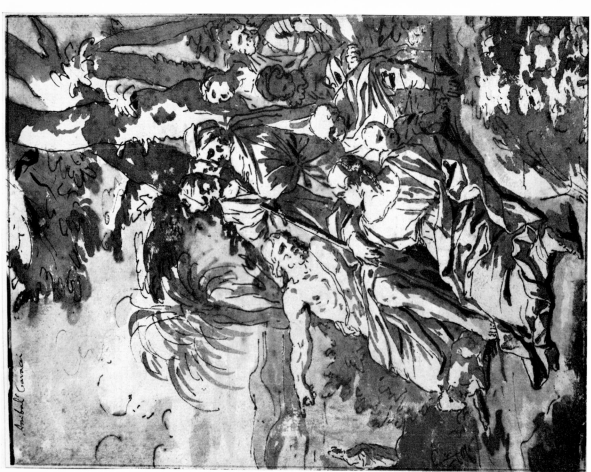

146. C. Maratta, Copy after Mola's *St. John the Baptist Preaching*, Pl. 110, (Cat. 35)

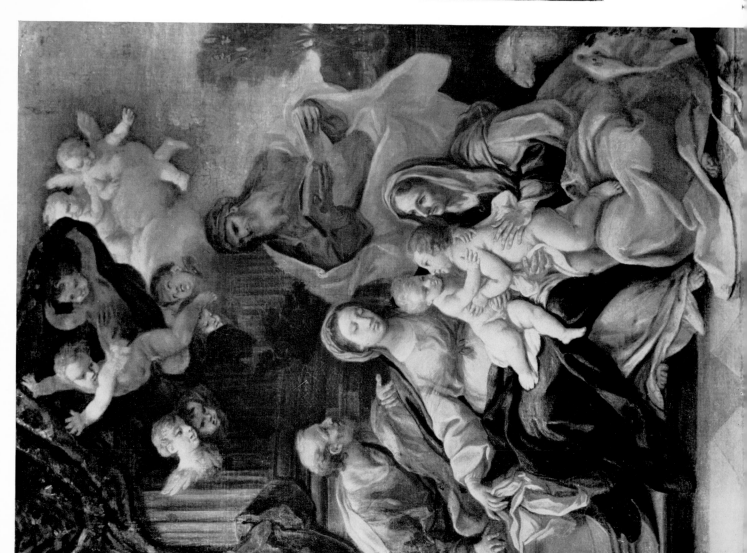